Electronic Cinematography Achieving Photographic Control over the Video Image

Electronic Cinematography

Achieving Photographic Control over the Video Image

Harry Mathias & Richard Patterson

Wadsworth Publishing Company Belmont, California A Division of Wadsworth, Inc.

Senior Editor: Rebecca Hayden

Production Editor: Leland Moss

Managing Designer: MaryEllen Podgorski

Designer: Joe di Chiarro

Copy Editor: David Hathwell

Technical Illustrator: Mark D'Antoni

Cover: Joe di Chiarro

Cover Illustration: Dave Jensen

Print Buyer: Barbara Britton

Printed in the United States of America

1 2 3 4 5 6 7 8 9 10—89 88 87 86 85

ISBN 0-534-04281-3

Acknowledgments

Paramount Pictures for Fig. 5.9 from *Flashdance,* Figs. 6.11a,
b from *Heaven Can Wait,* Fig. 6.11c from *The Godfather;*
Twentieth Century Fox for Figs. 5.11, 5.12, 6.12, 6.13 from *All
That Jazz;* United Artists for Fig. 5.10 from *Casablanca.*

Library of Congress Cataloging in Publication Data

Mathias, Harry.
 Electronic cinematography.

 Includes index.
 1. Electronic cameras. 2. Cinematography.
I. Patterson, Richard. II Title.
TR882.M38 1985 778.59 84–17309
ISBN 0-534-04281-3

To ANNA, BETSY, and VICTORIA for very different reasons.

Contents

Preface

There is an ancient Chinese curse that reads, "May you be born into an era of change!" Like it or not, all of us in film <u>and</u> video production are in an era of change . . . and the changes we have seen are nothing to the changes yet to come.

No one who is now in college to learn motion picture production—whether as a director, producer, cinematographer, or editor—will get through even the first few years of his or her career without making one or hundreds of video productions. No one now in the motion picture industry will retire (unless retirement is near) without doing the same. Even more importantly, within five years no *video* production people will be making videotapes with the production values or creative techniques in use today.

The often debated, tired question of whether film will replace video overlooks the more obvious conclusion that both will transmute each other into a third, much more subtle art form. This process has already begun.

In video, researchers at NHK (the Japanese National Broadcast Network) have demonstrated several working versions of high definition television systems (HDTV), and so, by now, have several other countries. The world television advisory body, the C.C.I.R., and the European Broadcast Union have acknowledged this advance in the technology of video quality by calling unanimously for the adoption of a single worldwide HDTV production standard. In America, the Society of Motion Picture and Television Engineers is working with them to make this a reality.

At this writing, two major and two independent dramatic features in current theatrical release were originated in whole or in part in video. Industrial Light Magic (the special effects arm of Lucasfilm that did all the special effects on the *Star Wars* films) is in the thick of the research for new and presumably more cost-effective electronic methods. Steven Schwartz, chief video engineer of Lucasfilm's computer division, has said, "We are building for a time when film will be the original photography and the releasing medium and in between it will be all video. But the next step will certainly be video from one end to the other."

Clearly, production techniques used for today's television programming will not be adequate for what Francis Ford Coppola calls the "electronic cinema," that is, motion picture production on video. The future demands a new analysis of the visual techniques that will be

required by the improved picture quality of HDTV and its application to dramatic subjects. This book takes the first step toward that analysis, while at the same recommending techniques that improve artistic and visual control over the present video technologies.

As the world of video changes to encompass traditional motion picture subjects, the art and science of the motion picture must change as well. Motion picture and television production people will have to give up their last lingering feelings that video is meant only for producing the six o'clock news or a local magazine show. Current video production quality is no longer limited by the technology, but by the skill of its application.

Electronic cinematography is a new form of production, born of the marriage of video hardware and film techniques; it offers not only the best of both worlds but entirely new creative possibilities. This book addresses the skills needed to apply current and near future technologies to the ancient craft of expressing ideas visually.

Video has begun to compete seriously with film as a means of artistic expression. There are limitations to overcome, but the basic tools are there. The problem is that very few creative people realize the potential of the medium. Cinematographers who can create the most dazzling images on film either regard video as a crude medium suited only to live audience sitcoms or are so intimidated by electronic paraphernalia and engineering jargon that they do not even attempt to explore the possibilities of video. At the same time engineers and video production people can be so ensconced in rigid concepts about the proper way to use the equipment that they do not see its creative potential.

The video engineer often functions as an oracle who must be consulted before any image manipulations are attempted. The imagination of video and film production people must be based on a sound technical foundation to allow them to exercise successfully their creative visual imagination. With a solid technical foundation, production people will have a more rewarding creative collaboration with their engineering associates.

Demystification of any complex technology, particularly a new one, is essential to its adoption as a technique for artistic expression. *Electronic Cinematography* is intended to demystify video and lay the groundwork for truly creative use of the medium. Without ignoring the current limitations of video, it sets forth a new working method designed to get the most out of today's equipment and to enable cinematographers to take full advantage of advances that are just around the corner. No previous technical or electronic background is necessary to understand the material presented.

This is not just a technical book that explains video. If it meets our expectations, it is a technology-in-the-service-of-art book. The technical

information in this book is, therefore, structured according to the needs of cinematographers, directors, producers, and video engineers (not necessarily in that order) whose primary concern is *creative visual control* over the video image.

Those aspects of video technology that enhance photographic control and the creative impact of the image are covered in great detail in this book. Other aspects of video (which may seem equally important to engineers) are dealt with in less detail, if they are incidental to the creative manipulation of the video image. The introduction to each chapter will explain the approach taken to that subject and why.

After an overview of the attitudes that tend to stagnate production quality in video, this book analyzes the way video cameras make and process images in order to provide a foundation for later discussions of tone manipulation and image control. The waveform monitor, long believed to be a piece of video engineering equipment, is discussed in Chapter 5 as a most useful tool for creative lighting and exposure control; and the use of a picture monitor for this purpose, although widespread, is cast into some doubt.

The application of tone reproduction knowledge is vital to the skillful control of film images, and it is central to the theme of this book that this information can be applied with equal success to video. Chapter 6 makes these points, and offers specific guidelines for applying modified film techniques to video. Color reproduction technology is then discussed (Chapter 7); this subject seems easier to understand once a basic foundation is laid. Camera set-up is also covered (Chapter 8 and 9); a basic understanding of camera alignment is vital to any intelligent discussion of video image quality, and the authors believe that the cinematographer or video production person can control a process only if she or he understands it.

After the image-making process is thoroughly understood by the reader, exposure and lighting techniques are discussed in Chapters 10 and 11. The use of a light meter as a basic tool of video exposure and contrast control along with the waveform monitor is covered in detail. (This practice, introduced by me many years ago, is now quite widespread.) Video recording and postproduction are covered both to encourage an understanding of these subjects and to reflect on how they affect the image control process (Chapters 12 and 13).

The motivation for including some subjects in the "peripheral" chapter may not be readily apparent. The subject of sync, for example, is included because any understanding of video that doesn't view it as a total system invites later confusion as ancillary systems are encountered.

In the closing chapters, high-definition television and future technologies are covered in as much detail as was possible with such a

rapidly moving subject. Any book can only reflect the progress made at the moment of its publication and make predictions based on trends observed. The subject of higher quality video and future choices is actually infused liberally into this entire book. As we discuss choices made in the selection of current video standards, we also discuss the compromises in quality that were incurred. Future choices are also discussed in terms of their practical tradeoffs.

This book grew from a series of popular lectures to industry professionals and students that I gave during a five-year period. Beginning as "A Cinematic Approach to the Use of Video Cameras" and eventually becoming "Production Techniques in Electronic Cinematography," this course changed considerably—along with the industry it reflected. The course arose from the demands of cinematographers who had video thrust upon them. They had an urge not just to master the technology but to find something visually unique in it. I found that film people face video feeling they have a lot to learn, and generally possess an eager attitude toward learning it. Video people agree that film people have a lot to learn about video. But they have been slower to realize that they could learn something from the "strange" approach the film people are taking to video production. This book was written to help open a practical dialogue between these two groups and to serve them as an interpreter.

The image control and production techniques described in this book are the result of twelve years of my experimentation. They began as film techniques and were applied to video; some were initially successful, but many had to be adapted for the specialized technical requirements of the video image. They have all proved effective in practical production situations for years. Many methods advocated by this book are not accepted industry practice. They have all been tested by me, and subsequently by others, and have proven valuable in actual production situations. These methods are now part of the daily production repertoire of myself and others. The responsibility for advocating any controversial methods, however, must remain mine alone.

Acknowledgments

This book would never have been a reality without the enormous writing skills and patient hard work of Richard Patterson. No one could hope for a more skilled writing partner or a finer friend. His ability to communicate complex ideas with grace and apparent ease is well known to the readers of *American Cinematographer* magazine. My collaboration with him has been a joy to me, and I hope that it will prove useful to you.

I would like to thank my gaffer and lifelong friend, John Bonfield, who tested many of these production methods with me and has taught me more about lighting than I ever taught him about video or film.

I would also like to thank Elizabeth Bailey, a superb video and film cinematographer, who spent many hours coordinating the illustrations and pulling the glossary together.

My sincere appreciation to Jac Holzman of Panavision for allowing me the use of Panavision facilities on weekends for photographing illustrations.

My deep appreciation to Ed Imparato, whose assistance and advice throughout the process of developing this work helped shape its final form.

I am also indebted to Mark D'Antoni, a consummate painter, for his illustrations, and to Afshin Chamasmany for his photography; to Rebecca Hayden, of Wadsworth Publishing Company, for her patience, support, and understanding; to Leland Moss of Wadsworth for his solid support and resourcefulness under fire; and to Mary Arbogast of Wadsworth for her early attention to style and organization.

Lastly, I would like to thank Herbert Zettl, my former teacher and long-time friend, for his review, comments, and encouragement on this book. I also owe thanks to Michael D. Covell, Southern Illinois University at Carbondale; J. Clive Enos, New York Institute of Technology; Franklin Miller, University of Iowa; William E. Mackie, University of Texas at Austin; and Gene Polito, ASC, University of Southern California, for their thoughtful reviews of the manuscript. I extend my special appreciation to Stanley Kronquist, video engineer, and Michael Humm, producer, who painstakingly read the manuscript and made suggestions for improvements; and to the people of C3400.

Harry Mathias
Aboard the Ariel at Avalon

Electronic Cinematography Achieving Photographic Control
over the Video Image

Electronic Cinematography

To introduce a new era of visual and pictorial control we must begin by questioning old ideas of style and old production habits. If we do not question them, they will be rejected anyway, and we will never know why.

Electronic cinematography combines the most sophisticated techniques of film production with state-of-the-art video equipment. The object is to give video production the same potential for creativity and aesthetic refinement that exists in film and to take full advantage of the creative possibilities of the electronic medium that do not exist in film.

Electronic cinematography maximizes the degree of control over every aspect of the production process and centralizes the creative decision making. For example, in order to maximize control over the lighting for each image, electronic cinematography tends to use a single camera so that the lighting can be custom tailored for each camera angle. Also, filtering and diffusion materials are used on the camera to increase control over the image. Responsibility for operating the camera is delegated among two or three specialized crew members rather than requiring one operator to do it all. All of these techniques, which have been developed for film production over an 80-year period, are new to video production and require adjustments in the working relationships among a video crew as well as modifications in the design of video cameras.

At the same time, in order to adapt film production techniques to the electronic medium, film crews must learn to use new tools. They must see that what appears at first to be an alien conglomeration of dials and switches is in fact a set of tools designed to give them the same control over an electronic image that they are accustomed to having over a photographic image.

Many veteran cinematographers view the encroachment of video production techniques into the realm of dramatic television and theatrical motion pictures with apprehension—not just because they fear that they personally may be ill equipped to work with electronic cameras but also because they associate conventional video production techniques with a loss of creative control over the image.

Because of its roots in live broadcasting with highly unstable equipment, video production has traditionally delegated much of the control over the camera to a video engineer. Decisions about composition and camera movement have been worked out directly between the camera operators and the director, and lighting has been supervised by a lighting director much as in a stage production. As a result there appeared to be no need for a separate director of photography.

On a film crew the director of photography coordinates the activities of everyone on the crew and is responsible, along with the director, for creating the visual style of the film. The director of photography is the focal point for all the creative and technical decisions that affect the look

of the picture, and at his or her best represents a unique combination of technical expertise and aesthetic sensitivity. To attempt a visually sophisticated production without a director of photography is self-defeating. On a large production with a tight schedule there must be one person who assumes responsibility for executing the visual style, and it is unreasonable to expect the director to do this along with all of his or her other chores. Without a director of photography there is little hope of achieving a consistent and thematically relevant look, not to mention a unique personal style in the images.

This book is dedicated to the hope that electronic production techniques will not throw away the fruits of 70 years of refinement in motion picture production techniques, but will ultimately present new opportunities for even greater control and personal expression. For this to happen it is imperative that video production personnel adopt a fresh perspective on conventional working methods and that film production personnel master the basics of video cameras, recorders, and signal-processing equipment.

The point of this book is not to train anyone to be a video engineer but to enable cinematographers and video engineers to collaborate creatively and to give everyone involved in video production an appreciation of how video equipment can be used to produce the kinds of images that have been previously associated with film.

THE CINEMATOGRAPHER AND THE VIDEO ENGINEER

Many cinematographers—even some of the most accomplished directors of photography in Hollywood—can be easily intimidated by video engineers or by the apparent mysteriousness of electronics. If an engineer who expresses concerns in incomprehensible jargon points at a little screen on a piece of high-tech-looking equipment and says that the green line has to be here and not there, there is not much the cinematographer can say in reply. He (or she) may very well just modify the lighting or do whatever else is necessary to get the green line where it has to be, feel disappointed with the results on the screen, and go home convinced that video is just not capable of doing the sorts of things he likes to do with film.

He (or she) may be right or he may be wrong. The only way he can find out is to learn enough about that little green line to evaluate the engineer's concerns. The same cinematographer would know perfectly

well how to evaluate a call from a timer at the lab telling him his negative had to be printed all the way at the end of the scale to produce a normal skin tone when the negative was in fact exposed to create a low-key effect. The techniques for processing and evaluating film images are every bit as complicated as the electronic techniques used by video engineers, but cinematographers have been trained to interpret a timer's reports, and—more important—they have been made to feel that the timer is there to help them get the effect they want rather than to tell them how to expose the film.

By the same token, many video engineers are confused by the kinds of things they are asked to do by cinematographers accustomed to working in film. An engineer who has been schooled in the characteristics of a proper video signal may very well get uncomfortable when a cinematographer starts insisting on recording a "bad" signal. It is, after all, the engineer's responsibility to ensure that the recorded signal is "good." The problem, of course, is that the engineer may have an unnecessarily rigid idea of what a "good" signal is and an inadequate appreciation for what the cinematographer is trying to achieve.

Film cinematographers tend to be a great deal more flexible and pragmatic than most video engineers. For instance, if you asked 33 of the world's great cinematographers what correct exposure is, they would probably all say something like, "Well, correct exposure is whatever it takes to create the mood I want or to create an image that is appropriate for this particular scene or to communicate the visual design I have in mind while being consistent with the rest of the film," whereas if you asked 150 of the world's best video engineers the same question, they would all say, "White level at 100 units and black at 7.5 units."

No cinematographer would insist that every image had to fill the complete latitude of the negative in order to be properly exposed. Too much depends on the content of the scene and the mood the cinematographer is seeking to create. Admittedly there have been limitations in the video recording and transmitting system that have influenced video engineers' thinking, but certainly today's equipment is sophisticated enough to justify less rigidity once the camera is shooting something other than a test chart.

COMMON FALLACIES ABOUT VIDEO

There are several other fallacies or prejudices about video that might as well be disposed of at the outset. These are misconceptions that might

influence decisions about whether to do a production on film or tape. Cinematographers who have worked in both film and tape think there are valid reasons for choosing each, but it often seems to them that the choice is made for all the wrong reasons.

It is generally very difficult, if not impossible, to convince a film producer to work in video or a video producer to work in film—even when they want to do something as ill advised as shooting thirty-six programs on ¾-inch cassette in order to transfer the edited shows to 16mm and release on film. And there are producers who want to do such things. Sometimes the cinematographer tells them, "This is crazy; I won't do it." They simply find someone else who will.

Sometimes this book may appear to be negative about video. It is not negative about video at all; it just expects a lot from video. What it is negative about is sloppy work, whether it is done in film or video, and it is negative about decisions that are based on myths and prejudices. So . . .

Fallacy 1

Video is cheaper Almost everyone—filmmakers and video engineers alike—seems to believe that video production is cheaper than film production. Many people who work in video production have promulgated this myth, and the irony is that they are constantly having to prove that it is true. Since the client and the producer decided to shoot a commercial on videotape because it's supposed to be cheaper, they then pay the crew less, use a smaller crew with less lighting and grip equipment, and have a tighter shooting schedule and a lower shooting ratio—all because video is supposed to be cheaper. The result, of course, is simply an inferior product. The truth is that *good* video is expensive—just as good film is expensive.

First of all, video equipment is expensive. Even if the cost of the camera is comparable to the cost of a film camera, once you add the recorder and the monitors, the cost of the video equipment is sure to exceed that of a film camera. And rental fees on video equipment tend to be even higher because of the shorter life expectancy of video equipment. It is not that video equipment wears out or falls apart, but that it becomes obsolete extremely fast; and it is very difficult to rent obsolete equipment. As a result it is necessary to charge higher rental prices in relation to the capital investment in order to have the equipment pay for itself before it becomes obsolete.

By comparison, one cinematographer used to own a 16mm Eclair camera that he purchased for $6,000. He kept it for 9 years and sold it for

$11,000. And it still worked well; the person who bought it got a good deal. Even forgetting the effect of inflation, this kind of thing is certainly not going to happen with video equipment in the near future.

The claim is also made that video is cheaper because the tape can be recycled, but it is very rare that any producer will erase a tape in order to record new material on it except in off-line editing.

Videotape stock may be cheaper than film stock and processing, but it depends on the nature of the production whether this is a significant enough factor in the overall budget to make video a less expensive medium for a shoot. If you need to shoot 8 hours of someone talking in 1 day, then it probably is; but suppose you are shooting a 30-second commercial with a 28-day shooting schedule. (This actually happened once. It was the *Heaven's Gate* of television commercials. They shot 3,000 feet in 28 days.) Then obviously the cost of the video equipment would far outweigh the savings in stock and processing.

These are extreme examples, but they serve to illustrate the point that video is not inherently less expensive. It all depends on the requirements of the production. One test done with an episode of "Harper Valley P.T.A." that was supposed to cost $37,000 less with tape ended up costing only $3,000 less because of complications in the off-line editing process. Another television production is reported to have cost more on tape than it would have cost on film because the extras and stand-ins were governed by a different guild.

Fallacy 2

Video requires less lighting than film People may commonly try to shoot video with less lighting equipment than they would use with film, but the truth of the matter is that video requires more lighting than film because it reproduces a more limited contrast ratio. The only way to reduce the contrast ratio in a scene—unless your production manager can call upstairs and order an overcast day—is to use more light to fill the shadow areas. The reason few, if any, commercials shot on tape win CLIO Awards is because the cinematographers shooting tape are forced into using mediocre lighting by the lack of time and lighting equipment (because tape is cheaper!).

Fallacy 3

Video is more sensitive than film The prevalence of this myth probably stems from the extensive use of video cameras for electronic news

gathering (ENG), but it is simply not true. At their best, current video cameras are about as sensitive as Eastman color negative type 5247 or 7291. The new higher-speed color negatives are at least twice as sensitive as the best video camera. (More on this in Chapter 10.)

Fallacy 4

It is easier and faster to light for video because you can see the end result on the monitor as you light Not only is it slower and less efficient to light using a monitor as you go; it is also not necessarily any easier. It can be harder because in some instances the monitor may be misleading. This will be explained in detail in Chapter 11.

Fallacy 5

A waveform monitor is only for video engineers The waveform monitor is actually the most valuable piece of equipment a cinematographer can have except for a light meter. In fact, for a cinematographer the waveform monitor can function like a light meter, and for some purposes it is even more valuable than a light meter. It is a tool that every cinematographer and gaffer and anyone else trying to light for video should be using. The problem is that even most video engineers do not understand how to use a waveform monitor properly in a creative context. One of the main objectives of this book is to enable cinematographers and video engineers alike to realize the potential of the waveform monitor as a tool for creative work.

IMAGE QUALITY AND PRODUCTION TECHNIQUES

It seems as though every major technological advance in the motion picture industry results in a temporary setback in image quality. One need only compare the visual finesse of late silent films with the mundane staging and compositions of early talkies or compare the lighting in early color films with the lighting of black-and-white films of the same vintage. The same thing is happening with the introduction of video cameras and recorders.

In order to take advantage of the other benefits of video production such as increased speed, compromises are accepted in lighting and camera style that really represent a giant step backward. Even in news

photography the wholesale adoption of ENG resulted, at least at first, in things being broadcast that would never have been acceptable in the days of 16mm newsfilm production. For the sake of the extra immediacy of live or almost live video coverage of news events, viewers have been asked to watch as a camera operator zooms in and out to check focus—the sort of thing that either would never have gotten news onto a film or would have been thrown out in editing if it had.

Image quality is not always the primary consideration in the development of new video equipment and techniques. For example, reducing the size and weight of a video camera may well have a higher priority than increasing the latitude or resolution of the image.

Video has come of age enough to begin competing with film without qualification. We have passed beyond the point where we should be impressed that someone was able to get a particular shot with a video camera. Video cameras have gone into the thick of battle and up to the very summit of Mount Everest. Video cameras have also been used on stylish dramatic productions and for movies exhibited in theaters.

Video now has to be taken seriously enough to be evaluated on an equal footing with film. There are some things that video can do better than film and some things that film can do better than video. With the advent of high-definition television systems in the near future, video will be able to do even more and will offer film even more competition.

Most of what has been regarded as proof of the inferiority of video has, in fact, simply been bad lighting. Because of its origins in live broadcast, video production has tended to rely on multiple cameras; and multiple-camera techniques necessarily involve compromises in lighting. This is nothing new. There is an article in the 1930 *Cinematographic Annual*, published by the American Society of Cinematographers, in which Victor Milner, ASC, discusses the difficulties posed by the adoption of multicamera techniques with the advent of sound. He points out that if there had been more than one camera shooting a silent scene, there were probably only two or three shooting from the same basic angle. Talkies often required as many as fifteen cameras shooting from completely different angles. His recommended solution to the problem also sounds familiar: flat overhead lighting.

There are good lighting and bad lighting for a multiple-camera show (be it film or tape), just as there are good lighting and bad lighting for a single-camera production. *Mork and Mindy* was a three-camera show, but the cinematographer, Meredith Nicholson, managed to light the entire set very carefully using smaller lighting units so that at any given point an actor never had more than a key light, a fill light, and a back

light; and there were no multiple shadows. *Mork and Mindy* was shot on film, but *Barney Miller* and *WKRP in Cincinnati* were also both quite well lit for multiple cameras, and they were both shot on video.

The problem is that very few people working in video are able to do good lighting. This is the influence of excessively rigid video engineers. One video engineer insisted that a show had to be shot at $f/4$ with 200 footcandles (fc) because that was what the specifications for the camera said would produce the best signal-to-noise ratio in the recorded signal. He insisted that the set be lit to 200 fc, and not 100 fc at $f/2.8$ or 50 fc at $f/2$, both of which would of course be exactly the same amount of light coming through the lens. The only difference would be the depth of field, but he insisted that the camera needed 200 fc.

Perhaps an even better illustration of the present state of video production techniques is an experience that one of the authors, Harry Mathias, had while shooting a recording-company corporate image film. The concept called for a satire on *Raiders of the Lost Ark*. It was quite well written and very funny. Harry was intrigued by the project and assumed that he would be shooting on film. It turned out that he would be shooting on video, and he was perhaps even more excited by the challenge of recreating the look of *Raiders* on video. It is indicative of the progress that has been made in recent years from a creative standpoint that one could even conceive of doing such a shoot on video.

Harry and his gaffer went to see *Raiders* again a couple of times and took notes on what Douglas Slocombe had done in shooting the film. They figured out how to duplicate the way he had lit faces warm and walls bluish and the way he had used low-key traditional lighting with a lot of rim lighting and depth-staged lens angles. They also decided to use a light double fog filter and a lot of atmospheric haze produced by a beeswax smoker.

Beeswax smoke is foul and horrible to breathe, but it hangs in the air, and it gave them the look they needed. Harry really felt they were succeeding in duplicating the look of *Raiders* as much as was possible on video. It looked about like what *Raiders* would look like if it were transferred to tape.

No sooner had they gotten all set to shoot than the video engineer, who had come with the production company, came up and said, "Your blacks are at 20 units and your whites are at 80." Harry said, "Yes, I know," and the engineer said, "Well, you've got to get your whites up to 100 percent."

"No," Harry said. "If we get our whites up to 100 percent it will look like a supermarket instead of *Raiders of the Lost Ark*. If you look at the

interiors in *Raiders,* you'll see there are no whites. If you put the film on a waveform monitor, there would be no whites at 100 percent; they'd all be at 80."

"Yes, well, but in postproduction," the engineer said, "when they bring it back up to 100 percent, they'll pick up noise."

"Yes, that's right,'" Harry replied. "That would happen if you brought it back up to 100 percent. That's why it's gonna stay at 80. There's no noise if it stays at 80."

The engineer went away for a minute then came back.

"But your blacks are at 20," he said.

"I know. This smoke we're breathing," Harry pointed out, "the only function it has is to bring the blacks up to 20 units, because that's what happens when you put smoke in the blacks."

The argument continued, and it became obvious that neither was convincing the other. Harry kept telling the producer and the director, "Now look, he's right. It's going to look really noisy if you bring the levels up to 100 percent, and we're not going to get the look anymore. And the blacks are supposed to be at 20 percent; that's what the smoke is all about. So you'll leave it this way, right?"

They said yes, and then took the tapes back to New York for post-production and sent him a cassette of the edited promo.

When he looked at it, Harry realized that someone had gotten to them in postproduction. The picture was noisy, the whites were at 100 units, the blacks were at 7.5, and the look was completely destroyed.

Harry called them and told them to lose his phone number, but what really infuriated him was that all the people he had worked with had had to breathe that awful beeswax smoke for a week and had probably gotten scar tissue on their lungs to bring the blacks up to 20 percent. One turn of the knob, and it was all in vain. Not only had it ruined the look, but it had pulled the smoke right out of it completely.

The only function of a fog filter or a low-contrast filter in either film or video is to fog the blacks, that is, to raise the black levels; and if the cinematographer is using a filter to do that, there is no reason on earth to pull the black level back down to 7.5 just because that's where the black is "supposed" to be.

Obviously a good video engineer will understand that—and there are good video engineers who are creative forces in production—but nonetheless there is a need for more appreciation among the rest of the video community for the creative techniques of a cinematographer.

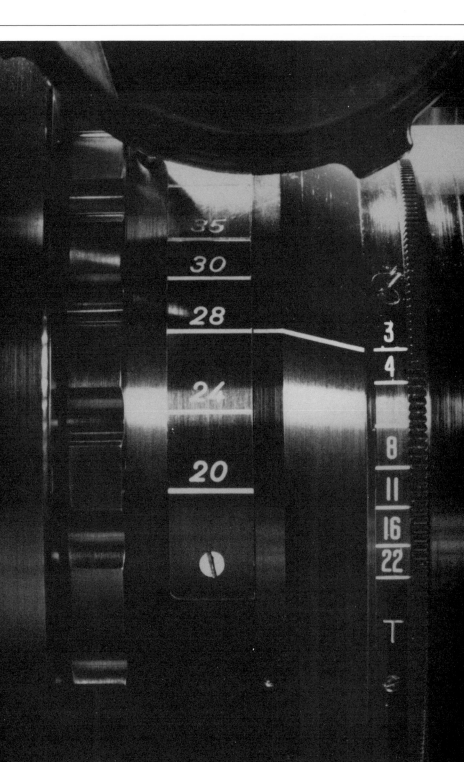

The Video Camera
Mechanics and Optics

Video cameras have gone through a considerable design revolution from the time when only news cameras and studio cameras were available. What a cinematographer expects from a camera depends on the level of production for which it will be used. The higher-quality the production, the more stringent the requirements for the camera's optics and mechanics and the more the cinematographer must know about his or her camera and lens.

CAMERA OPERATION AND CREW CONSIDERATIONS

The design of a conventional video camera is a reflection of the working methods of a video crew as they have developed from the early days of live broadcasting. Even the most sophisticated studio camera is designed to be operated by one person rather than a two- or three-person team, and as a result zoom lenses with remote-controlled zoom and focus are the norm. The f-stop or iris is often automatic, or is designed to be controlled by a video engineer. The focus and zoom controls are generally built into a handle by which the operator holds the camera.

In a studio the camera is probably mounted on a pedestal, so that the operator performs the function of a dolly grip as well as the functions of a film camera operator and assistant. Since the operator discusses the composition and camera moves with the director, he or she also assumes the function of a director of photography to some extent. In most cases, though, the video camera operator simply executes a shot called for by the director and is not expected to make the kind of aesthetic contribution with regard to composition that a director of photography makes on a film. What the operator is expected to do, however, is often the impossible when it comes to executing zooms, pans, tilts, focus pulls, and moves simultaneously; and the operation of a video camera can be a very specialized skill.

For reasons that are obvious to anyone who has worked with a sophisticated film camera, there is a growing demand for video cameras designed to be operated by a team rather than an individual. At the moment there are only two such cameras on the market: the Panavision Panacam and the Ikegami EC-35. Both of these cameras are designed to accept prime lenses as well as zoom lenses and to allow a camera assistant to control the focus and the f-stop as well as the zoom. They are also designed to accept filters and diffusion materials in front of the lens in the same way a film camera can, and they have special circuitry enabling the image quality to more closely approximate the look of a film image.

For many video people, however, the advantages of these cameras may not be immediately obvious. To someone concerned primarily with crew costs, changing over from a camera that requires one operator to a camera that is operated by a three-person crew (including the dolly grip) may seem like a giant step backward; and even experienced video camera operators may feel that the delegation of some tasks to an assistant is an awkward and inefficient mode of operation.

The key, of course, is control. There are plenty of documentary film camera persons who operate film cameras in essentially the same way

that video camera persons operate video cameras, although most use assistants to pull focus for many shots even on vérité documentaries. But if the subject matter is a staged scene with precisely controlled lighting and well-rehearsed movement, it becomes possible for a team to achieve a subtlety or refinement in the control over the image that a single operator could not hope to achieve on a consistent basis.

To some extent it is simply a matter of how intensely an individual can concentrate on a specific task. A camera operator who can devote full attention to the planning and execution of a composition or a move without having to be concerned with lighting a set or pulling focus will be much better able to refine and evaluate the framing throughout the shot. Another reason for having an assistant operate the zoom and pull focus is that it enables the camera operator to use a gear head for executing pans and tilts. A gear head is unquestionably the best means for achieving smooth moves (given an experienced operator!), but it requires two hands to operate. Its principal advantage is that it can hold the camera rock-steady before or after a move, and it permits very gradual and consistent adjustments within a move. If one were going to program a computer to execute a camera move that had to be repeated precisely, the best way to enter the data for the move would probably be by means of gear head controls on a real-time run-through.

EXPOSURE CONTROL

A video camera operator has already delegated control over the f-stop to someone else—either the video engineer or, in the case of automatic exposure control, the camera designer. The problem with delegating exposure control to video engineers is that they may not be in the best position to evaluate the exposure—both literally, in the sense that they are not likely to be situated on the set near the camera, and metaphorically, in the sense that they may not be attuned aesthetically.

Theoretically there is no reason that video engineers should not be able to understand what the directors of photography are doing just as well as assistant camera persons and control the exposure just as well, since they can see exactly what the camera is shooting on the monitor. Practically speaking, however, it is unrealistic to expect a director of photography to have the same kind of rapport with a video engineer that he or she has with an assistant, given the current state of affairs in production. It is still easier for most D.P.'s to talk to the person standing next to them than to talk to someone in another part of the stage by

means of an intercom. Also, it is difficult now to find video engineers who are sensitive to the kinds of effects that a film cinematographer may want to achieve. As far as exposure is concerned, assistants see their job as remembering and executing the f-stop changes given to them by the cinematographer. It is unlikely that "video control engineers" see their job in the same light.

Automatic exposure control has the same problems in video that it has in film. Some cinematographers may find it useful in news situations where it is impossible to control the light and there is no one available to control the f-stop during a shot, but it is definitely not a reliable technique for a production with controlled lighting. No automatic exposure control system is capable of interpreting adequately what the camera is shooting or what the cinematographer's visual intentions are.

Just for the record, however, it should be noted that the automatic exposure control system on a video camera can be a great deal more sophisticated than similar controls on a film camera because of the ability of the system to distinguish between colors in the scene being shot. The Panacam, for example, has a "tone capture" mode for the automatic exposure control that enables the system to be set so that a specified color will always be exposed to a certain value. The most obvious application of this is to set the tone capture on a skin tone and let the automatic exposure system ensure that whenever that tone is present in the scene, the exposure is set so that the skin tone is reproduced in a consistent way.

The limitations of such a system would become apparent if it were used to set exposure for a scene in which the person moved into a shadow area and one wanted to preserve the effect of the shadow area in the scene. Obviously for such a scene one has no use for any kind of automatic exposure control. In general, there are very few instances where a cinematographer could not control the lighting of a scene to within ¼ stop of the desired effect. No video camera has to be lit any more accurately than ¼ stop.

One difference between the Panacam and other video cameras (including the EC-35) is the location of the iris. The Panacam was designed to use existing Panavision lenses; but, rather than using the irises in the lenses, a second iris was designed into the optical relay system inside the body of the camera. This iris can be automatically or manually controlled, and there is a scale on the side of the camera on which the f-stop is read. The Panacam also has an optical reflex viewfinder in addition to an electronic viewfinder, and the iris is located behind the beam splitter for the viewfinder. This means that the image in the optical viewfinder

is always as bright as possible regardless of the *f*-stop setting. It also means that the effect of the *f*-stop setting on the depth of field is not visible in the reflex finder.

CAMERA CONFIGURATION

Video cameras differ in their physical configuration according to how they are intended to be used. For example, if a camera is intended to be hand-held, it will have an occular finder on it, that is, a small monitor mounted inside an eyepiece resembling the finder eyepiece on a film camera. If it is a traditional video camera designed primarily for studio work on a pedestal or dolly, it will have a "studio" finder that consists of a 3-inch or larger monitor. Many video cameras can be adapted for use with either kind of finder.

The Panacam can be equipped with both an optical and an electronic finder, which can be used simultaneously. Generally the electronic finder would be turned so that the assistant can see it while the operator uses the optical finder. It is also possible for an operator to have one eye on the optical finder and refer to the electronic finder with the other eye.

Another way in which video cameras differ in their configuration is in how the controls for the electronics are accessed. If a camera is designed to be used by an operator alone in the field (that is, an ENG camera), its electronics will be as automatic as possible and many adjustments to them will probably be made with a screwdriver. Cameras designed for more critical production work generally have electronics that can be adjusted with knobs by a video engineer via a remote camera control unit. This camera control unit is either detachable once the camera is adjusted or connected to the camera during operation. The most sophisticated cameras employ microprocessors to aid in the adjustment of the electronics.

The Panacam and the EC-35 represent two radically different approaches to the design of a sophisticated video camera. The EC-35 was designed to be as self-contained as possible. It requires a remote unit only for its initial setup and can be connected directly to the videotape recorder during shooting by means of a small cable. The Panacam was designed to minimize the amount of electronics in the camera body itself and to make maximum use of a computerized camera control unit that can be up to 600 feet away from the camera. Because of the variety of

signals going back and forth between the control unit and the camera body, a much heavier cable is required to connect the two.

Each configuration has its advantages and limitations. For example, the Panacam camera control unit can continuously monitor and adjust registration of the camera during shooting, the smaller cable on the EC-35 makes it much easier to use the camera hand-held or on a Steadicam.

Another camera configuration that should be mentioned is the recording camera (or Camcorder). The development of a new ½-inch videotape recording format has made it possible to design recorders that are small enough to be mounted directly onto a camera and yet good enough to record a broadcast-quality signal. While the cameras were originally conceived for ENG work, they will find as much use in other forms of production.

VIDEO LENSES

One of the differences between video cameras and film cameras is the lack of standardization in lenses for video cameras. Because it is relatively easy for a manufacturer to buy the components for a video camera and package them in its own way, there is a large number of video cameras with a bewildering array of lens mounts. Even different cameras from the same manufacturer will sometimes employ different lens mounts. Not only are the actual mounting brackets different, but in most cases the back focal lengths are also different, so it is not a simple matter to adapt a lens to a different mount.

Faced with the need to supply lenses for such a variety of video cameras, the lens manufacturer is forced to take one of two possible approaches. One approach is to manufacture a basic lens along with a variety of adaptor elements that permit the lens to be mounted on various cameras. This is essentially the approach that Angenieux takes. It enables them to put as much quality as possible into the basic lens— and their 10–150mm zoom, for example, is a very fine lens, mechanically superior to many video lenses—but the use of adaptors to correct back focal distance inevitably results in some kind of compromise in this lens in its video configuration as compared with its film counterpart.

The other approach, which is taken by the Japanese lens companies, is basically to manufacture a lens specifically for each camera. The prob-

lem with this approach is that the economics of the situation are such that all kinds of compromises have to be made in the lenses. The lenses that sell in volume have to carry all the other lenses, and there is no way that it is economically feasible to make the best possible lens for each camera. This is particularly true with regard to the mechanical construction of a lens. A film lens technician who once was given a new zoom lens of this type to check out felt that it needed to be overhauled completely; but the problems with the lens are built into it. It is simply a matter of aluminum sliding against aluminum rather than brass against polished stainless steel. There are also compromises in the optical design of these lenses.

Two design requirements for video lenses necessitate compromises when combined with the economic realities of the business. The first is the demand for an all-purpose zoom lens combining long telephoto ranges (for close-up shooting in three-camera situations) with extreme wide-angle capabilities. The second is the long back focal distance required because of the prism beam splitter in the camera.

The production of color images by a video camera resembles the old Technicolor three-strip process. The image coming through the lens is split into three separate images and filtered so that each image is a record of the red, green, or blue content of the scene. The image can be split with dichroic mirrors or with a prism. The beam-splitting prism is the means employed by most professional video cameras and is generally superior to dichroic mirrors, but it does pose some problems for the lens designer. The greatest of these is the back focal distance requirement.

Back focal distance is the distance from the last optical element to the image plane. In order to focus the image on the face of a pickup tube after it has gone through the beam-splitting prism, a video lens must have a back focal distance that is significantly longer than the back focal distance required by a film camera with a comparable image size. This is one reason why it is very difficult to adapt 16 or 35mm film lenses to a video camera, and any attempt to do so results in optical compromises.

The back focal distance requirement will vary according to the kind of glass used in the prism. There may be four or five different types of prism blocks used in competitive cameras, resulting in a variety of back focal distance requirements. A long back focal distance requirement is not a major obstacle in the design of telephoto or long-focal-length lenses, but it does make the design of wide-angle lenses extremely complex. Wide-angle lenses, because of their shorter focal length, require that the rear element be closer to the image plane than do telephoto lenses covering the same image area.

The use of prism optics in a video camera also introduces additional spherical aberrations that must be compensated for in the design of the lens. Film camera lenses do not have such prism optics compensation in their design and may not yield acceptable results on a video camera—especially at wide apertures and short focal lengths, where the effect of the prism is most pronounced.

Back focal distance is related to flange depth, the distance from the image plane to the front surface of the camera against which the lens is mounted. Normally all that is required to adapt a 35mm film lens designed for one camera for use on another is a modification of the mount to adjust the flange depth. The tolerances for such a mount adapter may be very critical, but it is nonetheless a machining problem and not a matter of optical engineering. If, however, the back focal distance of a lens is not sufficient to allow room for a beam-splitter prism, no amount of adjustment in the mount will enable it to work on a video camera.

All video lenses have to be retrofocal lenses (that is, lenses with optically extended back focal distances), and when this requirement is combined with the necessity for prism optics distortion compensation and the demand for zooms that go to extreme wide angles, the problems for the lens designer can become virtually insurmountable. Compromises have to be made in the resolving power and in the correction of various kinds of aberrations. These compromises have been acceptable partially because the standards in video production have not been very high and partially because the resolving power of the medium itself is so much lower than that of film.

The resolving power of current 35mm color negative film is at least twice that of broadcast-standard television cameras. (See Chapter 3.) Moreover, the resolution of the video image is further limited by the bandwidth restrictions in recording and broadcasting. Video lens designers have therefore concentrated on maximizing the performance of a video lens up to the limits of the broadcast system and not worried very much about performance beyond that point.

With the growing demand for better performance in video lenses and the prospects for the adoption of a high-definition television system, lens manufacturers have begun trying to find economically viable ways to improve video lenses. One approach is to make prime lenses for video cameras. Ikegami commissioned both Fujinon and Canon to create a set of high-quality fixed-focal-length lenses and zooms for the EC-35, and five Canon lenses are currently available for the camera in addition to the two zoom lenses.

Another approach is to design a means of adapting existing 35mm film lenses for use on a video camera. This is the solution that An-

genieux's designers believe is the most viable—especially given the limited market for a lens with a particular back focal distance. Panavision began with this approach and took it to its logical extreme by designing a completely new video camera with an optical relay system that permits it to use Panavision film lenses. This optical relay system not only adjusts the effective back focal distance of the lenses but also reduces the image from the 35mm format to the size required for a $\frac{2}{3}$-inch tube. The image area on a $\frac{2}{3}$-inch tube is slightly smaller than the image area for a 16mm film frame. Reducing the 35mm image results in a concentration of the light and therefore an increase in the speed of the lens. The field of view for a given Panavision lens remains the same as it would with a 35mm film camera, but the speed of the lens is increased to a maximum of $T1.7$.

One side effect of prism beam splitters currently used in $\frac{2}{3}$-inch video cameras is to limit the speed of any lens to $f/1.4$. This is not due to the transmission factor of the glass involved but rather to the geometry of the beam splitter. The angles of the light path through the prisms, together with the dimensions of the prism surfaces, act to limit the whole system to a speed of $f/1.4$.

One final note with regard to the mounting of a lens on a camera: A zoom lens on a 35mm film camera has to be seated to a tolerance of 0.0004 inch. A human hair is about 0.002 inch thick, so that the tolerance for the lens mount is less than a quarter the thickness of a human hair. Now an added consideration is the fact that a video pickup tube is mounted in rubber, and is heated by a filament so that it expands and contracts with temperature changes. As a result a pickup tube mount must be designed so that the position of the tube can be adjusted.

All of these factors conspire to make it extremely difficult to get an image on the face of a pickup tube that can compare with the image at the film plane in a 35mm camera. On top of all this, a video camera has not one image but three separate images that must in effect be electronically superimposed to yield the full color image. A color image on a piece of film is not going to get out of registration due to a displacement of one layer of emulsion relative to another, but registration is a major concern in a color video image.

DEPTH OF FIELD

Most discussions of the relative merits of film and video include some consideration of depth of field. For any given field of view the lens on

a ⅔-inch video camera will have a greater depth of field than the equivalent lens on a 35mm camera shooting at the same *f*-stop. This is because depth of field is a function of the size of the image at the focal plane, and the size of the image on ⅔-inch pickup tube is much closer to the size of a 16mm image than a 35mm image.

A point in a scene that is out of focus will be reproduced in an image as a circle (called a circle of confusion). Depth of field is determined by specifying how sharp the image has to be in order to be considered in focus, that is, how small the "circle of confusion" for any given point in the image has to be. The absolute size of the circle of confusion is determined by the performance of the lens, but the relationship of the circle of confusion to the overall image is a function of the focal length of the lens or the size of the image relative to the size of the circle of confusion.

2.1a
Panacam optics

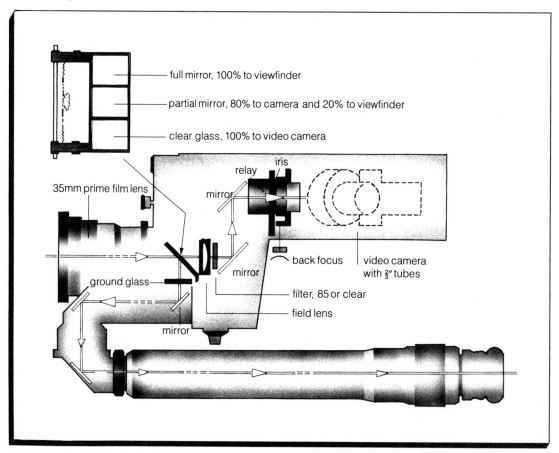

full mirror, 100% to viewfinder

partial mirror, 80% to camera and 20% to viewfinder

clear glass, 100% to video camera

iris

relay

35mm prime film lens

mirror

mirror

back focus

video camera with ⅔″ tubes

ground glass

mirror

filter, 85 or clear

field lens

mirror

The field of view is also a function of the size of the image at the focal plane. A 50mm lens has a much narrower field of view on a 16mm camera (or on a ⅔-inch video camera) than it does on a 35mm camera. In order to get the equivalent field of view on the smaller-format camera, it is necessary to use a shorter-focal-length lens, which will inevitably have a greater depth of field. The equivalent of a 50mm lens for a 35mm camera on a ⅔-inch video camera is a 19mm lens; and whereas a 50mm lens at $f/4$ on the 35mm camera would have a depth of field of 2 feet 4 inches when focused at 10 feet, the 19mm lens on the ⅔-inch video camera at $f/4$ would have a depth of field 57 feet 9 inches when focused at 10 feet.

The situation appears somewhat different with a camera like the Panacam, which has an optical relay system in it designed to enable film lenses to be used on a ⅔-inch video camera (see 2.1). Since the relay system reduces the image from the 35mm format to the ⅔-inch format, it has the net effect of changing the focal length of the lens. The angle of view stays the same, but the depth of field increases. The point is to make full use of the film lens by reducing the image rather than just cropping it, and this makes it easier for a film cinematographer, accustomed to thinking in terms of a 35mm film lens, to adapt to the ⅔-inch video format. When a cinematographer puts a 50mm lens on the camera,

2.1b
Panacam image sizes

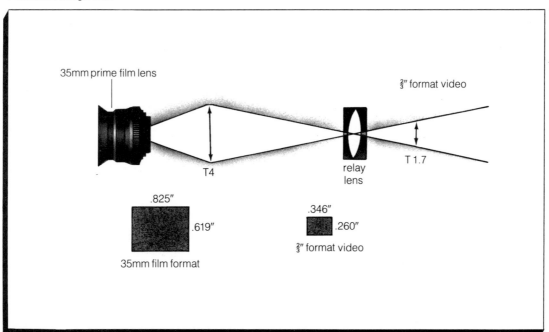

the image will be the same as that produced with a 35mm camera—except that the depth of field will be greater.

Whether an increase in the depth of field is an advantage or a disadvantage depends on the point of view of the director of photography. Many cinematographers have gone to great lengths to maximize depth of field for stylistic or technical reasons. On the other hand, cinematographers who use selective focus as a stylistic device find the increased depth of field in video a drawback. While one would never expect to hear a cinematographer complain about the increased depth of field in 16mm relative to that of 35mm, there are cinematographers who cite the greater ability to do selective focus as an advantage of 35mm over ⅔-inch video. The set or location walls, for example, are more likely to compete with the actor's face for the viewer's attention if both are equally in focus. It should be noted that 1-inch (or 25mm) and 1¼-inch (or 30mm) video cameras have a depth of field much more comparable to that of a 35mm film camera.

THE BEAM SPLITTER

As mentioned earlier, there are two methods of splitting the image into its red, green, and blue components: dichroic mirrors and prisms. For the sake of completeness, we should note that it is possible to make a single tube that can separate the three color components, thereby eliminating the need for a beam splitter in the camera. The resolution of these tubes is generally considered inadequate for professional applications, but researchers at Hitachi have developed a three-color tube capable of 500 TV lines of resolution. Sony also has a single-tube camera, the BVP-110, which is a broadcast-quality single-tube ENG camera using a "high-band Saticon Trinicon" tube said to be capable of a horizontal resolution of 400 TV lines. (See Chapter 3 for a discussion of TV lines as a measure of resolving power.)

Single-tube color cameras require a tube with red, green, and blue filter stripes applied to the face of the tube, and the resolution is limited by how fine these stripes can be made. It is probably safe to assume that refinements will continue to be made in single-tube design, but for the moment most professional video cameras employ a beam splitter and three or sometimes even four tubes. (Four-tube cameras have a separate tube for the brightness or luminance component of the image, which, as we shall see in Chapters 6 and 7, is processed separately from the color information.)

Resolution, of course, is not the only measure of tube performance, and single-tube cameras may also suffer in the areas of sensitivity, **signal-to-noise ratio,** and colorimetry in comparison to multitube cameras.

The dichroic-mirror optical system, which is also known as mirror-relay optics or the in-line tube system, consists of two dichroic mirrors, four lenses, three filters, and two additional nondichroic mirrors. (See 2.2.) The first lens is a relay lens onto which the image is focused. Behind it is the first pellicle (a partially silvered mirror), which is also a yellow pass filter; that is, yellow light (which consists of red and green) passes through it and the blue light is reflected to the side (due to the angle of the mirror). The blue light is then reflected from a second mirror toward the blue pickup tube, and there is a blue filter in front of the tube.

2.2
Mirror-relay optics

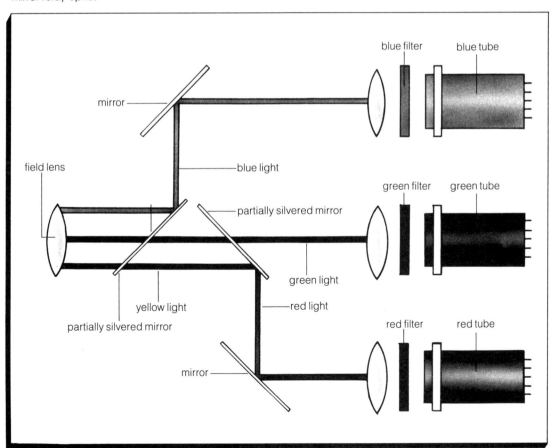

The yellow light passing through the first filter is split into its red and green components by a green pass dichroic. The green component goes directly to the green tube via a green filter. The red component is reflected to the side into a final mirror that deflects it to the red tube via a red filter. As can be seen from the diagram, the light paths for the different color components may have different lengths, and one of the functions of the lenses in front of the tubes is to compensate for any such differences.

The dichroic-mirror optical system has two principal advantages. The first is that it permits the three tubes to be arranged parallel to each other, resulting in a more compact camera body. The second is that it does not require as long a back focal distance in the lens as a prism optics system. A mirror system requires a relay lens between the mirrors and the camera lens, and the image is in focus at the relay lens. As a result a camera with mirror-relay optics (such as a JVC KY-2000) could accept film lenses if the mount were adapted.

The disadvantages of the mirror-relay system are that it is relatively inefficient in terms of the light loss associated with it and that it is relatively unstable from a mechanical point of view; that is, it is very difficult to mount the mirrors in the camera so that they stay at precisely the right angles relative to each other and the tubes. It is also difficult to keep dirt off the surface of the mirrors; and since the image is in focus on some of the mirrors, the dirt will appear in the image. The light loss with a mirror-relay system is ⅔ of a stop or more, and, given the limitations in the sensitivity of the pickup tubes, this is a significant factor.

A prism beam splitter consists of three prisms cemented together. (See 2.3.) The rear surface of the first prism has a dichroic coating that causes it to reflect blue light. The angles of the first prism are such that the blue light reflected by the rear surface is reflected internally by the front surface so that it exits the prism via the third surface and passes through a blue "trimming filter" on its way to the blue pickup tube. The second prism in the block has a red-reflecting coating on the back layer where it is cemented to the third prism. The red light reflected in the second prism is reflected internally by the front surface of the second prism because of the angle and the presence of an air gap between the front surface of the second prism and the rear surface of the first prism. This red light then exits the second prism to the red pickup tube via a red trimming filter. The third prism serves to equalize the path of the green light before it exits the prism via a green filter.

A prism system has a distinct advantage over a mirror-relay system in that the prisms are cemented together into one solid block. The

elements cannot possibly get out of adjustment relative to each other. There is also no way that dust can get inside the system, and it is a simple matter to clean the exposed surfaces. Generally a prism block can be removed from the camera body for cleaning and can be mounted in the camera body with the same precision as the lens. None of the dichroic surfaces of the prisms are exposed, so there is no risk of damage to them.

The design of the prisms also eliminates a variety of color defects associated with the mirror system, and it is much more efficient in terms of light transmission. The light paths for the three components are the same length, but it should be noted that the three tubes have to be placed at an angle to each other. This results in a bulkier camera body, and also complicates the way in which a magnetic field will influence the tubes. The principal drawback of prism optics, however, is the long back focal distance requirement.

2.3
Prism beam splitter

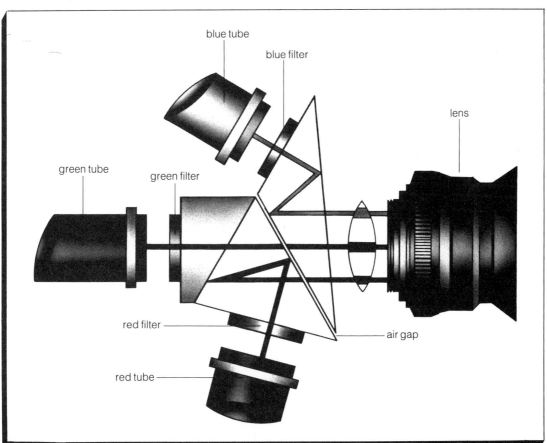

The Video Camera

Electronics and Image Characteristics

Knowing the subtle workings of the video pickup tube is as vital to a cinematographer working in video as knowing the characteristics of film emulsion when working in film. All exposure limitations and image problems, as well as the camera's visual look, originate right at the video tube, even if the problems are solved by circuits located elsewhere. The cinematographer must understand the video tube in order to control the video image.

THE PICKUP TUBE

The heart of a video camera is a device called a pickup tube, which converts the optical image into an electrical signal in a way analogous to that in which a microphone converts sounds into electrical signals. Understanding the pickup tube is the key to controlling the photographic characteristics of the video camera under various contrast and lighting conditions.

A light meter is a dumb pickup tube. It does exactly the same thing that a pickup tube does except in a much cruder fashion. A light meter translates light into an electrical current by means of a photoelectric cell in such a way that the strength of the electrical current varies according to how bright the light is. In a light meter the electrical current causes the needle to swing across a scale so that you can read how bright the light is. The current from a pickup tube is transmitted to a TV set, where it determines how bright the picture will be at any given point on the screen. The tricky thing, of course, is defining where that point is on the screen.

If you focus an image on the surface of a light meter, the meter will read the amount of electricity generated by the whole photoelectric cell and then give you a measurement that is essentially an average of the brightness range for the overall image. It does not distinguish between a bright spot in the image and a dark spot. If you point a spot meter at every point in an image and systematically record the brightness at that point, then you have a means of recreating the image.

A pickup tube is designed to scan an image from left to right, top to bottom, reading the brightness as it goes. The information is transmitted to a picture tube that recreates the image—provided that the scanning of the picture tube matches the scanning of the pickup tube.

A pickup tube is a cylindrical glass bottle with a vacuum inside it. Pickup tubes come in four standard diameters: 1¼ inches (30mm), 1 inch (25mm), ⅔ inch (18mm), and ½ inch (13mm). There is a "faceplate window" at the front end of the tube through which the optical image is focused onto a target. Behind the window is a thin transparent layer that serves as an electrical conductor. The target itself is a layer of photoconductive material, that is, a substance whose ability to conduct electricity varies according to its exposure to light. An electron beam comes through the tube and strikes the target from behind, and anywhere the target has been exposed to light a certain amount of current is conducted through to the transparent layer, which in turn conducts it to a connection on the outside of the tube.

A more accurate way of describing what happens to the photo-conductive layer in the tube when light strikes it is that it emits electrons and therefore builds up a positive charge. When the electron beam from the tube strikes the layer, it essentially discharges the layer and makes it light-sensitive again.

The more light striking the target at any given point, the greater the charge built up there and the stronger the signal that is produced when the electron beam discharges the target layer at that point. The variations in the strength of the signal produced during the time it takes the electron beam to scan the target area completely thus constitute a record of the variations in the brightness of the image analyzed from left to right and top to bottom.

All you need to know to reconstruct a black-and-white image from the variations in the strength of the electrical signal is the position of the scanning beam on the target that corresponds to each moment of the electrical signal.

Now if we can make an electron beam systematically scan a target area from left to right and top to bottom, then whatever system we have for controlling the beam can supply us with the information we need to determine the location in the image of the brightness value corresponding to the strength of the signal coming from the target of the tube at any given moment. It is as though one elf is aiming the electron gun at the target and calling out coordinates all the time ("3 down, 4 across . . . 3 down, 5 across . . .") while another elf at the other end is simultaneously calling out brightness values. The TV receiver just follows their instructions. ("At 3 down, 4 across I make it 90 percent white . . . at 3 down, 5 across I make it 20 percent white . . .")

For the time being we are not going to worry too much about exactly how the elf aims the gun and calls out the coordinates. Suffice it to say that a beam of electrons can be deflected by a magnetic field and that precise variations in the current in two separate circuits can produce precise variations in the magnetic field through which the electron beam is traveling on its way to the target.

We are also not concerned here with color reproduction. Once you understand how a black-and-white video image is created, it will be a simple matter to see how three black-and-white images can be used to create a full color image.

The most important thing to understand is what happens as the photoconductive layer is charged and discharged. The light forming the optical image focused on the target creates in the target an electrostatic image of the scene. As the electron beam reads this image, it erases it. If the light is still striking the target after it has been scanned, a new

electrostatic image is created that will be read and discharged during the next pass of the electron beam.

Scanning the target area is like opening and closing the shutter of a film camera and then pulling down the film for the next frame. The only difference, of course, is that the physical surface onto which the image is focused in a pickup tube does not change from one frame to the next as it does with film; and this fact is probably the single most important difference between film and video cameras. For one thing, it can cause image defects in video that never existed in film.

IMAGE RETENTION AND OVEREXPOSURE

Image retention is an image defect comparable to persistence of vision in the human eye. It is a way in which the image continues after the object has disappeared or moved to a different place.

Just as you can see a greenish spot in the air after staring at a black dot on a white card, a television pickup tube will continue to register a spot (in this case a highlight) if the charge on the target has not been completely discharged by the scanning beam. Obviously film never has this problem, because each time the shutter opens there is a new section of emulsion onto which the image is focused. If one frame of film is overexposed, the adjacent frame is not affected.

Image retention in a static frame can be seen on moving objects within the scene. Image retention associated with movement is called **comet tailing** or smear. A bright object moving through a frame will leave a trail behind it, and often the trail has a colored tint because of a difference in the level to which the beam currents have been set in the red, green, and blue tubes. If the red image takes longer to be completely discharged because of insufficient current available to the beam on the red tube, the comet tail will have a reddish cast.

LAG

Lag is a form of image retention associated with the weak signal conditions caused by low light levels. Lag is generally less of a consideration for the cinematographer working with state-of-the-art equipment, al-

though it may be visible as a "ghost" or faint image on the trailing edge of a moving object if the object is either underexposed, or located in a low-light-level portion of a properly exposed picture. Lag will also occur if the camera's gain boost is set to high levels to compensate for low-level "available light" conditions.

Image retention or "stickiness" characteristics of a tube can be specified by measuring the signal current as a highlight is switched on and off. It is generally expressed as a percentage of the full signal that is present three fields (or 0.05 seconds) after the source has been shut off, and can range from 2 to 20 percent.

One thing that is revealed by measuring image retention is that image decay is faster for brighter images. This means that lag will be less visible in a scene that is brightly lit overall.

It also means that one method of reducing lag is through the use of a bias light. **Bias light** is light directed onto the faceplate of the tube from a source inside the camera optics. It assures a certain amount of current flow through the faceplate of the tube even if no light is coming through the lens. By raising the level of the signal in the low-light portions of the image, bias light reduces the effect of lag. It can have a dramatic effect on the appearance of moving objects in low light levels and on shadow reproduction in general. Since the bias light can be individually adjusted for each color tube in some sophisticated cameras, it can also help iron out differences in the lag in the red, green, and blue components of the image.

If an area of an image on a pickup tube is overexposed so that one pass of the scanning electron beam cannot fully discharge it, the result is called **beam starvation** or **beam pooling** if it is a large area, and **comet tailing** if it is a light source or specular highlight.

How much of a charge can be released on the first pass is a function of how much current is in the electron beam, and one approach to reducing image retention is to increase the current in the electron beam. This is what is done in an anti-comet-tail (**ACT**) tube. Unfortunately, simply boosting the current of the electron beam in a tube has the side effect of shortening the life of the tube.

In order to have their cake and eat it too, tube and camera designers came up with automatic beam optimization (**ABO**), automatic beam current (**ABC**), or some other patented circuitry that essentially enables the strength of the electron beam to vary according to the brightness of the image. If there are highlights that require extra current in order to be discharged, then the beam current is boosted. If the image is within the normal range, the current stays lower in order to maximize the life

of the tube. Today's cameras employing ABO can handle highlights that are up to 5 stops overexposed without significant image defects.

It should be noted that there is a limit beyond which not even special circuitry can help, and a pickup tube can be burned by an excessively hot light source. This means that if you leave a camera on and pointed at a 10K light while you and the director have a long discussion about the next setup, you may very well find a spot permanently burned into your image.

Another reason for not eliminating retention by simply boosting the current of the electron beam is that boosting the beam current has a detrimental effect on resolution. There is a complex explanation for this in terms of electronics; for our purposes it is sufficient to think of the electron beam as a stream of water hitting a wall. The harder the stream of water, the more it splatters as it hits the surface. If an electron beam "splatters" as it hits the target, it causes the system to read the charge (that is, the brightness) of a larger area of the target.

The larger the area being read at any given moment, the less the definition or resolution of the image, so to some extent there is a trade-off between beam current and resolution. Steps taken to improve one can degrade the other. With ABO the loss of resolution is only in extreme highlight areas, where there will not be significant detail to resolve in any case, since it is outside the contrast range of the camera. The net effect of ABO on the overall resolution of the image is negligible.

SHADING

Another image defect associated with a pickup tube is a darkening of some portion of the image called **shading.** It is generally the outer edges of the image that are darker; the effect is caused by variations in the light response of the tube due to differences in the thickness of the target or the way in which the beam strikes the target. Fortunately shading errors tend to be systematic enough that they can be corrected electronically by processing the signal coming from the tube.

TUBE AGING

As a pickup tube grows old, it begins to show defects or blemishes in the image. In a Saticon tube the ability of the target's light-sensitive sub-

stance to respond to light begins to decrease. In a Plumbicon tube minute particles from the mesh screen that helps to focus the electron beam can fall onto the target surface and create shorts that show up as blemishes in the image. Most tubes can be expected to last perhaps 1,500 hours without significant loss of quality, though the life of a tube will depend greatly on the way in which it is used.

TUBE TYPES

Pickup tubes vary in size and in the type of photoconductive material used in the target area. To some extent choosing a size and type of pickup tube is comparable to choosing a size and emulsion type in a film. Some of the same considerations come into play as would in a choice between 16 or 35mm, Eastman film or Fuji, and so on.

Size

As with film, the size of the image area affects the potential for resolution in the image. However, there are other factors limiting the resolution of a video image, such as bandwidth limitations (see Chapter 4), that may be more significant than tube size.

As noted, pickup tubes currently come in four different sizes: 1¼ inches (30mm), 1 inch (25mm), ⅔ inch (18mm), ½ inch (13mm). Tube size should not be confused with the size of the magnetic tape onto which the signal is recorded. Both affect image quality, but they are independent of each other. The size of the tube is the outside diameter of the glass bottle, and the widest dimension of the image focused on the target area is substantially less than the diameter of the tube. For example, the dimensions of the image area for a 1-inch tube are 9.6 × 12.8mm, and the image area for a ⅔-inch tube is 6.6 × 8.8mm.

The larger the image area, the longer the tube must be in order to keep the scanning beam from striking the target area at too great an angle. When the beam strikes the target at an angle, it is not as focused as it is when it strikes perpendicularly. The result is a loss of definition in the image as the angle increases, and there is a limit to how short a tube can be and still produce an acceptable image.

Although research is being done on ways to refocus the beam even when it is striking at a very oblique angle, the length requirement with larger-format pickup tubes is currently their major disadvantage with regard to the design of cameras intended to be used like film cameras. A

1-inch tube is generally about 8.5 inches long, whereas a ⅔ -inch tube is usually about 5 inches long. If a prism beam splitter is used in the camera, the three tubes have to be mounted at angles to each other, so that the amount of room required for 1-inch tubes becomes even greater.

Saticon versus Plumbicon

The type of photoconductive material used in the target area affects resolution, sensitivity (that is, speed), and other image characteristics. There are currently two principal types of pickup tubes used in professional production cameras: **Saticon** and **Plumbicon** (See 3.1). These are trade names for tubes having different photoconductive materials for the light-sensitive surface onto which the image is focused. Both are vidicon-type tubes that operate on the same basic principles described above (as opposed to the image orthicon-type tubes used in the early days of television), but the term *vidicon* is generally used to refer to "regular" vidicon tubes with a target made of antimony trisulfide.

Plumbicon tubes were developed by Philips and take their name from the Latin for lead (*plumbum*), since the photoconductive material in them is lead oxide. Saticon tubes were developed by NHK and Hitachi and take their name from an abbreviation of the three ingredients used in the target layer: selenium, arsenic, and tellurium (with the *-icon* tacked on from *vidicon*).

The principal advantages of Plumbicon tubes are that they are more sensitive than Saticons and that they have a more linear response to the gray scale. Estimates of the relative sensitivity of Plumbicons versus Saticons will vary according to how much noise the camera designer is willing to accept for increased camera sensitivity, but a Plumbicon tube is probably 1–1¼ stops faster than a Saticon. On the other hand, Saticon tubes are capable of much higher resolution than Plumbicon tubes, and are also more evenly sensitive to red, green, and blue light. Theoretically the resolving power of a Saticon tube could be two to five times that of a Plumbicon tube.

Another advantage of Plumbicon tubes is that they produce a lower dark current, than Saticon tubes. **Dark current** is the signal produced by a tube when absolutely no light is falling on it. The lower the dark current the easier it is to achieve "low-noise black reproduction" (that is, to get a clean image at lower light levels).

One other difference between a Plumbicon and a Saticon is that the photoconductive material in the Saticon is black, and the lead oxide in

the Plumbicon is a light tan. Light reflected by the surface of the photo-conductor in a Plumbicon tube can cause halation when it is reflected back onto the photoconductor from the front surface of the glass tube. As a result, Plumbicon tubes require a glass "antihalation button" on the front of the tube. Since so little light is reflected by the black photo-conductor in a Saticon tube, there is no need for such a button.

In general, any professional video camera can accept either Plum-bicon or Saticon pickup tubes. It may be necessary to make minor modifications in the camera when converting from one type to the other, however, since there are differences in the voltage requirements for each.

Diode Gun

One of the recent developments in pickup tube design is the intro-duction of the diode gun type of Plumbicon and Saticon tubes. The gun is the electrode array emitting and shaping the scanning beam, and essentially a **diode gun** is one in which the electrons are focused at two points instead of three, with the result that the beam spot is smaller. This produces improved resolution and other benefits.

A 1-inch diode gun Plumbicon tube may be capable of resolving 1,600 TV lines, whereas a conventional 1-inch Plumbicon tube would not be able to resolve more than 1,000 TV lines. (TV lines as a measure of resolving power will be explained in Chapter 4.) Even the diode gun Plumbicon cannot approach the potential resolving power of a Saticon tube, which can be well in excess of 2,000 TV lines.

It should be noted that the resolving power of all of these tubes exceeds the limitations of the current National Television Systems Com-mittee (**NTSC**) standard broadcast system by a substantial margin. For reasons that will be discussed in Chapter 4, the resolution of an image being broadcast can never exceed 340 TV lines. There are advantages, however, to having a camera that can resolve much finer detail than can actually be transmitted, as we shall see in Chapter 4.

A diode gun also permits a thinner target coating. A thinner target coating means that the target has a lower capacitance, and the picture highlights are discharged more easily. It is not necessary for the cine-matographer to understand exactly what capacitance means in terms of electronics, but it is related to image storage or charge-discharge delays at low signal levels. The lower the capacitance, the less residual image is present in low light conditions and therefore the less lag will be visible in the dark areas of the image.

A lower-capacitance tube also has a better signal-to-noise ratio. **Signal-to-noise ratio** is the electronic equivalent of grain. The higher the ratio, the more clearly distinguishable the signal is from the "noise" generated by the system, that is, the less "grainy" the image.

YOKE AND DEFLECTION

A pickup tube is mounted in a "yoke" in the camera in such a way that it is surrounded by coils producing the magnetic fields that guide and focus the electron beam. There are separate coils to focus the beam and to create the scanning pattern. Ideally the yoke is designed to permit the tube to be removed relatively easily for cleaning of the faceplate or for replacement. (See 3.1.)

3.1a
Schematic diagram
of saticon pickup
tube

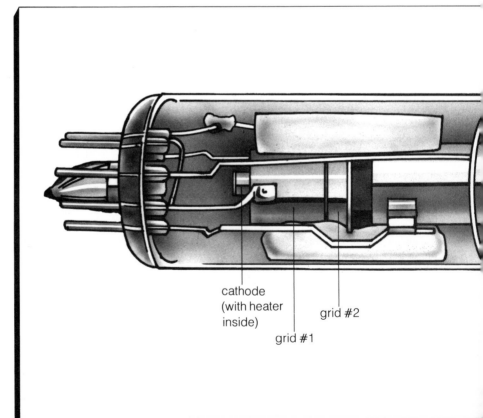

cathode
(with heater
inside)

grid #1

grid #2

MIXED-FIELD TUBES

Mixed-field tubes are a promising new type of tube combining two different methods for guiding and focusing the electron beam: electrostatic and magnetic. Using electrostatic deflection with magnetic focus makes possible a tube with higher resolution and lower geometric distortion.

SOLID-STATE SENSORS

Just as transistors have replaced vacuum tubes in amplifiers, so solid-state sensors are being introduced that will eventually replace pickup

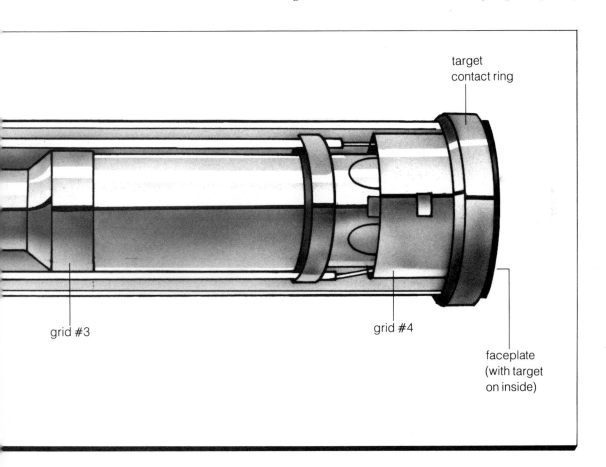

target
contact ring

grid #3

grid #4

faceplate
(with target
on inside)

tubes. Solid-state sensors have been used in consumer cameras for several years and began to make their appearance in professional cameras in 1982, when Hitachi unveiled their SK-1 solid-state ENG camera using three metal oxide semiconductor (MOS) sensors instead of a pickup tube. NEC followed in 1983 with their SP-3, which uses three charge-coupled device (**CCD**) sensors, and RCA has a camera employing CCD sensors that they have developed. (See 3.2.)

The main difference between a solid-state sensor and a pickup tube is that a solid-state sensor does not scan the image with an electron beam. Since there is no electron beam, there is no need for a vacuum in a glass tube and no need for the yoke and coil used to deflect or focus the electron beam. Solid-state sensors use various other methods for scanning the image, all of which can be contained in a chip onto which the image is focused.

The scanning of a solid-state imaging device is accomplished by one

3.1b
Schematic diagram
of plumbicon
pickup tube

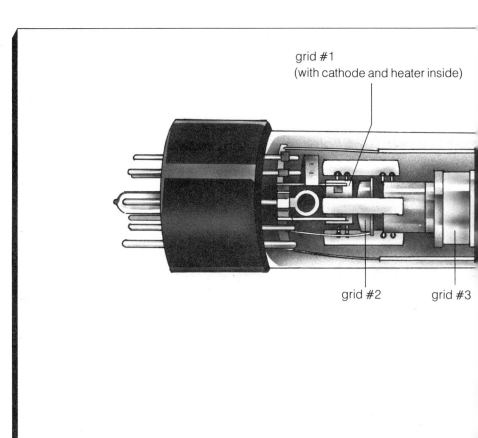

grid #1
(with cathode and heater inside)

grid #2 grid #3

of two methods. If the sensor is an MOS array, the scanning is done by means of what is called an X-Y addressing scheme. The array actually consists of 200,000 or more discrete capacitors corresponding to "picture elements" or "pixels" of which the image is composed. The charge built up in each of these capacitors by the effect of the light striking it is read at the appropriate time in the same way that bits of data in a computer memory are read. The result is a series of discrete values that can be translated into a video signal comparable to the video signal produced by a pickup tube.

If the device is a CCD sensor, the charges are read by an ingenious form of electrical manipulation that can be compared to a bucket brigade. Rather than having a separate solid-state "switch" for each pixel, the charge accumulated at each pixel is transferred through the semiconductor material. The charges contained in one row of pixels are gradually transferred down the line and read out at the end of the row in much the

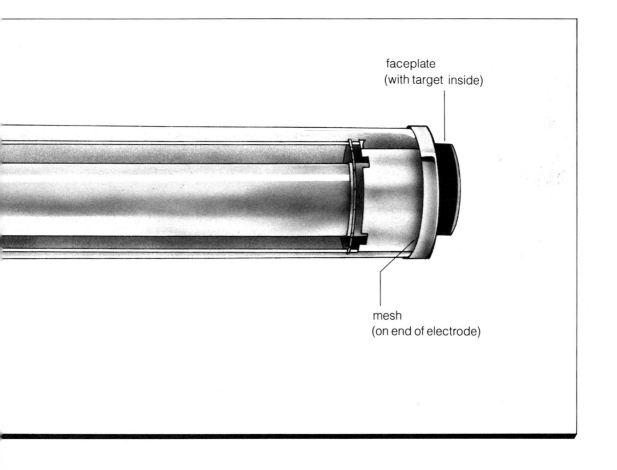

faceplate
(with target inside)

mesh
(on end of electrode)

same manner as a bucket of water is passed along the line of a fire brigade.

CCD sensors were first used in telecines (for example, the Bosch FDL-60) in which a row of 1,024 photodiodes is used to capture one scan line of picture information and read it out into a digital storage device as the film moves continuously past a narrow gap in front of a lamp.

CCD sensors for a camera have enough elements to take in the entire image rather than just one line. A clock controls the way in which the charges are transferred out of the sensor. In a frame transfer CCD an entire frame's worth of charges is first transferred vertically to a storage area (or "register") during the time corresponding to the vertical inter-

3.2
CCD diagram

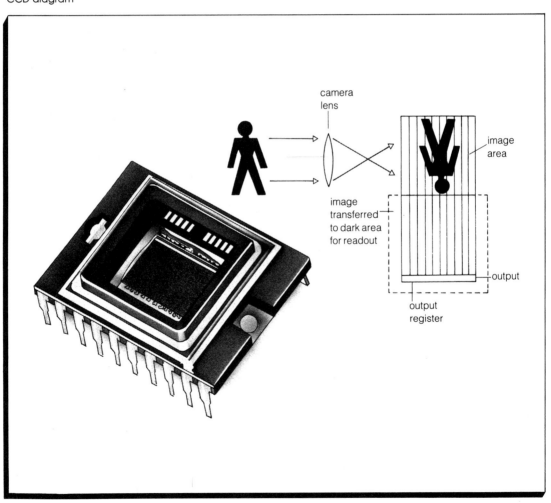

val. While a new set of charges is being built up in the image area, the charges in the storage register are read out horizontally one line at a time at a rate corresponding to the conventional scanning rate.

The difficulty in achieving a broadcast-quality image with a solid-state sensor in a camera is largely a matter of the manufacturing techniques required to cram enough pixels into a chip. The horizontal resolution of a solid-state sensor is determined by the number of discrete elements in the chip, and there are limits to how large the surface area of the chip can be before its performance begins to decline. The first sensors developed for professional cameras have an image area slightly smaller than that of a ½-inch tube.

Since the image generated by a solid-state sensor is composed of discrete picture elements, an optical image with extremely fine detail can easily produce moiré patterns or other types of image beat-frequency defects that might not show up in an image produced by scanning continuously with an electron beam. There is no cure for this except an increase in the number of picture elements in the sensor or through the use of an "optical low-pass filter," which term is a euphemism for a type of diffusion filter that softens the image as it approaches the frequency repetition rate of the diode array.

Since each picture element in a solid-state sensor is a separate photodiode, a defective photodiode will result in a permanent blemish in the image. Manufacturing solid-state elements is to some extent a hit-or-miss proposition, so that the chances of getting a defective element are fairly significant. In the chip developed for the NEC camera there are 188,160 photodiodes, so the odds against manufacturing a blemish-free chip are staggering, and the odds of making a higher-resolution chip would be geometricaly higher.

There have also been difficulties in achieving sufficient sensitivity with solid-state sensors. This is one reason why a CCD sensor could be used in a telecine more easily than a camera, since a telecine can have a much more intense light source. Solid-state sensors have reached the point where they are feasible in cameras, however. The specifications for the NEC solid-state camera list its sensitivity as $f/5.0$, 2,000 lux, 3,200 degrees Kelvin (K), 89.9 percent reflectance, which translates into an exposure index of about 100.

Other problems with solid-state sensors include fixed pattern noise, vertical smear, and an effect that is loosely termed blooming. Fixed pattern noise is the result of variations in the sensitivity of the photodiodes. Since it is permanently built into every signal put out by the sensor, it can be isolated by exposing the sensor to an even white field. Then a signal can be generated that corresponds to the noise pattern and

can be subtracted from any signal coming from the sensor to compensate for the fixed pattern noise.

Vertical smear and blooming are the result of an overflow of excess current from one area into adjacent areas. The overflow may be in the form of a ripple effect in which rings of overexposure radiate from a highlight, or it may be in the form of a general diffusion of the highlight resembling the effect of halation. This type of blooming can be prevented by circuitry that functions as overflow drains to drain off excess current, but the drains themselves can cause vertical smearing, since they run vertically and a certain amount of leakage is inevitable. While vertical smearing will vary according to the degree of overexposure of the image, it is possible to devise circuitry to compensate for vertical smear as well.

The advantages of a solid-state sensor in comparison to a conventional pickup tube are many. First of all, solid-state sensors use a different type of photosensitive material and do not have the same image retention characteristics as a photoconductive pickup tube. This means that solid-state sensors do not suffer from lag. They also are not subject to image burn. Not only do they eliminate comet tailing, but they also cannot be damaged by excessive light. RCA claims that its CCD can handle highlights on the order of 10,000 times without burn or retention. A solid-state sensor should virtually never wear out.

A second major benefit is that a solid-state sensor can be free from any form of geometric distortion of the image. Eliminating electron beam scanning eliminates the possibility of geometric distortions. The camera's performance will also be immune to the influence of magnetic fields that can disturb the scanning of a pickup tube. Solid-state sensors are impervious to radar or microwave fields that might cause distortion or defects in an image from a pickup tube.

Registration is simplified because the solid-state sensor can be permanently mounted onto the prism assembly. Once the registration is set at the factory it should not have to be adjusted again.

Solid-state sensors also have very low dark current, so that the blacks or shadow areas of an image from a solid-state sensor will be cleaner than the corresponding image from a pickup tube. This is reflected in the higher signal-to-noise ratings for solid-state sensors.

PROCESSING AMPLIFIERS

The signal coming from a pickup tube goes through two types of amplifiers before it is ready to be recorded or transmitted. The first is a

preamp that essentially does nothing but increase the strength of the signal to the point where it is possible to do something with it. The signal coming from the pickup tube is so low in level that it cannot even be transmitted over any distance by a wire much less processed in any way or used to create a picture on a monitor.

The preamp for a video signal is analogous to the preamp in your stereo system, but it does not permit any creative or corrective manipulation of the signal. It is generally located in the camera as close as possible to the pickup tube, and there is one for each tube in a three-tube color camera.

It is necessary to shield the preamp with metal to prevent radio signals, radar, or other spurious signals from affecting the video signal. Once the signal has been boosted by the preamp, it is possible to transmit it over some distance in a cable. With a two-piece camera like the Panacam the signal coming from the preamp leaves the camera, and the next amplifier is located in the camera control unit. With self-contained cameras the next stage of amplification is also done in the camera.

The second amplifier is the **processing amplifier** or "proc amp." It is roughly equivalent to the power amplifier in a stereo system, except that a video signal goes through a great deal more processing than any audio signal in a stereo system.

With a three-tube color camera there is a separate proc amp for the signal coming from each tube. The proc amp is a flexible device designed to be used for creative purposes. It is comparable to a miniature film laboratory designed to do custom processing. It can be used to do the equivalent of forced development, flashing, gamma control, tinting or color balancing, solarization, you name it.

Depending on the camera, the controls for the proc amp may be computerized electronic adjustments in addition to the conventional screwdriver adjustments or knobs and switches. Once a cinematographer understands how to use the controls for a proc amp, it is like having a film emulsion and its processing custom tailored for each individual scene being shot.

THE ENCODER

The video signals representing the red, green, and blue components of the image are combined into one composite signal by means of an **encoder.** The encoder can be in the camera, or it can be separate from the camera. What the encoder does is to combine the signals into one

signal that can be recorded or broadcast, and it does so in such a way that the composite color signal can be compatible with black-and-white receivers.

It is possible to record and broadcast the three separate red, green, and blue component signals, but it is not practical to do so in a way that would be compatible with black-and-white receivers. When color television was first introduced, compatibility was a major consideration; and the NTSC devised an extremely complex system for encoding and decoding the color information onto what is essentially a black-and-white signal. The basic principles of this system, as well as its implications in terms of image quality and color control, will be discussed in Chapter 7.

The encoder in a video camera is not a creative tool. For the most part a cinematographer need only be aware that the encoder combines three video signals into one in such a way that both a black-and-white receiver and a color receiver can properly interpret it, and that the camera's encoder must be calibrated to the same standards as every other one to operate properly.

The Video Signal and the Electronic Image

Being conversant with the basics of video image quality is essential if a cinematographer wants to exercise critical control over video imaging.

THE PICTURE MONITOR

The best way to understand the electronic image and how it is transmitted by the video signal is to begin with the way in which the image is displayed on a black-and-white picture monitor. The surface of a picture tube is coated with phosphors that glow when they are bombarded with electrons. The stronger the beam current striking them, the brighter the glow of the phosphors, so there is a direct relationship between the level of the current determining the strength of the electron beam and the brightness of the image on the screen.

The video signal is the current that determines the strength of the electron beam in the picture tube. If the video signal is at 100 percent consistently over a sufficient period of time, the "image" on the screen will be a uniformly white field.

The electron beam systematically scans the face of the picture tube from left to right, top to bottom. It does not create an entire frame of picture simultaneously, but the phosphors continue to glow long enough after they are hit by the beam that they create the impression of a full frame of picture information—when aided by the persistence of vision in the human eye.

Anyone who has tried to photograph a television screen has probably discovered the difference between the way the screen appears to the human eye and the way it appears to a camera. If the shutter speed is less than $\frac{1}{30}$ of a second, the entire TV screen will not have been scanned during the exposure of the film. The result can be that a portion of the image on the screen will be darker; that is, there will be a horizontal bar across the image where the film sees the phosphors that have not been rescanned during the exposure and therefore are not glowing as brightly as the others during the exposure of the film.

THE SCANNING PATTERN

As anyone familiar with the design of the film projector knows, a projected image must have a flicker rate of at least 48 times per second in order to be perceived as a continuous image on the screen. With a film projector running film at 24 frames per second, this flicker rate is accomplished with a double-bladed shutter, so that each frame of film is essentially projected twice.

The frame rates for the television systems currently in use were originally designed to be easily compatible with the frequency of AC current. AC current is generally 50 or 60 cycles per second, and a frame rate of 50 or 60 cycles would be ideal from the point of view of eliminating any visible flicker. Unfortunately it is not practical to operate a broadcast television system with a frame rate of 50 or 60 frames per second—for reasons that will become clearer as we progress.

There is a trade-off between the frame rate and the resolution of the image. In order to maximize the number of scan lines making up the image (and therefore maximize the vertical resolution) and to achieve a flicker rate of at least 50 times per second, a television frame is split into two "fields," each of which consists of half the total scan lines for a frame.

The first field contains the odd-numbered lines from top to bottom, and the second field contains the even-numbered lines. The result from the point of view of image flicker is the equivalent of a system having twice as many frames with half the number of scanning lines. From the point of view of image resolution the net effect is an image composed of the total number of lines in both fields. This is as close as you are going to come to having your cake and eating it too in television. For the time being we shall ignore the other trade-offs involved in "interlaced" scanning.

BANDWIDTH

The image in the NTSC television system used in the United States consists of 525 lines at a rate of 30 frames per second or 60 fields per second. This means that the video signal during 1 second contains the brightness information for 15,750 discrete lines of picture transmitted one after the other along with the signals that control the scanning process.

In order to have the horizontal resolution equal to the vertical resolution, it is necessary for each horizontal line of picture to be capable of distinguishing between 340 vertical lines or picture elements. We shall examine the derivation of this figure shortly; for the moment just accept it on faith. The point is that a video signal must be capable of changing from a high level to a low level and back again over 4 million times a second. To do this, a video system requires a frequency response on the order of 15,000 to 4,000,000 cycles per second. Compare this to the

frequency response required of a top-of-the-line stereo system, which is probably 50 to 20,000 cycles per second.

Cycles per second is abbreviated Hz for **hertz,** a unit named after the nineteenth-century scientist who first investigated electromagnetic waves. A thousand cycles per second is abbreviated kHz for **kilohertz** and a million cycles per second is abbreviated MHz for **megahertz.** Specifications for video equipment are often given in terms of megahertz to indicate the **bandwidth** or range of frequency response of which the equipment is capable. The important thing to recognize is that the resolution of a camera or recorder or broadcasting system is limited by its bandwidth.

In broadcasting, the video signal is imposed or modulated onto a "carrier" signal. The frequency range of the video signal itself is thus limited by the bandwidth or range of frequencies of the "channel" used for broadcasting it. A channel is simply a specified range of the total spectrum of electromagnetic waves.

When the Federal Communications Commission decided to regulate the broadcasting of television signals, it cut up the pie into channels that were 6 MHz wide. For example, Channel 3 is from 54 to 60 MHz. A portion of each channel was set aside for the audio content of the programming and another portion was set aside for room to ensure that there was no interference between channels. The net result is that the bandwidth for the video signal in the NTSC system is 4.2 MHz.

RESOLUTION

A bandwidth of 4.2 MHz means that the horizontal resolution of a 525-line image with a frame rate of 30 frames per second is limited to 334 TV lines. Before we attempt to compare this to the resolving power of film, it may be helpful to explore the relationship between bandwidth and resolution in a video signal.

Although one frame of video in the NTSC system consists of 525 lines, not all of those 525 lines are devoted to picture information. Just as some space on a piece of film is devoted to the frame line, there is a black "frame line" for the video frame that can be seen by throwing off the vertical hold on your TV set. In television jargon, this frame line is called vertical blanking, since it represents a portion of the vertical dimension of the image in which there is no picture information. It

takes up 40 of the 525 lines. This leaves 485 "active" lines of picture information.

It would seem that 485 horizontal scan lines with space between them on the screen would enable the system to resolve up to 485 horizontal lines in an image; that is, a test pattern consisting of 485 alternating black and white lines could be reproduced on the TV screen. It was discovered fairly early in the game, however, that this is not the case. A television image with 485 lines can resolve only about 340 lines.

A man by the name of Kell investigated this phenomenon and came up with a theory to explain why the scan lines appeared to be overlapping each other by about 25 percent. His theory is that the area hit by the electron beam as it moves across a line is not a circle but bell-shaped. It flares out in back as it moves almost like the wake of a boat moving through water. This spreading of the beam causes the scan lines to overlap partially and therefore reduces the maximum vertical resolution of the image.

The upshot of all this is the Kell factor (also known as the scanning factor), which is a fraction by which the number of scan lines is multiplied to reveal the maximum vertical resolution. The Kell factor is not an absolute number, but varies according to a variety of other factors. For the NTSC system the Kell factor is approximately 0.7. It represents a loss of vertical resolution over and above the limitation imposed by the bandwidth, frame rate, and number of scanning lines.

Since the aspect ratio of a television screen is 4 × 3 or 1.33 : 1, the number of picture elements in a horizontal line must be 1.33 times the number of active scanning lines times the Kell factor if the horizontal resolution is to be comparable to the vertical resolution. (The Kell factor affects only vertical resolution and not horizontal resolution.) A line in an NTSC image should be capable of resolving about 452 picture elements.

This would mean that the same test pattern of 340 horizontal lines that represented the maximum vertical resolution of the image could be resolved if it were turned on its side so that the lines were vertical instead of horizontal. This is what is meant by "TV lines" of resolution. It is a number of lines relative to picture height.

A picture that contains 452 vertical lines (or 452 picture elements in each horizontal line) has a horizontal resolution of 340 TV lines. It is important to remember that TV lines do not refer to black lines on a white field (or pairs of black and white lines) but to picture elements. The white space between the black lines counts as a line.

It is also important to remember that "picture elements" are a fiction when we are talking about conventional analog television systems. There are no discrete picture elements or "pixels" in an analog video signal as there are in a digital signal or a computer graphics image. In an analog signal there is only a constantly changing current level.

If the picture elements are black and white lines on a resolution test chart, the video signal goes through a complete cycle for each pair; that is, it goes from minimum level to maximum level and back to minimum level as it scans a white and a black line. The bandwidth requirement for a system in which the horizontal resolution is equivalent to 340 TV lines can be calculated by dividing half the number of picture elements in the line by the time spent scanning each horizontal line.

With 30 frames per second and 525 lines per frame (including the blanking interval) there are 0.0000635 seconds or 63.5 microseconds per line. Of that time about 11 microseconds are devoted to scanning or synchronizing information rather than picture information, and constitute what is known as horizontal blanking. (It is possible to observe horizontal blanking on your home receiver if you get really creative in messing up the picture or tune into a scrambled pay-TV signal. It is a vertical black area that is normally outside the right or left side of the screen.)

The amount of time devoted to scanning picture information in each scan line is therefore 52.5 microseconds. Divide 226 cycles (half of 452 picture elements) by 52.5 microseconds and you get a frequency requirement of about 4.3 MHz. Since the video bandwidth in the NTSC system is 4.2 MHz (actually 4.18 MHz at the transmitter), you can see that broadcast television has a horizontal resolution that is only slightly less than its vertical resolution.

There is a handy formula for calculating the relationship between bandwidth and horizontal resolution in the NTSC system. For every eighty TV lines of horizontal resolution you need 1 MHz of bandwidth. A transmitter with 4.18 MHz of bandwidth can broadcast a signal with a horizontal resolution of 334 TV lines (the equivalent of 444 picture elements per line).

Many of the cameras and recorders used in professional productions are designed to have a bandwidth of 8–10 MHz. It is not uncommon for a top-of-the-line studio video camera to have a horizontal resolution of 800 TV lines, and a studio monitor may very well display an image with 640 TV lines of horizontal resolution. You can never see such an image in your home, however, because the channel used to broadcast the image cannot accommodate more than 334 TV lines of horizontal resolution. In

fact, the chances are good that what you see at home is more likely to be in the neighborhood of 200 TV lines of horizontal resolution unless you happen to have a very finely tuned receiver in an area where you get excellent reception.

If our video system is capable of resolving about 340 TV lines both vertically and horizontally, how does this compare with the resolving power of 16 or 35mm film? The resolving power of film is generally expressed in terms of line pairs per millimeter, and color negative, roughly speaking, is capable of resolving 100 line pairs per millimeter. Note that this expression is counting line *pairs*—even when it is stated simply as lines per millimeter. The white spaces don't count. Lines per millimeter refers to the number of black lines on a white field in every millimeter.

Since the height of the 1.33 : 1 projector aperture in 35mm is 15.24mm, 100 lines per millimeter would be roughly the equivalent of 3,048 TV lines. The projector aperture height of a 16mm frame is 7.21mm, so that 100 lines per millimeter in 16mm would be the equivalent of 1,442 TV lines.

DEPTH OF MODULATION

Neither TV lines nor lines per millimeter is a sufficiently accurate way of specifying resolution, since each tends to imply that the lines are completely resolved into absolute black and white. Needless to say, this is not the case. As the lines get finer, they begin to blur and blend together in both a photographic and an electronic image; and some way is needed to specify exactly how resolved the lines are.

For film this is quantified with the help of the concepts of acutance and modulation transfer function. Acutance is a measurement of the density change at the edge of a line and is comparable to the measurement of the rise time for a video signal. The modulation transfer function is essentially a measurement of contrast or of density variations in the image produced by the test chart. Modulation transfer functions can be plotted for video cameras as well, but the concept generally used to specify resolution in video is depth of modulation.

To understand depth of modulation we should begin by considering a test chart with black lines of a consistent thickness and spacing on a white background. As the image of the lines on the pickup tube is scanned by the electron beam, the lines would appear as a series of black

and white spaces. We can assume for now that the area hit by the beam at any moment is a circle, the ideal spot shape. This circle is called the aperture. As the beam moves from a black area to a white area, there is a period of time during which part of the aperture is on the white area and part is on the black area. Since the beam cannot distinguish between a black area and a white area within the aperture, the pickup tube will interpret this as a gray area, so that the hard edges of the lines of the test chart will inevitably be softened to some extent in a video image no matter how thick or wide apart the lines are. The image will always contain a gradual transition from black to white or vice versa.

In addition, there is the amount of time required for a video signal to go from its minimum level to its maximum level and vice versa, known as rise time and decay time. Rise time and decay time are quite independent of this "aperture distortion." They are a function of the bandwidth or the frequency response of the system and represent a much more significant limitation on resolution than aperture distortion (unless the aperture of the scanning beam is grossly out of focus).

The wider the bandwidth (or the greater the frequency response) of the system, the shorter the rise time. If the line that the pickup tube is reading is wide enough to allow the signal to rise or fall completely while the beam is still completely within the area represented by the line, then at least some portion of the line will be rendered as completely black (or white). If, however, the scanning beam completely crosses the line before the signal has reached its maximum or minimum level, then the darkest or brightest portion of the line in the video image will be some shade of gray. The net effect is comparable to throwing the image of the test chart out of focus; the contrast between the black and the white areas is reduced.

In a sense, the beam has already begun to read the next space on the test chart before the signal has completely registered the previous one. Before the video signal can get to absolute black, the beam is telling it to turn around and go back to white. As the lines on a test chart get finer, the difference in the gray of the black line and the gray of the white line as rendered by the video signal will decrease until at some point the camera will read a series of fine black and white lines as a continuous gray field.

Depth of modulation is a difference in the signal levels generated by two standard sets of lines and is expressed as a percentage that one signal level is of the other. The higher the percentage figure, the more fully resolved the fine lines are.

To measure depth of modulation two sets of lines are used: One is the equivalent of 40 TV lines (corresponding to a frequency of 0.5 MHz)

and the other is the equivalent of 400 TV lines (or 5 MHz). The signal is set so that the peaks of the 0.5-MHz pattern register at 100 percent on the waveform monitor. Then the signal levels generated by the 5-MHz pattern under the same conditions are compared. The test chart used actually has both sets of lines on it, so that they are shot simultaneously. The level of the peaks for the 5-MHz pattern are the depth of modulation figure.

ENHANCEMENT

Sharpness or fine detail in an image results in high frequencies in a video signal. In a video image of a white barn at night in which the barn fills most of the frame, the white area representing the barn would be a low frequency—meaning that the black-to-white transitions in the video signal would be at a low repetition rate. If a picket fence were located in front of the barn, the fence would be rendered as a high frequency.

In order to increase the apparent sharpness of a video image, it is possible to devise circuits that accentuate the edges of areas in the image or peak the high frequencies. Edge enhancement or detailing can be accomplished by a variety of means, and may be referred to by a variety of euphemisms such as image enhancement, crispening, image sharpening, or aperture correction. Essentially it is a method of introducing a fine white line in the image at the point of transition between one sharply defined area and another. More accurately, it is a matter of accentuating the high-frequency transitions by boosting the level at the edge of the brighter area.

While it does increase the apparent sharpness of the image, edge enhancement can be easily overdone, and one of the elements of the "video look" as opposed to the "film look" is simply overenhanced edges.

Studies indicate that under certain conditions the human eye performs a similar type of edge enhancement, and it is argued that such a feature in a video image is therefore "natural." There is also a "developer adjacency effect" in film that produces a similar form of edge enhancement, but it is a good bit more subtle than most examples of edge enhancement in video. Admittedly, a certain amount of edge enhancement is necessary to make video images acceptable—given the current limitation in the resolution stemming from the bandwidth restriction. Nonetheless, edge enhancement as it is used so often today is one of the major reasons why video images have an electronic or artificial look to

them. It is the overdefined edges, the artificial outlines, in a video image that can give it a comic book quality.

The fact that video images are so strongly associated with live news and sports broadcasting has created a curious paradox in terms of the average viewer's response to image quality. The "crispness" or artificial sharpness created by edge enhancement is associated with images of live or real events and is therefore associated with a greater degree of immediacy. As a result an artificial quality is perceived as an indication of reality. If the same image quality occurs in dramatic programming, it is regarded as contributing to a sense of phoniness—perhaps because the viewer's mind knows that the events being depicted cannot possibly be real. Presumably if one wanted to achieve the video equivalent of the Orson Welles "War of the Worlds" radio show, which was designed to make listeners believe it was actually happening, one would shoot on tape with plenty of edge enhancement.

The important thing to realize about edge enhancement is that it is variable and can be controlled by the cinematographer. In addition to the on/off switch for detailing or edge enhancement, there are variable controls that set the degree of edge enhancement and separate controls for vertical and horizontal enhancement.

To a large degree, the amount of edge enhancement an image requires is a matter of taste, and one need not be intimidated by the taste of the camera manufacturer or whoever set the enhancement levels last. Some cameras can yield perfectly acceptable images with little or no edge enhancement, whereas others need all the help they can get. It may very well be that for certain scenes you will want to boost the edge enhancement a bit, but for others you will want to back off with it. This decision must be made subjectively, while looking at the subject being photographed on a picture monitor; it can't be made with test equipment or charts.

Additional image enhancement can be added in postproduction, but enhancement added to an image during production can never be removed at some later stage.

RINGING

There is one trade-off, however, of which you should be aware. Increasing the edge enhancement increases the likelihood of ringing.

Ringing is a phenomenon caused by certain limitations in a video amplifier that is perhaps comparable to internal reflections of the energy passing through the amplifier and that appears on the screen as a faint (or sometimes not so faint) line or series of lines adjacent to an edge in the image. It is like an outline of the object that is displaced to the right, similar to a drop shadow.

Theoretically, ringing will occur any time the bandwidth of an amplifier is too limited to resolve frequencies that are being fed into it. This is why some video engineers argue that it is counterproductive to use high-resolution lenses on a video camera, since there is a point beyond which the amplifiers cannot handle detail without ringing. In practice, however, ringing tends to become objectionable only when an excessive amount of edge enhancement is used.

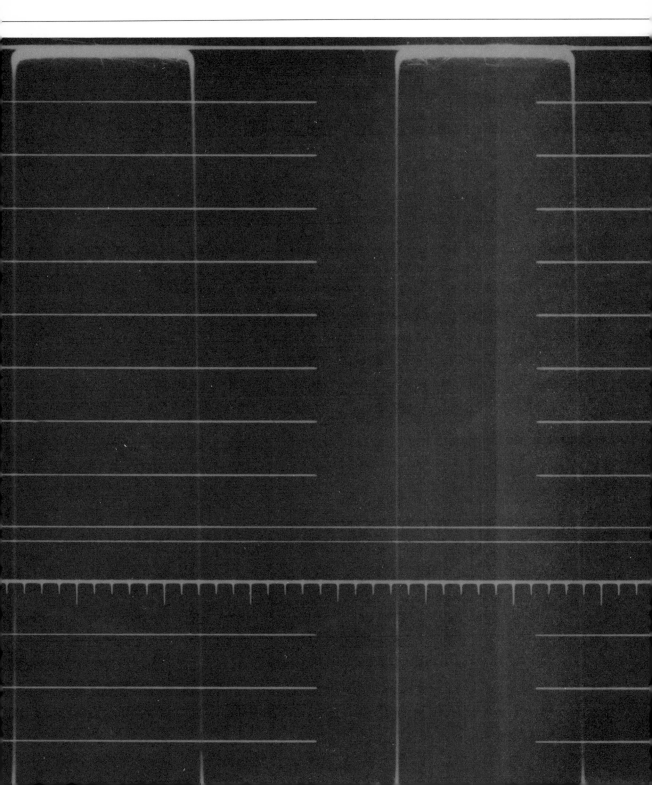

The Waveform Monitor

The waveform monitor is a vital and underused instrument of video creative control. The understanding and use of this device takes the naive guesswork out of image control.

THE DISPLAY

The waveform monitor is the most valuable tool a cinematographer can have when shooting video. It cannot replace your eyes, but it could replace your light meter in a pinch, and it can provide you with more detailed information about the image you are recording than you could ever hope to get out of a film lab. In addition, it provides the information while it is still possible to do something about it. No cinematographer should attempt quality work in video without an understanding of a waveform monitor.

A waveform monitor is a graphic display of the video signal being generated by the camera (See 5.1). To the uninitiated eye, it may simply look like a bunch of green smears on a screen that belongs in an old Flash Gordon serial, but it is, in reality, a precise indication of what the video signal is doing at any given moment.

The display screen on a waveform monitor is essentially a graph plotting the amplitude or level of the video signal against time (or image brightness against position from left to right). It is possible to set a

5.1
Waveform monitor showing standard color bars

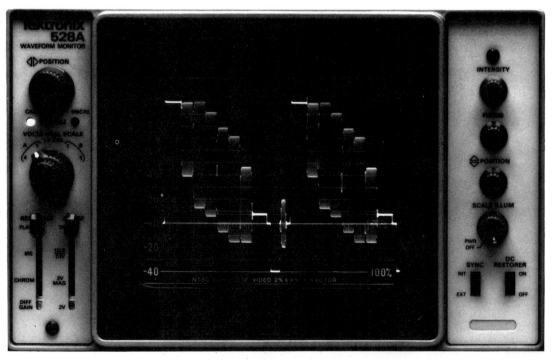

waveform monitor so that it displays the signal for only one line of a video image, and this display makes the easiest starting point for understanding the whole instrument.

As a line of the image is being scanned in the pickup tube from left to right, the amplitude of the signal varies according to how bright the image is at any given point. This signal level can be measured in **IRE** (Institute of Radio Engineers) or IEEE (Institute of Electrical and Electronic Engineers) units. An IRE unit is essentially 1 percent of the difference between the peak white level (or maximum "recommended" amplitude of the video signal) and the blanking level or absolute black. The vertical axis of the waveform monitor display screen is calibrated in IRE units. The horizontal axis represents time—generally the time required to scan one line of picture and return to the starting point for the next line.

When only one line of a video image is being displayed on the waveform monitor, what you see is a single line on the screen that plots the signal level during the scanning of that line. If the image is static the line on the waveform monitor will remain static. Left to right on the waveform monitor corresponds to left to right in the image.

The waveform displayed looks sort of like a landscape on a video game. Where there is a highlight in the image, there will be a mountain on the waveform; where there is a shadow area, there will be a valley. (See 5.2.)

A waveform monitor can also be set to display the signal levels for an entire field or frame of a video image. It does this by superimposing the waveforms for each line, thereby producing the weirdly shaped green smears normally seen on a waveform monitor.

Just for the record, there are a variety of possible display modes for a waveform monitor, including one displaying the two fields separately side by side. For the most part, however, what you will see on a waveform monitor is a composite of the signals for every line in the frame. (See 5.3.)

INTERPRETING PICTURE CONTENT

It is a relatively simple matter to learn to interpret a waveform monitor display by comparing it to the image and looking for specific highlights or shadows. It is best to do this with a black-and-white picture monitor,

5.2
Typical display on
waveform monitor
at horizontal rate

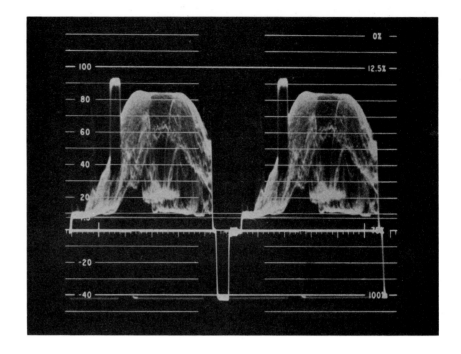

since a waveform monitor is telling you mainly things about the image brightness (luminance) and less about color (chrominance). As you can see by turning the color on and off on a picture monitor, different colors have different luminance values or degrees of brightness.

Certain parts of the waveform monitor display, however, do not correspond to elements in the picture. There is a portion of the waveform, for instance, that is "blacker than black," and there are negative values on the scale.

Zero on the scale represents the blanking level, or the level to which the signal drops while the scanning beam is returning from right to left across the target area to the start position for the next line or returning from the bottom to the top of the target area to begin scanning the next field. Although blanking level could be considered dead black—and the black "frame lines" that become visible when the vertical hold on a receiver is thrown off are representative of the blanking level—it is preferable to set the "reference black" that corresponds to dead black in the picture to a level between 5 and 10 units above the blanking level. This ensures that retrace lines created as the beam returns across the image to begin a new scan will not show up in the image owing to imperfections in the broadcasting system. The level at which black is

5.3
Other types of wave-
form monitor displays
and their equivalent
image on a picture
monitor

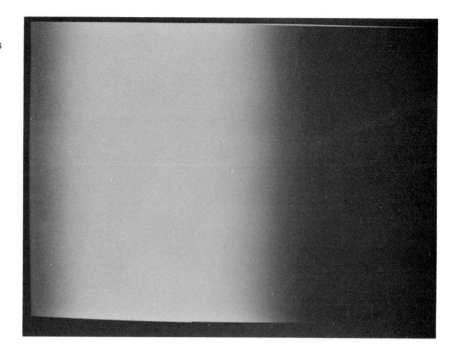

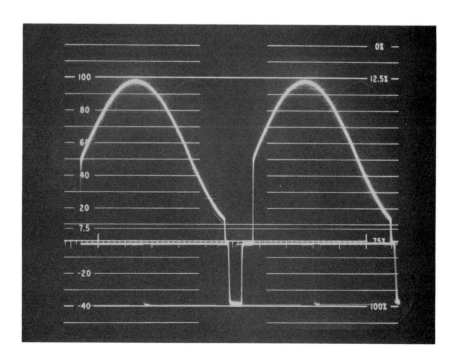

Six black to white
transitions (picture
and wave form)

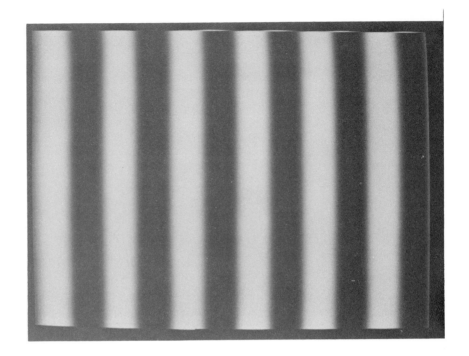

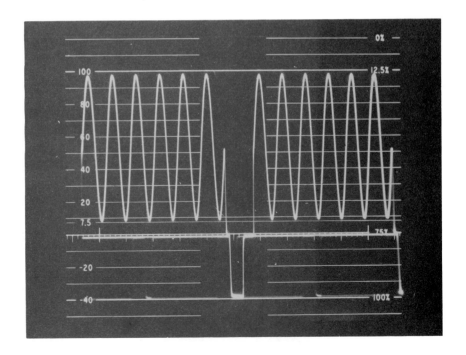

Ten step gray scale
(picture and wave
form)

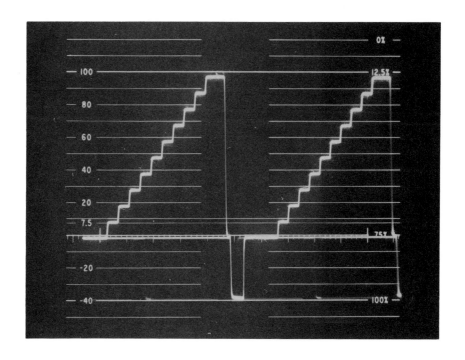

set is called the **setup** level or the **pedestal,** and it is normally set at 7.5 units.

Please note that this setting represents the minimum value that any shadow area in the image can have, but the existence of such a setting does not imply that every image must have some picture element with that value. Also, for visual or cinematographic applications you may think of black as being 0 on the IRE scale, even though strictly speaking it is set at 7.5.

The portion of the video signal represented by the segment of the waveform that is at −40 is the **sync** pulse for the system, and the portion going from −20 to +20 outside the picture area is the **color burst.** Sync and color burst will be discussed in Chapter 13.

The important thing here is to understand how the waveform monitor functions as a combination light meter and "lab contact." It can be thought of as a form of real-time exposure and contrast indicator. What you see on the screen of a waveform monitor is essentially a brightness range reading for the scene. The highest peak reached by the green trace is your hottest highlight, and the lowest valley is your darkest shadow. Where these fall on the vertical scale between 7.5 and 100 tells you how much of the latitude of the system the scene is using.

If the highlights are jammed up against 100 in such a way that the mountains appear to have plateaus on top, chances are the clipping level is set at 100 and you are losing highlight detail. **Clipping** can be thought of as shaving the peaks off the mountain tops whenever they exceed a certain level. How that level should be set and the effect that the clipping level can have on the image will be discussed in the next chapter.

The following illustrations will give you a better idea of exactly how the waveform monitor works than any verbal description.

5.4 shows the waveform generated in the absence of any image (when the lens cap is on or the camera is framed on an absolutely black field). Notice that certain portions of the signal representing control pulses such as sync, blanking, and color burst are still present, but the portion of the waveform representing the picture area is flat at the setup level or pedestal.

5.5 is a uniformly white field—a white card with enough light on it to generate a peak white signal level at this particular *f*-stop. Ideally the waveform monitor should represent this with a thin line right at 100 units. If the card is not absolutely uniformly lit and/or if the three tubes in the camera are not properly balanced (white balance will be discussed in Chapter 9), then the line on the waveform monitor will get thicker.

5.4
Waveform display
with lens capped

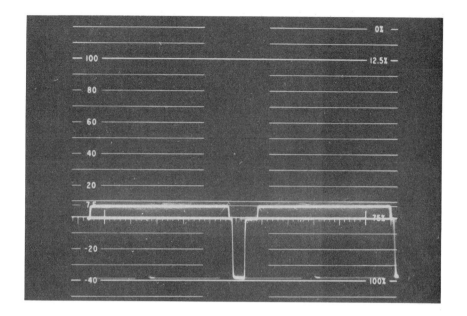

5.5
Waveform display
of uniformly
white field

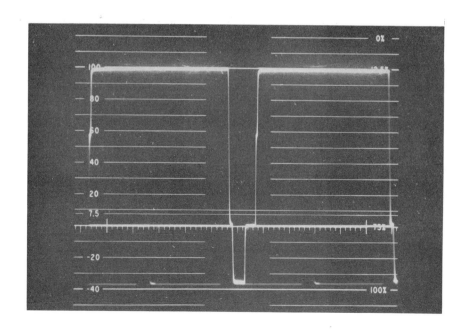

5.6
Waveform display of
three-step gray scale

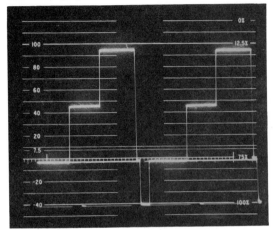

at horizontal rate at vertical scan rate

5.7
Waveform display of
nine-step gray scale

5.6 is a three-step gray scale consisting of black, gray, and white bars. Note the difference in the waveform when the bars are observed at the horizontal and at the vertical rate.

5.7 is a standard nine-step gray scale.

5.8 is a typical test chart involving two gray scales (or chip charts)—one running from left to right and the other running from right to left.

5.9–5.11 are representative black-and-white video images from a camera. 5.12 is an overexposed version of 5.11 and shows the effects of clipping and beam pooling (see page ☆☆) or a loss of detail resulting from overexposure of the tube.

By now, it should be clear how a waveform monitor can function as a light meter. It is comparable to a behind-the-lens reflective light reading or, more accurately, to a series of spot meter readings. If the illumination of the scene or the *f*-stop of the lens changes, there will be a corresponding change on the display of the waveform monitor.

If you know that you want the skin tones to have a certain value in a given scene, it is possible to pinpoint the portion of the waveform display that corresponds to the skin tones and adjust the exposure or lighting to set that portion of the image at a precise value.

5.8
Test chart with two gray scales running in opposite directions

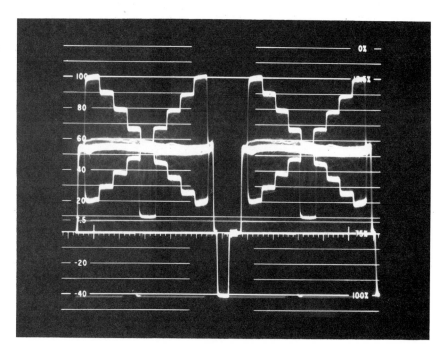

5.9
Black-and-white im-
age 1 with waveform
display

5.10
Black-and-white im-
age 2 with waveform
display

5.11
Black-and-white im-
age 3 with waveform
display

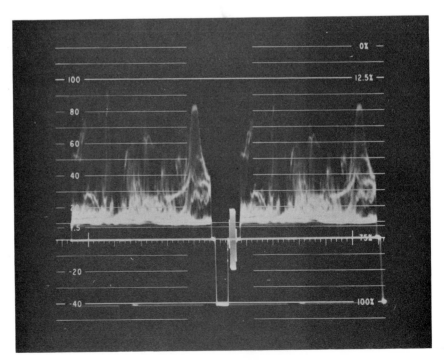

5.12
Black-and-white im-
age 4 overexposed
with waveform display

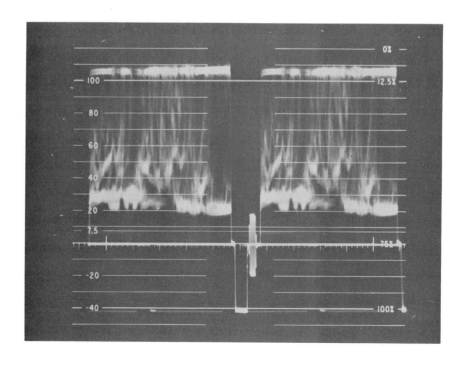

THE PICTURE MONITOR

You may wonder why you should bother with a waveform monitor at all when you can just look at a picture monitor and see whether the image looks the way you want it to. The problem is that a picture monitor is not a reliable indication of the signal you are recording or of how the image will look in the finished product.

To some extent the picture monitor on the set is comparable to dailies when you have no communication with the lab. What the image looks like may be more a factor of what happens in the reproduction of it than of what was actually photographed originally.

Every cinematographer has had the experience of having a lab try to help by "correcting" for an effect he or she was trying to achieve. Only if you know the printer lights for the dailies can you know whether or not the effect is actually in the negative. Similarly, a picture monitor on the set is an indication of what the recorded image looks like only if you know how it was calibrated and how stable it is. The waveform monitor tells you what the printer lights tell you. Actually it tells you what a densitometer would tell you if you read every portion of the image in each frame of your negative.

Maybe you think this is more than you want or need to know about the exposure of your image, and you might have a case if the information were not so readily accessible. Because of the way it is displayed on the waveform monitor you can see it instantly for an entire scene.

More important, the information displayed on the waveform monitor is the key to understanding the potential for creative manipulation of the image with the processing amplifiers. As we shall see in the next chapter, a video image is capable of being manipulated in ways that not even a still photographer can manipulate a photographic image, and the information you need to control these manipulations is displayed on the waveform monitor.

Tone Reproduction

Tone reproduction in video as in film is the method used to shape and control the image. Lighting and shades of tone are the notes and scale of the visual photographic arts. It is time that video is included among these arts.

The reproduction of tones in the black-and-white component of a video image can be manipulated in ways that are difficult or impossible with film. At the same time tone reproduction in a video image is limited in comparison to what is possible with film. In order to understand the differences between film and video and to appreciate the creative potential of electronic signal processing, we need to examine the concepts of contrast, latitude, and gamma as they relate to both video and film.

Understanding how a camera captures and reproduces the tones or gradations of brightness in a scene is the key to creative cinematography on film or video. Brightness values are the tools and materials of visual expression; and the more control we have over them, the more subtle and beautiful the images we can create.

Some cinematographers have a seemingly intuitive grasp of the fundamentals of tone reproduction garnered from years of experience. They are able to do marvelous work even though they cannot explain the theoretical basis for what they do. Obviously one does not have to be a theoretician in order to be a creative cinematographer. If, however, one does not have the time to spend years of apprenticeship developing such an intuitive grasp of tone reproduction, it is possible to get a substantial head start by grappling with a little theory.

What we propose to do is to present the theory of tone reproduction as it applies to electronic cinematography in the simplest possible terms using as a model conventional photographic theory. Readers familiar with characteristic curves for films will recognize immediately the framework being used and see that adapting to electronic cinematography is essentially like adapting to a new film stock. Readers unfamiliar with any theory of this sort will be able to grasp the basics well enough to apply them to both film and video.

LUMINANCE AND CHROMINANCE

We are concerned here purely with the **luminance** signal or the black-and-white component of the video image. A video camera, like the human eye, perceives gradations of brightness separately from variations in color. The eye actually has one set of cells for perceiving color and another that is more sensitive for perceiving fine detail by means of differences in brightness. As we saw in Chapters 2 and 3, a color video camera is generally composed of pickup tubes that are essentially black-and-white imaging devices. A pickup tube by itself does not distinguish

between colors. It is only because the beam splitter and filters separate the red, green, and blue components of the image that the tubes can produce a signal representing a full color image.

This process is similar to the use of three strips of black-and-white film in the original Technicolor system of photography or the use of black-and-white film in making color separations for printing in the graphic arts. Even the current color negative motion picture films utilize black-and-white silver halide layers selectively filtered through built-in separation layers. The resulting image is then colored through the use of dye couplers during the processing phase.

Some video cameras have a fourth pickup tube that is used to produce the luminance signal by exposing it directly to the full color image. Most video cameras, however, reconstruct a black-and-white image of the scene by mixing together appropriate amounts of the signal from each of the three tubes being used to generate the color information. The exact manner in which the signals are mixed together will be discussed in Chapter 7, but the net result is approximately what you would get from a single-tube black-and-white camera. The luminance signal is a black-and-white image comparable to a black-and-white photograph.

CONTRAST AND LATITUDE

A black-and-white image is a record of the gradations of brightness in a scene. These gradations of brightness are a function of two things: the amount of light striking the objects in the scene and the reflectances of those objects. An object whose surface uniformly reflects a given percentage of the light falling on it will be rendered in varying shades if varying amounts of light strike different parts of it. Likewise an object that is uniformly lit will be rendered in varying shades of gray if its surface varies in reflectance.

It is possible, of course, to measure the amount of light coming from any object in a scene. This is essentially what a spot meter does. If you measure the brightness of the darkest and the brightest areas of a scene, these two readings will give you the brightness range of the scene. The ratio of the brightest value to the darkest value is the contrast or contrast range of the scene. A natural scene may have a contrast ratio as high as 1,000:1.

The eye perceives gradations of brightness in relative rather than absolute terms. An object that is twice as bright as another object will

appear to have the same relationship to it regardless of whether the brightness values of each are 50 and 25 or 500 and 250.

The eye can distinguish about a 5 percent difference in brightness, so that two objects having a difference of 1 footlambert in brightness could be distinguished if their respective brightnesses were 20 and 21 footlamberts but not if their brightnesses were 30 and 31 footlamberts. (Five percent of 20 equals 1.0, but 5 percent of 30 equals 1.5. The second object would have to have a brightness of 31.5 footlamberts to be distinguishable from one at 30.) In others words, tones are perceived by means of contrast. It is the ratio of one brightness to another that determines how different or distinct the two are.

Like a camera, the eye has an iris to control the amount of light entering it because there is a limit to the contrast range that it can handle. On an average the eye can probably accept a contrast range of 100:1 for a given iris opening, but the iris adapts very fast and the brain interprets signals from the eye in such a way that it can scan an environment with a much greater contrast range and see it in what appears to be one glance.

The contrast range over which an imaging system can accurately reproduce tonal gradations is the latitude of that system. Eastman color negative has a latitude of at least 7 stops, which is the equivalent of a contrast range of 128:1 or just over 100 discernible shades of gray. Pickup tubes in video cameras have a latitude of about 5 stops or a contrast range of 32:1 (about seventy-two discernible shades of gray).

It is this limitation in the latitude of both film and video that makes necessary not only exposure control techniques but also other methods of manipulating the image that affect the reproduction of tones in the image. In order to evaluate how the reproduction of tones is affected by various techniques a cinematographer may use, it is helpful to have a standard image that includes a sufficient range of tones. This is generally a gray scale or chip chart.

GRAY SCALES AND CHIP CHARTS

A gray scale is a systematic progression from black to white that can be reproduced on film or by a video signal. Since it is impractical to produce a test chart that progresses from black to white continuously in an even way, a gray scale is composed of discrete steps that form an even progression from black to white. Since these steps are sometimes printed

on small cards that are physically removable from the chart, a gray scale may be referred to as a chip chart (as in paint chips).

Since what is perceived as an even progression from black to white is one in which the *ratio* of brightness between adjacent steps is constant (rather than the difference being constant), the progression is logarithmic rather than linear or arithmetic. This means that if you want to put together a gray scale you would not use a series of cards having reflectances of 10, 20, 30, 40, 50, 60, 70, 80, and 90 percent. This is a linear progression and would actually appear uneven to the eye; the difference between the 10 percent chip and the 20 percent chip would appear to be much greater than the difference between the 80 percent chip and the 90 percent chip. If you started with a 10 percent and a 20 percent reflectance you would need a 40 percent and an 80 percent to create an even gray scale. It would, of course, have only four steps in it, and it would encompass a total contrast range of only 8:1. (All of this assumes, of course, that your gray scale will be illuminated absolutely evenly when it is observed or photographed.)

Perhaps the ultimate gray scale is a transparency used in testing film that has twenty-one steps and encompasses a contrast range of about 1,000:1. It is such that each step is the equivalent of a half-stop increase in exposure (or every other step is a doubling of brightness). While it could conceivably be used to test some video equipment, its range so far exceeds the range of current video pickup tubes as to make its use pointless.

Ansel Adams, in his theory of exposure with the "zone system" for black-and-white still photography, analyzes scenes in terms of a ten-step gray scale in which each step represents an increase of 1 stop of exposure. Such a gray scale represents a contrast range of 512:1, and with carefully controlled exposure and development it is possible to make use of this entire range with black-and-white still photographs. This gray scale is primarily one that is visualized in analyzing a scene and not a test chart that is actually photographed.

Many cinematographers use the zone system as a tool to predict reproduction contrast when photographing a scene on film. According to the zone system, zone two represents the darkest exposure level in which any texture may be preserved in the final print. Zone three is a dark gray in which good texture reproduction should be present, and zone four is a light gray. A middle gray is represented by zone five. Zone six is the level at which Caucasian skin is usually reproduced. Zone seven is the upper limit of white reproduction with good texture, and zone eight is the limit of any texture in the reproduction of white.

It is possible to correlate the scale on a waveform monitor to the zones used in the zone system. If we remember that at a gamma of .45 (the standard video gamma) one *f*-stop of camera exposure equals twenty units on the waveform monitor, then the following relationship becomes clear: Zone one is below 7.5 units, while zone two is from 7.5 up to 20 units. Zone three is at 20 units; zone four is at 40 units. Zone five, the middle gray zone, is at around 60 units (actually, 55 units). Zone six is at 80 units, zone seven at 100 units, and zone eight at 120 units. The zone system, used in this way, becomes equally effective for predicting contrast reproduction in video as it is in film.

The standard Kodak gray scale is a seven-step scale with reflectances of 2, 4, 10, 18, 38, 60, and 93 percent. The contrast range of the total scale is 46.5:1, and the steps represent approximately 1 stop of exposure. The middle step in this chart is 18 percent reflectance, which is also the value of the standard Kodak gray card used in exposure control. The white chip at 93 percent represents the maximum possible reflectance with a nonglossy surface.

The standard EIA gray scale used in setting up video cameras is a nine-step scale with reflectances of 3.0, 4.4, 6.3, 9.2, 13.4, 19.5, 28.4, 41.3, and 60 percent (see 6.1). Two things are obvious about this scale in comparison to the Kodak gray scale. First of all, even though the EIA chart has nine steps instead of seven, it encompasses a contrast range of only 20:1 instead of 46.5:1. Second, it is a closer approximation to a logarithmic progression. (Each step is about 1.45 times that of the previous step.) Every other step in the scale represents about a 1-stop increase in exposure.

An eleven-step gray scale adopted by ITE in Japan as a standard for use with video cameras has reflectances of 2.0, 4.75, 8.3, 13.4, 19.5, 27.4, 37.0, 46.0, 57.0, 71.0, and 83.0 percent. In addition, the chart has another, separate square with a reflectance of 89.9 percent, so that the total contrast range represented by the test chart is 45:1. This gray scale was adopted in recognition of the fact that pickup tubes are now capable of a contrast range well in excess of 20:1, but there is some debate among video engineers in this country as to the advisability of using such a chart to set up a camera.

Just for the record, in the old days of television when the black-and-white cameras had image orthicon tubes, the standard test chart for cameras recommended by the Radio and Television Manufacturers Association included a ten-step gray scale with a 30:1 contrast range. CBS at that time proposed the use of a ten- or eleven-step gray scale in

which every other step represented a 1-stop increase in exposure and the contrast range was 22:1 or just over 30:1.

In addition to putting a chip chart in front of a video camera in order to create a test signal, it is possible to generate such a signal electronically and feed it into the amplifiers rather than taking the signal from the pickup tubes. A gray scale can be simulated by a **staircase** test signal that consists of a series of appropriate signal levels during the equivalent of each scan line.

It is also possible to create electronically what is virtually impossible to produce physically: an absolutely continuous transition from black to

6.1
Chip chart

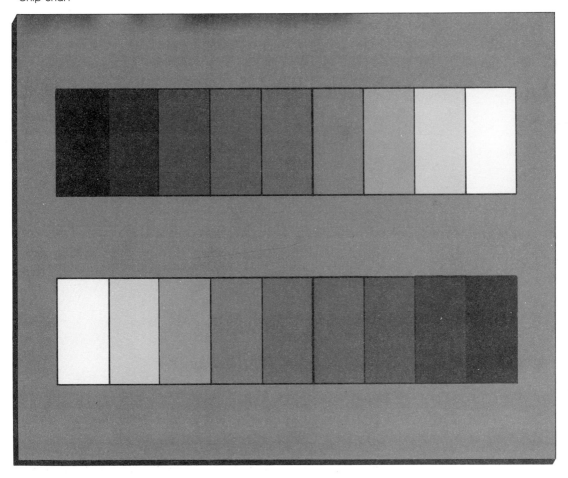

white. This is called a test pulse on cameras, or a luminance ramp because the waveform resembles a ramp. If the transition from black to white occurs over the entire screen from left to right, the signal will be a line ramp (see 6.2) because each scan line must gradually go from 0 to 100 as it scans across the frame. If the transition from black to white is vertical (that is, the screen is black at the top and white at the bottom), the signal will be a field ramp that is superimposed on the scanning signal since each line will be uniform but different from the ones above or below. These test signals are used primarily for testing the linearity of amplifiers and circuits, but they can be used to examine the effects of various circuits for manipulating tone reproduction in a video image.

The point of this catalog of chip charts and test signals is simply to enable you to recognize the particular tool that is being used to evaluate tone reproduction and to see that gray scale rendition on film may differ from gray scale rendition in video partially because a different gray scale is being used. Just as you cannot evaluate a weather report without knowing whether the temperature is being given in degrees Fahrenheit or Celsius, you must know what kind of gray scale is being used in order to compare tone reproduction in film and video.

6.2
Line ramp signal

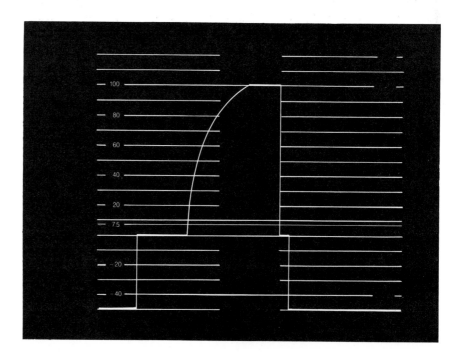

TRANSFER CHARACTERISTIC OR CHARACTERISTIC CURVE

The simplest way to analyze tone reproduction in any imaging system is by means of a graph plotting image brightness (or density) against scene brightness. With the ideal imaging system there would be a direct 1 : 1 correlation between brightness in the original scene and brightness (or density) in the image. This image would be an exact monochromatic reproduction of the scene and could be represented by a graph that has a straight line at 45 degrees to the axes representing the brightness of the scene and the brightness of the image. (See 6.3.) In this instance, the scale on each axis would be identical—an object in the scene giving off 20 footlamberts would be represented by an area on the screen giving off 20 footlamberts.

Needless to say, such an imaging system does not exist. As we have already noted, not even the human eye has sufficient latitude to encompass the range of brightnesses found in natural (or unnatural) environments, and any attempt to reproduce the actual brightness of a scene in its image would represent a tremendous waste of energy. An image does

6.3
Characteristic curve for ideal 1:1 imaging system

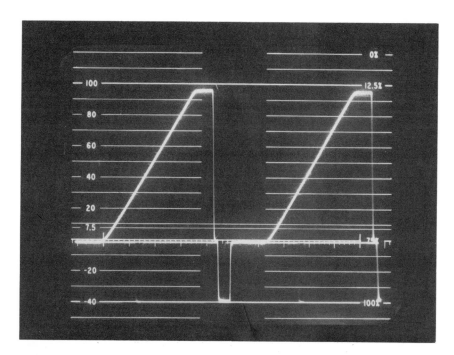

not need to have the same brightness as the scene it represents; it only needs to have brightness relationships within it that are proportional to those in the original scene.

The goal, then, is to have an image with the maximum possible brightness range and a consistently proportional relationship between brightness in the scene and brightness in the image. Such a system might again be represented by a graph with a straight line at a 45-degree angle to each axis, but the scales on the axis would be different. Also, the range of values possible on the vertical axis (representing image brightness) would be limited in comparison to the range of values possible on the horizontal axis.

Since the horizontal axis of our graph represents the scene brightness range, we can measure it in terms of amount of exposure. The most convenient way to express differences in exposure is in steps corresponding to the f-stop scale in which each step represents a doubling of the exposure. This is a logarithmic scale, that is, one in which the intervals between 2, 4, 8, 16, 32, and so on are equal.

The axes on the graph representing a transfer characteristic are always calibrated logarithmically. There is no need to be intimidated by the intrusion of this form of mathematics into our discussion of tone reproduction. The scales are logarithmic because it is mathematically convenient and because it permits the graph to represent a gray scale in the way common sense implies that it should be represented. With a logarithmic scale the steps in a conventional gray scale will occur at even intervals along the exposure axis and can easily be translated into f-stops.

A graph plotting image brightness against scene brightness represents the net effect of an entire imaging system. With any system there are several stages involved, and it is possible to plot the transfer characteristic of each stage of the system individually. The signal generated by light striking the pickup tube can be measured separately from the brightness created by that signal in a picture tube. Generally some stages in an imaging system are more critical than others and more attention is devoted to analyzing their effect on tone reproduction. This is particularly true of the negative in a photographic system. Controlling the exposure (and in many instances the development) of a negative is the most crucial step in the creation of a photographic image, and the graph plotting negative density against exposure is the most common of all forms of the graph we have been discussing. It is called the characteristic curve or the D log E curve (for density versus logarithm of exposure) or the H&D curve (after Messrs. Hurter and Driffield, who first plotted

the curve in the nineteenth century). The equivalent in video of a D log E curve for a film camera negative is the curve representing the transfer characteristic of a pickup tube in which a log of exposure is plotted against a log of signal strength or voltage level. (See 6.4).

The way in which any particular film stock reproduces tones with a given form of development is best represented by the characteristic curve, and most of the terms used to describe the performance of the film are defined by reference to the characteristic curve. For example, latitude, which we loosely defined as the range over which an imaging

6.4
D log E curve for 5247 color negative and transfer characteristic for typical pickup tube with same log E scale

system can reproduce tonal variations, is more strictly defined as the range of exposure values corresponding to the range of values possible on the vertical axis of the characteristic curve (minimum and maximum density with film or dark current and peak signal strength or maximum picture monitor tube brightness in video).

With video, it is the pickup tube and the processing amplifiers in the camera or camera control unit that correspond to the negative and its development. While it is customary to use a graph comparable to a characteristic curve to represent the transfer characteristic of a pickup tube, the effects of the processing amplifiers are generally analyzed by means of a waveform monitor. Once you know how to interpret it, a waveform monitor will tell you exactly what the characteristic curve for a film stock tells you. If one wants to achieve a "film look" with video, one must understand the significance of a typical film characteristic curve and see how it relates to tone reproduction in video.

6.5 is the characteristic curve for a typical black-and-white negative film. The first thing that is obvious is that it is not simply a straight line. It has three general areas: the curved portion at the left end, called the toe, the straight-line portion in the middle, and the curved portion at the right end, called the shoulder. The transition between the straight-line portion and the shoulder is sometimes called the knee, but so far no one has felt any need to label other portions of the curve the shin or the ankle.

The curved portions of the characteristic curve for film are an important factor in the "film look." Video cameras that are designed specifically for electronic cinematography and have a "knee compression circuit" or a "soft clip" are trying to duplicate the way in which film responds to overexposure. The transfer characteristic for a pickup tube is an absolutely straight line (see 6.4), and special circuitry is required in the amplifiers to duplicate the gradual transition to complete overexposure. What the curved portion at the shoulder of a characteristic curve for film negative represents is a gradual change in the rendition of tonal gradations in the scene. So long as the exposure values fall within the straight-line portion of the curve, a given increase in exposure will always result in a consistent increase in density in the negative. As the exposures move into the shoulder, that same increase in brightness will produce less and less of a difference in the density of the negative. The loss of texture or detail in highlight areas is thus softened.

Another way of viewing the effects is in terms of the range of exposure values that can be encompassed between the minimum and maximum densities possible in the negative. The minimum and maxi-

mum densities are given, and the curved portions of the curve have the effect of extending the range of exposure values that can be reproduced. If the characteristic curve were a straight line throughout the entire density range, the range of exposure values that had any effect on the density would be more limited. The result would be that any highlight area above a certain point would be totally devoid of detail.

The presence of the curved portions of the characteristic curve for film also provides aesthetic possibilities that may be exploited by a cinematographer. If, for example, a given scene has a brightness range

6.5
D log E curve for black-and-white negative

that is easily contained within the straight-line portion of the curve, deliberate underexposure or overexposure can place a portion of the scene in the toe or shoulder and alter the look of it.

GAMMA

The relationship between changes in exposure and resulting changes in image brightness (or density) is expressed by the concept of **gamma.** In photography, *gamma* is defined as the slope (or gradient) of the straight-line portion of the characteristic curve. The slope of a line in a graph is the ratio of vertical change to horizontal change (or the tangent of the angle created by the projection of the straight-line portion to intersect with the horizontal axis). Again, the mathematics are not important. It is easy enough to visualize the way in which increasing or decreasing the slope of the straight-line portion of the characteristic curve will affect tone reproduction (see 6.6).

If the gamma or slope of the line is 1 (resulting in a line at a 45-degree angle to the baseline), there is a 1 : 1 relationship between exposure and image brightness. A doubling of exposure will result in a doubling of image brightness. If the gamma is greater than 1, the slope will be steeper and a given change in exposure will produce a greater change in image brightness; that is, the contrast will be greater in the image. If the gamma is less than 1, the slope will be flatter and the same change in exposure will produce less of a change in image brightness.

With black-and-white still photography it is possible to change the gamma of the film by varying the development, and this technique is often used as part of an exposure control system in order to achieve the best possible tonal rendition in the final image. With color motion picture film it is not really feasible to alter the gamma, but with video the gamma can be altered by means of a gamma correction circuit in the proc amplifier.

There are differences, however, in the use of the term *gamma* in video and in film, and in order to understand gamma in video we must first understand the concepts of system gamma and point gamma. Just as it is possible to plot the relationship between scene brightness and image brightness for an entire imaging system or for any stage in that system, it is possible to determine the gamma for an overall system or

for any stage in the system. It is also possible to calculate the gamma of the overall system simply by multiplying the gammas of each stage in the system.

If each stage has a gamma of 1.0, then the net result will be a system gamma of 1.0. If one stage has a gamma of 2.0, then it will be necessary to design another stage to have a gamma of 0.5 if the net result is to be a system gamma of 1.0. This is in fact what happens with both film and video. It is customary to design negative stocks with a gamma in the

6.6
Two curves with different gammas. The lower gamma has a wider latitude.

range of 0.6–0.7 in order to reduce contrasts found in nature to a manageable level. This results in a need for the gamma of positive print stock to be very contrasty to reproduce "snappy" prints from a flat negative.

With video the gamma of a picture tube is about 2.2. Since current pickup tubes have a gamma of 0.95 or 1.0 and every other stage in the transmission and recording process has a gamma of 1.0, it is necessary to design a gamma correction circuit in the camera or camera control unit that introduces a stage with a gamma of 0.45. This is why the "normal" gamma setting on a video camera is 0.45 and a setting of 1.0 is available for testing purposes.

6.7
Waveform of nine-step chip chart at gamma of 0.45

If for some reason the characteristic curve has no straight-line portion, the gamma might be different for every point along the curve. In this case it is only possible to specify the gamma for a given point, and it is called point gamma. Because of the nature of the electronic processing to which it is subjected, a video signal does not necessarily have a continuous straight-line portion in its transfer characteristic; and gamma in video is generally point gamma for a specified voltage level.

There is another, more important difference, however, in the use of the term *gamma* with respect to a video image. When video engineers talk about gamma, they are referring only to the gamma of the middle

6.8
Waveform of nine-step chip chart at gamma of 0.35

portion of the transfer characteristic. With electronic processing it is possible to alter the gamma of only a portion of the curve, and generally there are separate controls for the whites, the blacks, and the midgrays. In general, *gamma* in video refers to the way in which the midgrays are reproduced. The adjustment of the black and white ends of the curve is generally referred to as black level and white level or gain.

If a video camera is set up on a nine-step EIA chip chart so that the black chip is at 20 units on waveform monitor and the white chip is at 100 units, then the middle gray chip (or crossover chip) will fall at about 55 units if the gamma is set at 0.45. (See 6.7.) Changing the gamma to a setting of 0.35 will cause the midgray chip to move up to 65 units (see

6.9
Waveform of nine-step chip chart at gamma of 0.55

6.8), and changing to a gamma of 0.55 will cause it to move down to 45 units (see 6.9). There is a convenient relationship here in that if you forget the decimal point, the total of the gamma and the value of the midgray is always 100. Since the extremes of the gray scale are not affected by the gamma control, lowering the gamma has the effect of stretching the blacks and compressing the whites, whereas raising the gamma has the effect of compressing the blacks and stretching the whites.

EXPOSURE

If the brightness range for a given scene exceeds the latitude of the pickup tube (or film, in motion pictures), there will be a loss of detail in shadow and/or highlight areas. If the exposure is set so that the brightest highlight in the scene is at the level corresponding to maximum signal strength, then the loss of detail will occur in the shadow areas if no other adjustment is made. If the iris is opened up, the entire range of exposure values will shift to the right and upward on the characteristic curve. Placing the darkest shadow area at a value corresponding to minimum signal strength (or exposure level) will cause the highlight areas in this scene to exceed the exposure level for maximum signal strength and the loss of detail will occur in the highlights. If the cinematographer is unable to reduce the brightness range of the scene by adding fill light to bring up the shadow areas and cannot otherwise manipulate the signal, then he or she must choose the exposure setting that produces the most acceptable compromise. (See 6.10.)

Even when the brightness range of a scale can be encompassed by the latitude of the system, it may be necessary to compromise in tone reproduction in order to achieve consistency of certain tones from scene to scene. In cinematography it is usually considered important to maintain consistency of skin tone. Because of the way in which scenes are cut together, it can be very distracting if your leading lady's skin seems dark in one shot and light in the next. An incident light meter with a photosphere is designed to enable a cinematographer to determine the exposure setting that will make an 18 percent gray card appear as a midgray regardless of the content of the rest of the scene, and it is very helpful in maintaining consistency of skin tone.

If the latitude of the system is limited, however, exposing for consistency of skin tone may cause problems with highlights or shadows. This

is illustrated in 6.11, where three scenes are compared. If they are exposed so that the skin tone is always at a level corresponding to 70 units on the waveform monitor, there will be a loss of detail in highlight areas of scene B and and a loss of shadow detail in scene C—unless some other adjustment is made. Adjusting the exposure would enable each scene to be encompassed by the latitude of the system, but would result in a radical difference in the skin tone for each scene.

Please note that there is no federal law that says Caucasian skin has to be pegged at 70 units in all video images. The skin tones in a video

6.10
Effect of under- and overexposure on characteristic curve

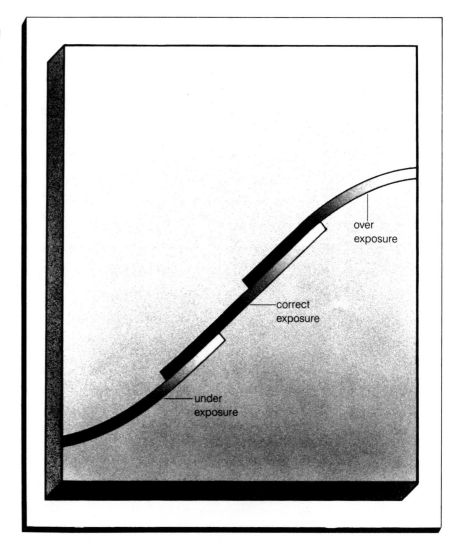

over exposure

correct exposure

under exposure

6.11
Three scenes exposed
for skin tone at 70
units with their re-
spective waveforms.
Scene A is "correctly"
exposed for the effect
intended. Scene B
shows a loss of high-
light detail and scene
C a loss of shadow
detail.

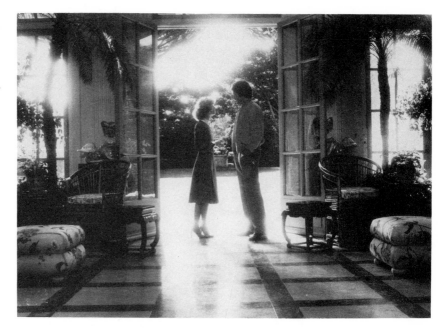

Scene A

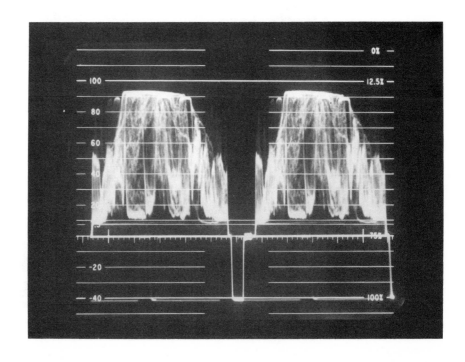

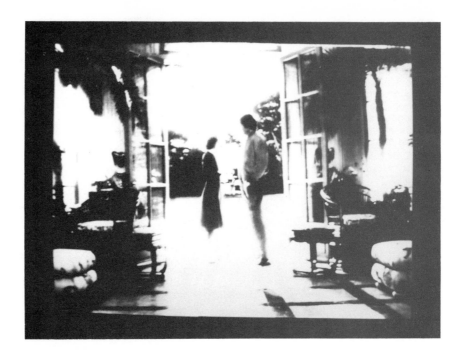

Scene B

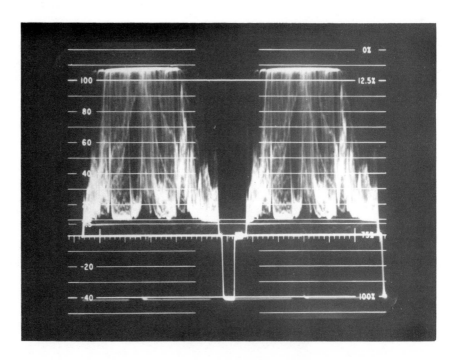

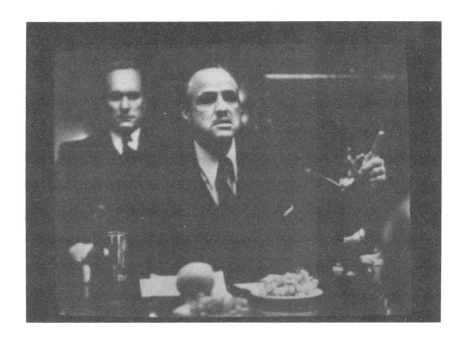

Scene C

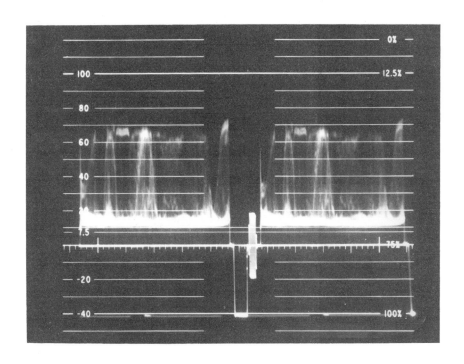

transfer of *Raiders of the Lost Ark* are probably at around 30 units, and they look just fine. It is only if shots are to be cut together within a scene or sequence that consistency of skin tone is a consideration, and it is the *consistency* rather than any absolute level that is important. Traditional textbooks recommend maintaining flesh tones between 60 and 80 percent of peak white, but recommendations like this are meaningless without consideration of the overall content of the scene and the narrative or dramatic context. Nor do they take into account variations in skin coloration and reflectance that are found when photographing people as opposed to test charts.

SIGNAL PROCESSING

In black-and-white still photography, the Ansel Adams zone system of exposure is essentially a means of fixing Caucasian skin tones or any tone considered primary to a photographer's visual intentions. By "fixing" a particular midtone to a consistent density in the negative and then modifying the exposure and development of that particular image in order to optimize the rendition of tones at the extremes of the gray scale, the photographer can manipulate tone reproduction to advantage. With motion picture photography such scene-to-scene modifications in the processing are not feasible, especially with color; but with video it is possible to modify the gamma on a scene-to-scene basis, provided the cinematographer knows what he or she is doing. In fact, it is possible to manipulate the gray scale of a video image in ways that Ansel Adams never dreamed of doing.

First of all, it is possible to vary the gamma of the image in three separate regions or portions of the gray scale. What is normally termed the gamma control affects the midgrays, whereas gamma compression (in cameras so equipped) and black stretch affect the blacks and whites, respectively. Stretching the blacks is essentially a means of bringing out detail in shadow areas by expanding the portion of the gray scale devoted to black or dark gray reproduction while compressing the rest of the gray scale. By increasing the range of signal strength for a given area of exposure, it permits subtler gradations in subject brightness in the range to be captured by the video signal.

It should be noted that black stretch operates independently of the color information in the image. This is not to say, however, that it does

not affect the rendition of color. Increasing the brightness of an area of the image without altering the amount of color will have the effect of desaturating the color.

It is also possible to alter the overall contrast range of a video image by raising the pedestal or lowering the white level. The pedestal is the minimum signal strength for picture information. It is generally set at 7.5 units in order to ensure adequate separation between picture information and the synchronizing signals that are set at levels lower than reference black. Raising the pedestal has the effect of compressing the tonal rendition of the entire image, compressing the blacks slightly more than the grays and the whites least of all. The closest photographic equivalent would probably be flashing the film. Peak white in the signal continues to correspond to the same exposure value no matter how much the pedestal is raised. (See 6.12.)

The pedestal can be raised as much as you want, but it cannot be lowered in such a way that picture information goes below 7.5 units. If the pedestal is lowered below 7.5 units, the black will be clipped. Any exposure value that would produce a signal below 7.5 is indistinguishable from the value represented by 7.5. The result will be a "crushing" of the blacks in the picture and a loss of detail in shadow areas. There may, of course, be some occasion when this is a desirable special effect, but as a rule it represents a needless sacrifice of shadow detail.

As we shall see when we discuss camera setup, there is never any reason to have black clipping in an image unless you want to use it to create a special effect. The key is using absolute black to set black level rather than an object in a scene that appears to be black. A black object— even a black velvet coat—will often have detail in it that should be visible, and will generate enough of a signal to be higher than the pedestal. If you use any element of a scene to set black level instead of capping the lens to create absolute darkness, there will be the possibility of clipping blacks in a scene (see 6.13).

Clipping of overexposed whites is required in broadcasting to prevent picture information from interfering with the sound track that is modulated onto the carrier signal "above" the picture information. This interference is sometimes noticeable when white letters are superimposed onto a picture at too high a level, producing an audible buzz that comes and goes with the super. Clipping is also sometimes required in production to prevent overloading the input stages of a recorder, but it is a mistake to assume that a signal must be clipped in production since it is going to be clipped eventually in broadcasting. There are many instances where it is worth recording a signal that exceeds 100 units and

6.12
Effect of raising
pedestal

6.13
Black levels in a
scene being clipped.

letting it be adjusted in postproduction to bring the peak white level
back down to 100 without clipping.

It is possible to lower the clipping level so that it crops off highlight
detail that would normally be within the latitude of the signal. This
affects only the highlights; the midgrays or blacks are not affected at all.
Clipping is not an alteration of the gamma of the signal but simply a
filtering out of everything above a certain level. There is really no direct
photographic equivalent, and the loss of detail caused by clipping
should not be confused with the loss of detail caused by beam pooling
when the target of a pickup tube is overexposed.

GAMMA COMPRESSION CIRCUITS

In order to better simulate the film look with a video camera, circuits
have been developed that gradually change the gamma of the signal in
the highlight area above 80 units. The effect of one such circuit on the
gray scale rendition can be seen in 6.14. What was formerly at 100 units

6.14
Effect of gamma
compression (a) with-
out compression;
(b) with compression

(a)

(b)

is now at about 90 units. Exposure values that would have been at 120 units or higher are now at 100, and the extreme highlight detail is compressed rather than lost altogether. The gray scale below 80 units is not affected at all.

The addition of this knee compression or soft clip circuit to a video camera results in a dramatic improvement in the video images that can be created in situations involving extreme contrast ranges. It permits a video camera to handle, for example, a low-light interior with a hot daylight background beyond a window in much the same way as film would respond to such a scene. Even when there is loss of detail, the effect is softened. When this form of gamma compression is used in conjunction with ABO circuitry, it takes at least 4 stops of overexposure before harsh or distorted highlight reproduction begins to appear. Generally the level at which the compression begins is set above 80 units in order to avoid any undesired effects in the area of skin tones, but the level at which it begins to work can be varied.

CREATIVE APPLICATION

Chip charts and test scenes can only hint at the creative potential of electronic signal processing. There is probably no cinematographer working today who has fully explored the possibilities of the video camera. When you consider the painstaking care with which Ansel Adams created black-and-white photographs, and you realize that electronic signal processing is an infinitely more flexible tool for the manipulation of gray scale than any of the techniques used in the exposure, development, and printing of black-and-white photographs, your imagination may begin to sense the untapped potential of video as a creative medium. And all of these tools apply to color video photography. Electronics offer the cinematographer the equivalent of a means for redesigning a film emulsion for every scene or every shot.

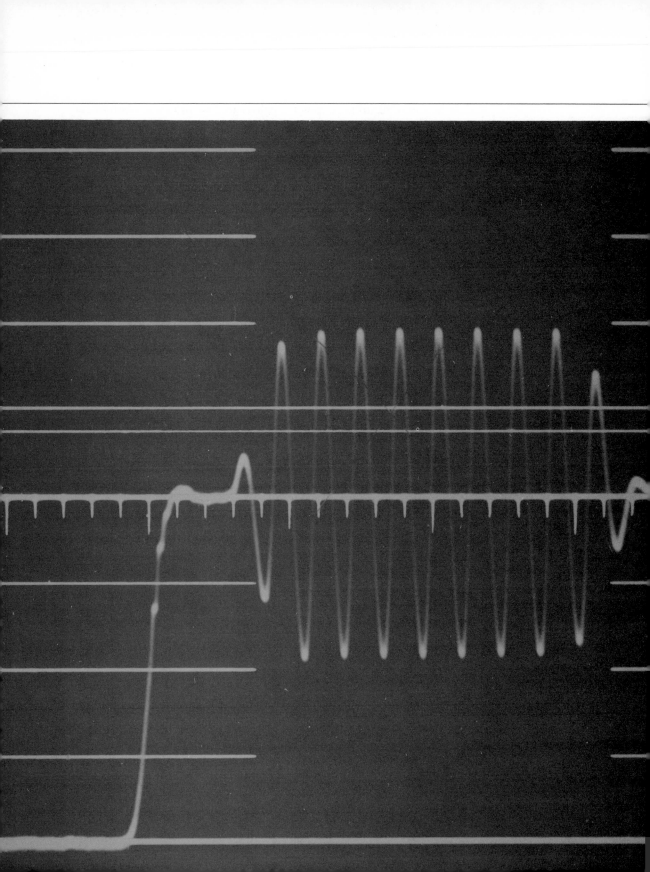

Color

In video, unlike film, color reproduction is not designed in at the time of film stock manufacture. The cinematographer in video must work harder to achieve faithful color reproduction, but has an easier time manipulating colors creatively.

THE COLOR MONITOR

The best way to begin achieving photographic control over color reproduction in video is with a basic grasp of the color picture tube on which the final image is displayed. An image is created on a picture tube by bombarding phosphors with electrons and thereby causing them to glow. The electron stream is created and guided in basically the same way as it is in a pickup tube, and the phosphors glow in proportion to the strength of the electron beam striking them.

A color image is created by using different phosphors that glow different colors instead of one type that is simply white or some shade of gray. A full color video image is created by an additive process mixing red, green, and blue light. The screen is coated with a fine dot or stripe pattern in which red, green, and blue phosphors are grouped in triangular clusters. The process is similar to the way a full color image is created on a printed page by means of patterns of yellow, cyan, magenta, and black dots, except that a TV screen creates colors additively rather than subtractively.

ADDITIVE VERSUS SUBTRACTIVE

A brief review of additive color may be helpful. White light can be created by combining the appropriate amounts of red, green, and blue light. Similarly, any color in the spectrum (as well as some reddish purple colors that are not in the spectrum) can be created by mixing together appropriate amounts of these primary colors.

Mixing colored light sources together is different from filtering out colors from a white light source. Color film has three dye layers that produce a full spectrum of colors subtractively. The layers are yellow, cyan, and magenta and filter out blue, red, and green, respectively. To produce blue, color film uses the magenta and cyan layers but no yellow. A magenta layer transmits blue and red, and a cyan layer transmits blue and green. Since blue is the only color transmitted by both layers the net result of superimposing the two layers is blue light projected onto the screen.

On a TV screen blue is created simply by bombarding only the blue phosphor, and yellow is created by activating the red and green phosphors simultaneously. It is interesting to note that the eye responds to this combination of red and green in exactly the same way it would

respond to a pure yellow light of a particular wavelength even though the combined red and green light does not contain any radiation at that specific yellow wavelength.

A color picture tube has three separate electron guns (one for each color). If the guns are arranged in a triangular pattern, it is called a delta gun tube; if they are arranged in a row, it is called an in-line gun tube (see 7.1). In a delta gun tube a metal plate called a shadow mask has a million tiny holes in it and is positioned near the phosphored surface so as to ensure that only the right electron beam hits the right phosphor dot. An in-line gun tube shadow mask has vertical slots arranged so that each beam strikes its corresponding phosphor line on the screen.

7.1
Two popular types of monitor electron gun configurations

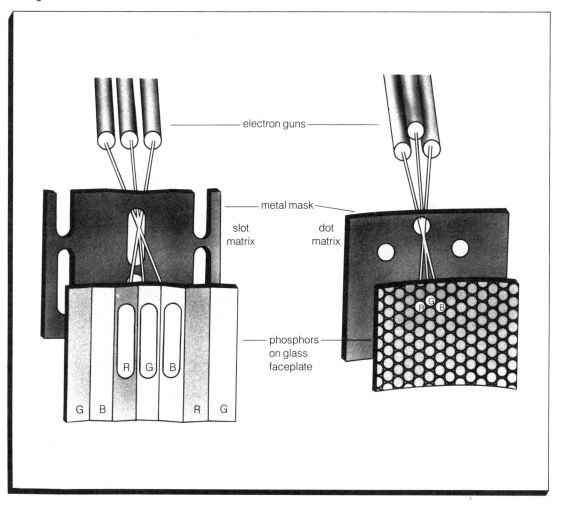

Ideally each phosphor on the picture tube should give off a color that correspond exactly to one of the three primary colors. Elaborate tests have been conducted by the Commission Internationale d'Eclairage (CIE), or International Commission of Lighting, to determine the precise wavelengths of the primary colors that can be mixed additively to duplicate all of the colors in the spectrum. It is theoretically possible to match these primaries with the phosphors in a picture tube, but unfortunately the eye's sensitivity to brightness in the red and blue extremes of the spectrum is so low that it is impractical. The red and blue phosphors would require disproportionate amounts of energy to glow brightly enough. It is therefore necessary to compromise and shift the color of the red and blue phosphors slightly toward yellow or green. It is essential, however, to select red, green, and blue phosphors that will still produce an apparent "white" to the eye of the viewer when they are combined.

RGB VERSUS COMPOSITE VIDEO

Since a color picture tube consists of red, green, and blue phosphors activated by an electron beam, and a video camera generally has three pickup tubes capturing the red, green, and blue components of a scene, it would seem that the most logical way to transmit the video image would be as three separate red, green, and blue signals that go directly to the appropriate electron gun in the picture monitor. This is known as an **RGB** signal. It is used in certain phases of production, but it is not the conventional method of transmitting or recording a video signal.

There are two reasons why an RGB signal is not the conventional means of transmitting or recording a color video image. The first, and the most important at least from a historical point of view, is compatibility. When color television was first introduced, it was considered absolutely essential that it be completely compatible with the existing black-and-white broadcasting system so that the black-and-white sets in people's homes could still receive a program broadcast in color, and the new color receivers could receive a black-and-white program.

In order to achieve this compatibility, the RGB signal from a color camera must be converted into a signal that conveys brightness or luminance information separately from the color or chrominance information. If the luminance signal is the same as the conventional black-and-white signal, then a black-and-white receiver can simply ignore the color

information. In other words, the color information is "encoded" or added on to an already existing black-and-white signal.

The key to the success of such an encoded color system is the fact that the eye is so much more sensitive to variations in brightness than it is to variations in color. This means that fine detail is perceived more in terms of brightness differentiation than in terms of color. The color information in a video signal therefore does not have to have the same degree of detail or resolution as the luminance component of the image. The chrominance signal, then, can have a much smaller bandwidth than the luminance signal; and as a result it can be superimposed on a portion of the luminance signal in such a way that the two components can be separated in a receiver. The chrominance signal is actually contained in a **color subcarrier** that is "interleaved" with the luminance signal.

A side effect of this form of color encoding (and the second reason for its popularity) is that the color signal requires no more total bandwidth for transmission than the black-and-white signal. An RGB signal in which each component is recording the same degree of picture detail as the luminance signal in a composite video signal would require three times the bandwidth. This would mean that one color program would need three of the channels normally used to broadcast a black-and-white program. Needless to say, this is not a particularly attractive alternative for broadcasters who are dependent upon the availability of numerous channels for television broadcasting. It is important to note, however, that all encoded systems pay a price in terms of picture quality for their conservation of bandwidth space. Transmission of an RGB signal may be more feasible with cable and direct satellite broadcast.

COLOR ENCODING SYSTEMS

Several different systems for color encoding are currently in use around the world. The NTSC system developed in the United States is built on a 525-line, 30-frame-per-second system and is used in Canada, Mexico, and Japan as well as the United States. The **PAL** (Phase Alternation Line) system developed in Germany is based on a 625-line, 25-frame-per-second system and is used in Germany, England, Australia, Italy, most of Western Europe, and much of South America. SECAM (Sequentiel Couleur à Mémoire), developed in France, is also based on a 625-line, 25-frame-per-second system, but encodes the color information in a

different manner. SECAM is used in France, the Soviet Union, and most of the Eastern European nations. PAL-M is a 525-line, 30-frame-per-second system with PAL color encoding that is used in some South American countries.

ImageVision, which is a higher definition (or, as defined technically by the SMPTE High Definition Study Group, an "extended-definition") television system developed by Image Transform, is actually a patented color encoding system using recorders capable of a much wider bandwidth than conventional broadcast systems. Altering the color encoding system is one of the ways ImageVision achieves greater horizontal resolution in the image (See Chapter 15.)

The ways in which these color encoding systems differ or the exact method by which each works need not be of excessive concern to the cinematographer or the producer. It is sufficient to know that they are incompatible methods of recording or broadcasting color, although conversion from one standard to another is possible with some degree of compromise in image quality. More important, these color encoding systems are not the only possible ways to record or broadcast color images, and each system has its limitations with regard to its effect on image quality.

One of the drawbacks of color encoding systems that combine or "composite" the chrominance signal with the luminance signal is that certain image defects can result. The most common of these (with NTSC signals) is chroma crawl or cross-chrominance, a barber-pole-like effect along edges of colored areas in the image. Chroma crawl is the inevitable result of NTSC encoding under certain circumstances when chroma information in the composite signal cannot be adequately distinguished from luminance information. It is a defect in the chrominance signal that disappears if the color is turned off on the picture monitor. Similarly, cross-luminance is a defect produced by the encoding system that causes such things as the moiré pattern on a checked sports jacket.

COMPONENT RECORDING

There is another form of component recording that represents a middle ground between the conventional NTSC composite signal and a pure RGB signal. This is the kind of recording used in the new ½-inch Betacam or M-Format recorders as well as the Quartercam ¼-inch format developed by Bosch and others.

Each of these formats is different, but they share a common approach in that the standard chrominance and luminance signals are derived from the RGB signals in the camera. The chrominance and luminance signals are recorded on separate channels, however, rather then being composited. Recording in this manner is made possible by high-density recording techniques and, in the case of the Betacam and Quartercam formats, time compression of the chrominance signal. The result is the elimination of the image defects associated with composite video without the bandwidth requirements of a full RGB signal. (See Chapter 12.)

LUMINANCE AND CHROMINANCE

In a three-tube color camera the luminance signal is derived from the three color signals. The luminance signal is made up of 59 percent of the green signal plus 30 percent of the red signal and 11 percent of the blue.

These percentages are based on the average sensitivity of the human eye to various wavelengths of light. The eye is most sensitive to green and least sensitive to blue. This is partially compensated for by the amount of ultraviolet in natural light. In order to appear "natural" a black-and-white image or the brightness component of a color image needs to match this spectral sensitivity of the eye. If two objects reflect an equal amount of light but one is blue and the other is green, the blue object will appear darker to the eye. Incidentally, color film is also balanced to match the eye's spectral response and combines colors according to these same percentages.

The percentages of the three color signals used to make the luminance signal must also add up to 100 percent. If the camera is seeing pure white and each tube is putting out 100 percent signal strength, then the luminance signal should be at 100 percent as well.

THE VECTORSCOPE

The color information contained in the chrominance signal can be analyzed in terms of two parameters: hue and saturation. **Hue** is the tint that can be adjusted on a color receiver. When the faces look purple, the hue information is being misinterpreted. For most colors the hue can be

specified by reference to a specific wavelength in the spectrum of visible radiation. (The reddish purple nonspectral hues that are made by mixing varying proportions of red and violet do not correspond to a single wavelength.)

Saturation refers to the purity of the color or the extent to which it is mixed with white light. Pink is not a different hue from red; it is a desaturated version of red.

Neither hue nor saturation should be confused with brightness, which is simply the amount of light being reflected or given off. The amount of light is independent of the color of the light (even though in a black-and-white image colors must be translated into brightness values). In video terms the brightness is the luminance component of the image and the hue plus saturation make up the chrominance component.

The easiest way to represent the relationship between hue, saturation, and brightness is by means of a three-dimensional graph in which brightness is measured along an axis that is perpendicular to the plane in which hue and saturation are specified. (See 7.2.) Saturation is specified as the distance away from this central axis, and hue is the direction in which saturation is measured. That is to say, hue is specified in terms of degrees of rotation from an arbitrary reference point.

If the luminance information is ignored, and we simply examine the chrominance information (that is, hue and saturation), we can do so with a two-dimensional circular graph. This is essentially what is represented on the screen of a **vectorscope.** (See 7.3.) A vectorscope (along with the vector analysis involved in the formulation of the color encoding systems) is based on an internationally standard method for measuring color. While the principles of the CIE system are fascinating and well worth studying, they need not concern us here. All the cinematographer needs to know is that a vectorscope is a very convenient and logical representation of the hue and saturation in a video image.

While a vectorscope is less useful as a production tool than a waveform monitor, it is necessary for matching color between cameras in a multiple-camera shoot where live switching will be done between cameras. The vectorscope is also an essential tool in postproduction, and it is well worth understanding. If any attempt is made to manipulate color reproduction in video images during postproduction, a vectorscope is an invaluable reference tool for analyzing exactly what is being done to the image. The postproduction facility may be equipped with a sophisticated color correction system having as many as forty-eight different controls, each of which has a different effect on the image. The vec-

torscope is the only precise indication of exactly how the color is being manipulated.

A cinematographer who opts for the electronic manipulation of color during production (rather than controlling color through lighting and filters) will probably want to refer to a vectorscope on the set.

A few examples of a vectorscope display will suffice to demonstrate how hue and saturation are represented. The screen of the vectorscope has markings on it indicating the proper positions of the magenta, red,

7.2
Graph showing hue, saturation, and brightness relationships

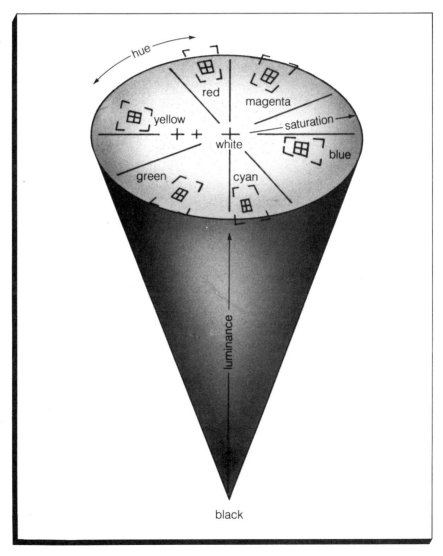

yellow, green, cyan, and blue hues and saturation levels of a standard color bar signal. (See 7.3.) The distance from the center of the circle to each of these points represents correct saturation for a standard color bar signal. The reference point for specifying the degrees for each hue is at three o'clock on the screen, and the calibration goes counterclockwise. Magenta is at 61 degrees, red at 104, yellow at 167, green at 241, cyan at 284, and blue at 347.

A black-and-white image would register on the vectorscope simply as a bright dot in the center, since there is no hue or saturation to be measured. A monochromatic image such as a pure sepia image would appear as a bright dot in one area of the circle. If it is sepia, it would probably be in the vicinity of 120 degrees, and its distance from the center would reflect how saturated the tone is. A full color image will have a variety of streaks or spots on the vectorscope, and it is a simple matter to relate them to the portions of the image that they represent.

In addition to the picture information, the vectorscope displays a representation of the color burst signal. This appears on the vectorscope as a short horizontal line at 180 degrees. **Color burst** is nine cycles of the

7.3
Vectorscope screen markings

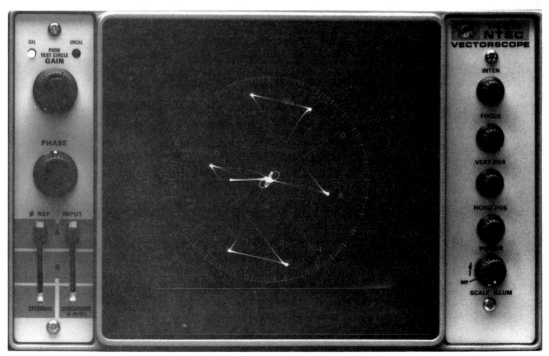

color subcarrier (the superimposed signal carrying all the color information), which is outside the picture area and enables a receiver to lock into the proper interpretation of the chrominance signal. It is color burst, for example, that tells home receivers that they are seeing a color broadcast rather than a black-and-white one. While the cinematographer rarely needs to be concerned with color burst, it may be useful to be able to distinguish it from picture information on a vectorscope or waveform monitor. (See 7.4.)

The important thing to bear in mind about color in a video image is that it can be processed separately from the luminance information. One repercussion of this is that certain kinds of manipulation of the luminance signal can have detrimental effects on color rendition. For example, black stretch is an adjustment that affects only the luminance signal without altering the chrominance signal; it is a lowering of gamma in the shadow areas of the image only and is designed to "flatten" the image and bring out shadow detail. If the gamma of a portion of the luminance

7.4
Color burst on
vectorscope

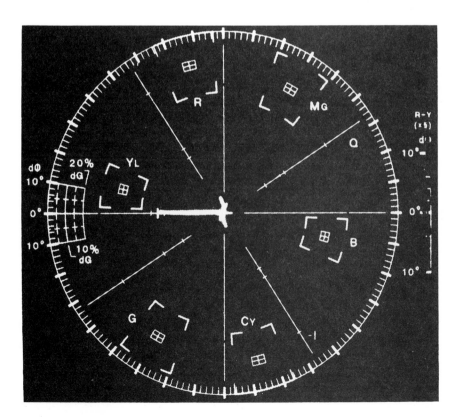

signal is adjusted without a corresponding alteration in the chrominance signal, the net result on a picture monitor will be an alteration in the saturation of color in that portion of the image; that is, the color will appear less saturated in shadow areas than it does in middle or highlight areas. For this reason black stretch should be used sparingly.

Gamma correction circuits, on the other hand, alter the gamma of the red, green, and blue signals before the luminance and chrominance signals are derived from them. Provided the gammas for the three color signals are matched, adjusting the gamma will not have a detrimental effect on color rendition.

If the gammas are not adequately matched, a hue will shift as it moves from a shadow area to a highlight area; that is, the hue of an object will vary according to its exposure. White-balancing a camera, which will be discussed in Chapter 9, requires matching the gammas of the three signals as well as their white and black levels. One of the critical factors in making a gray scale to be used with a video camera is ensuring that the various grays are uniformly neutral, since the camera must be color balanced for every exposure level. If a camera is color balanced to reproduce correctly a neutral gray at every level of exposure, it is said to be "tracking colors" correctly.

With film the color balance is part of the design of the emulsion and cannot really be altered by the cinematographer except with filters, but with video color balance is a concern each time a camera is used.

COLOR FIDELITY IN VIDEO

The fidelity of color reproduction in video is a function of several factors, including the type of phosphor used in the picture tube, the spectral sensitivity of the pickup tube, the color temperature of the illumination for the scene, the spectral characteristics of the filters in the camera, and the way in which the signals from the pickup tubes are manipulated.

Basically the problems of color fidelity in video are the same as those of any color reproduction system that attempts to create the impression of a full spectrum by means of only three distinct colors or wavelengths. There is a limit to how accurately a video camera can reproduce colors, just as there is a limit to how faithfully film can reproduce colors. There is no simple way to catalog the hues that video may have trouble reproducing accurately (although the errors can be plotted mathematically

on a "uniform chromaticity color triangle"). If color rendition is a critical factor in a production, it would be wise to shoot tests experimenting with different illumination and/or filters. For most cases, however, the key to faithful color reproduction is proper color balance and color tracking in the camera.

ELECTRONIC COLOR MANIPULATION

Although controlling color in a video image is best achieved by means of the same lighting and filtering techniques used with film, it should be pointed out that electronic manipulation of color offers a degree of flexibility that is unattainable with film. A sophisticated color correction system can alter the hue and saturation of any one of six color components in an image (red, green, blue, yellow, cyan, and magenta) without affecting that of the other colors and without altering the white balance.

These systems were originally designed for color correction in film-to-tape transfers, but it is possible to apply the same kinds of color correction to a tape-to-tape transfer; and it is conceivable that it could be applied to a live signal before it is recorded.

One example of what can be done with such a system involves film footage of a sailboat on an overcast day. The producers had wanted a clear day with blue sky and water. What they had on film was gray sky and water. Electronic color correction in a film-to-tape transfer process made it possible to enhance the blue of the sky and water without affecting the white of the sail or any of the red, green, yellow, cyan, or magenta tones in the image.

Electronic techniques for achieving certain overall color effects such as tinting during production will be discussed in Chapter 9 after we have discussed white balance. For the most part, however, the simplest way to achieve color effects in video is through the use of filters on the camera or the lights, since the effect is absolutely repeatable, whereas an electronic adjustment may not be.

To manipulate the color in a scene uniformly, put a filter on the camera. To mix colors in the scene, put filters on some of the lights. For instance, it is usually helpful to put a warm gel on the hair light for a brunette since the rim of light around the hair tends to go blue otherwise.

It is possible for an experienced cinematographer to achieve much subtler color effects through lighting and camera filters than can generally be achieved electronically. Although equipment is constantly improving, it is still true with video as it is with film that the best results will be obtained by achieving color effects in production rather than postproduction.

Color correction of a recorded video image requires that the image be decoded, and this will introduce noise into the image. Recording a component signal rather than a composite signal would alleviate this problem, and one of the great advantages of the adoption of component recording in production would be the increased flexibility of color manipulation in postproduction.

Camera Setup

Back Focus and Registration

Registration is a craft necessary to image control. Not every cinematographer need be able to personally register a camera, but familiarity with camera registration techniques will enable a cinematographer to evaluate the camera's imaging performance knowledgeably.

Setting up a video camera and monitor is a routine procedure that any cinematographer or camera assistant should be able to do. While it may be more efficient to have the video engineer set up the camera at the beginning of the day—and the engineer should certainly check it out thoroughly before you start shooting—nonetheless the cinematographer or the camera assistant can perform the routine setup if necessary. Most sophisticated cameras now have microprocessors that do most of the work automatically.

Whether you do it regularly or not, knowing how to set up a camera enables you to evaluate better the image quality produced by a video camera.

It is customary to do camera setup first thing each day, and it is advisable to repeat it first thing after lunch as well. It is also possible to check camera setup after each "printed" take if the production quality level justifies this much attention to picture quality. This may strike fear into the heart of production managers and assistant directors who still associate video cameras with extended periods of costly downtime devoted to the elimination of some glitch in the image. The fact of the matter, though, is that with a little teamwork and discipline it is possible for the camera assistant and video engineer to routinely check the setup parameters on the camera in 30 seconds after each good take. Nobody even has to know it is being done. By the time the director has called for the next setup, a video camera can be checked in the same way an assistant routinely checks the gate in a film camera. Once video cameras are commonly used on major quality productions, this will become standard practice.

Three basic parameters need to be checked: back focus, registration, and color balance. If the assistant and the video engineer develop an efficient routine, it really is possible to run a check on these three parameters in less than a minute without causing any disruption or anxiety on the set. In fact the assistant director may even find it reassuring to see the crew routinely checking the camera after every good take.

Once you understand the basic construction and operating principles of a video camera, it is easy to grasp the logic behind the camera setup procedures. There is nothing mysterious about camera setup; and, provided you follow the Golden Rule, there is no way that you can damage a camera. The Golden Rule is:

Don't mess with the green tube!

THE GREEN TUBE

The green tube is the most critical of the three tubes and is the reference to which the red and blue tubes are set. This is because the majority of the information for the luminance signal (59 percent) comes from the green tube. As a result the camera is designed so that the optical path from the lens to the green tube is the most direct, and the position of the green tube is set by the factory or by the maintenance engineers. What the camera considers to be vertical and horizontal is a function of the alignment of the green tube. If there is a discrepancy between the green tube and the red or blue tube, it is the red or blue tube that must be adjusted.

Just think of the green tube as your bratty older brother—or as a producer. He's always right, and you can never change the way he sees things. Others have to accommodate themselves to his views.

BACK FOCUS

Back focus is the first parameter to be checked or adjusted in setting up a camera, since an adjustment in back focus will alter the registration. There is little point in going through the registration process if you are going to turn around and adjust back focus, thereby undoing what you have just done. Besides, registration is much more difficult if all three images are not completely sharp.

Back focus or back focal distance is the distance from the vertex of the rearmost element of the lens to the focal plane. It is related to, but not identical with, flange depth or flange focal distance, the distance from the rear of the lens-mounting flange to the focal plane. Interchangeable lenses for a given camera must all have the same flange depth, but the back focal distance will vary with the focal length and design of the lens. Adjusting back focus is a matter of moving either the focal plane of the lens or the surface with which the focal plane is supposed to coincide.

There are two means for adjusting back focus: an adjustment on the lens and an adjustment on the pickup tube mount. Not all lenses have a back focus adjustment on them.

The back focus adjustment on a video lens generally has a set screw that can be loosened with the fingers and used to adjust the distance between the mount and the rear element of the lens. Basically the set screw is loosened and an adjustment is made until the image on the green tube is as sharp as possible. Then the set screw is tightened.

Film lenses as a rule do not need such a back focus adjustment built into them. Back focus on a film camera is adjusted by means of shims on the lens or by an adjustment of the mount on the camera. The lens housing and the lens mount on the camera are machined to exacting tolerances, and there is not going to be any significant variation in the flange depth of a film camera. The flange depth can be measured very accurately with a mechanical depth gauge, and it is an absolute parameter (± 0.0004 inch or one-fourth the diameter of a human hair) to which interchangeable lenses must be matched. This means that lenses can be checked and adjusted on a bench with the aid of a lens collimator before they are mounted on the camera. A lens collimator is an optical device used to accurately set the infinity point or back focal distance of a lens.

With a video camera the flange depth cannot be measured in the same way, because there is a prism block between the lens mount and the tube faceplate. Moreover, pickup tubes expand and contract with temperature variations (including those caused by the heat from their own internal filaments), so the flange depth is never a constant on a video camera. It would be theoretically possible to design pickup tubes so that they had a steel mounting plate near the faceplate and expanded or contracted to the rear of the faceplate. This would make possible a constant flange depth, but it has not been considered a priority in video camera design. Perhaps with the advent of high definition television the importance of a constant flange depth will be reevaluated.

Because a pickup tube is a glass bottle that changes size, it is mounted in rubber. The mounting is designed to permit adjustment in the position of the tube relative to the lens. While this makes possible the adjustment of back focus and rotation, it also ensures that such adjustments must be made. As Murphy points out, "Anything that can be adjusted will get out of adjustment."

Given the dimensional instability of a pickup tube and the way in which tubes are mounted in the camera, lens designers wisely concluded that a video lens should ideally have a back focus adjustment on it that was accessible and simple to use. The design motto in video seems to be "If you can't make it precise, make it adjustable." Moving the back focus adjustment causes the optics of the lens to move slightly away from or toward the camera. This obviously affects the focus on all three

tube faceplates simultaneously. Since the tubes can each be out of focus to a different extent, the back focus adjustment on the lens is used to adjust focus purely on the green tube (which, as you hopefully recall, must not be moved in its mounting by anyone except the maintenance engineer). Once the back focus for the green tube is set with the adjustment on the lens, the positions of the red and blue tubes are adjusted to bring the image into sharpest possible focus.

The Panacam, which was designed to accept Panavision 35mm film lenses, has the back focus adjustment in its optical relay system. Since it uses film lenses that do not have a back focus adjustment, and since an optical relay system had to be incorporated for several reasons, it made sense to include the back focus adjustment in the relay system.

Back focus should be set with the lens wide open and at its widest angle (assuming it is a zoom). Opening the lens to its widest aperture produces the minimum depth of field and permits the most critical check of the focus. The test chart or object being imaged should be as far away from the camera as possible, so that the focusing ring can be set at infinity. The ideal object is a distant building miles away, but still showing fine detail. Try to have fine detail of some sort near the edges of the frame as well as in the center so that focus can be checked across the entire field.

First set the focus in the telephoto position using the back focus adjustment on the lens while looking at the green image on a black-and-white monitor. Once focus has been set at the telephoto position, the lens should be zoomed to its extreme wide-angle position. Focus is checked again here. If any adjustment is required for this position, then focus must be checked again at the telephoto position. It is best to start with the wide angle since an image may be sharp at a telephoto position and go soft as the lens zooms back to a wide angle if the flange depth is incorrect. It is also wise to check the lens footage calibrations against actual measured focus distances, as the camera assistant may need these for focusing.

Adjusting the positions of the red and blue tubes is also a simple manual adjustment. There is generally a locking screw and a separate back-focus-adjusting screw. The tube and yoke mount actually has two screw adjustments: one for focus, which moves the tube back and forth, and another for rotation, which rotates the tube to facilitate registration of the images from the three tubes. (See the next section.)

There is only one thing to be careful about in adjusting focus on a tube. Make sure that you release the locking screw completely and that you do not overtighten it after you are finished. You may be tempted to

leave the set screw partially engaged in order to keep friction on the tube to minimize backlash while adjusting its position. This is not really necessary and can damage the tube mount, which is a precision-machined device that can be easily damaged with excessive force.

Focusing can be accomplished by means of a black-and-white picture monitor displaying only the signal from the tube on which focus is being checked. A large enough monitor (at least 9 inches) should be used so that fine detail can be seen clearly, and the adjustment is made until the image on the monitor seems to be as sharp as possible. The viewing eyepiece on ENG-type cameras (a 1.5-inch CRT) is not critical enough for professional applications except as a last resort.

Another precise way of evaluating focus is with a waveform monitor. This method works best with a test chart, but it could conceivably be useful with other images. A waveform monitor can be set to display only a portion of one scan line or a portion of a frame. The magnification switch enables you essentially to enlarge a portion of the display and observe it more closely. If the image is one involving a line pattern, the more sharply focused the image is, the more clearly defined and vertical will be the edges of the relevant section of the waveform. It is possible to see the waveform change as the back focus is adjusted, and the optimum position can be precisely determined in this manner, but it is a method that takes considerable practice to be useful. (See 8.1.)

The most precise way of all to set back focus is with a back focus collimator. Two back focus collimators for video cameras are currently available. One made by Mitchell Camera Company projects an image onto the faceplate of the tube, which is then inspected by eye through the collimator's viewing system. The image being projected corresponds to an image at infinity, so the back focus adjustment can be made on a bench.

This collimator is limited by the fact that it must project onto the tube an image that is bright enough to reflect and be clearly visible. This is particularly difficult in the case of Saticon tubes, which have a black photoconductive material on the face of the tube. It is possible that the image projected by this type of collimator would have to be so bright that there would be a risk of burning the tube.

The other collimator is one designed by Harry Mathias and Al Meyer for use with the Panacam. The Panacam is designed for Panavision film lenses, which are, of course, manufactured to exacting tolerances and are meant to be seated with the aid of a lens collimator. In order to ensure interchangeability of lenses on the Panacam, Panavision has produced a

small battery-powered collimator that mounts on the camera just as a lens does and projects a test image onto the face of the tubes (via the relay optics and the beam-splitter prism).

Instead of evaluating the focus of this test image by eye, the camera assistant or technician uses a waveform monitor to examine the sharpness of the edges in the image. (See 8.1.) As a result the image does not need to be bright enough to be clearly visible to the eye but only bright enough to generate a clean signal. There is no danger of burning the tube, and the use of the waveform monitor with this precision-focusing reticle permits a degree of accuracy and repeatability that is unattainable with the eye.

8.1
Magnified display on waveform monitor for checking back focus

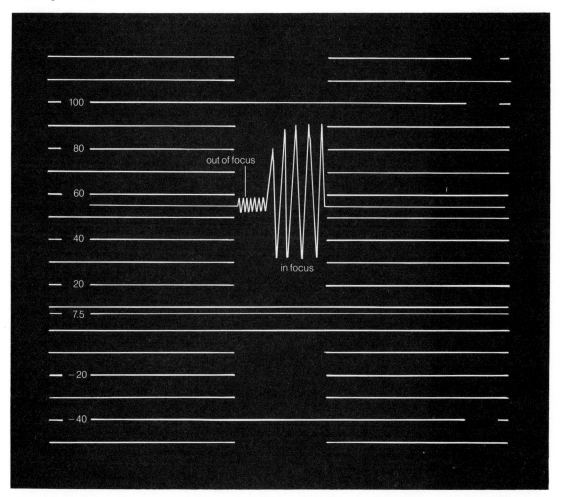

While adjusting back focus requires a certain amount of time, it is possible to check back focus quite quickly. Simply switch a picture monitor to the green, red, and blue signals in turn, and check the image of the test chart (or any fine detail) at first the telephoto and then the wide-angle positions with the lens wide open and set at infinity. When shooting in a studio, it may be feasible to have a test chart off to the side with a minimal amount of light on it so that the camera can simply pan over to it for a quick check between setups. Otherwise simply use an element in the scene as far away as possible.

REGISTRATION

Registration is the process of ensuring that the images from the red, green, and blue tubes are exactly superimposed when the signal is composited. If they are not accurately registered, color fringes will appear around objects being photographed.

The necessity for registration adjustments is easy enough to grasp once you realize the parameters of the scanning patterns that must be exactly matched. Each $\frac{2}{3}$-inch tube has an electron beam scanning an area that is 8.8×6.6mm at a rate such that the time devoted to each line is $\frac{1}{15,750}$ of a second (and a discrepancy of 0.0000002 second represents one TV line of horizontal resolution). Consider the fact that the starting and ending position for each of those scan lines must correspond exactly and that not only must the total time devoted to each line be constant but also the speed with which the beam moves during the scan must be constant. If, for example, a scan line in the red and green tubes starts and ends at exactly the same point, but one accelerates and decelerates while the other moves at a perfectly constant speed, then there will be discrepancies toward the middle of the scan line. Add to this the dimensional instability due to temperature variations causing the pickup tube to expand and contract, and then consider the effect of variations in the optical paths to each of the three tubes.

Contemplating all the ways in which the scanning parameters in each tube can differ from those in the others may induce dizziness, but it can also help clarify the need for registration controls. Fortunately almost any errors introduced by electronic variations can be corrected by more electronic variations. Any of these discrepancies will show up as some form of geometric distortion of one image relative to another.

The image against which all parameters are judged is the green image, and—you guessed it—you do not attempt to alter anything about the green image. If the green image appears to be distorted, you send the camera back to the shop.

BASIC PROCEDURES

Assuming that the green image is sufficiently undistorted, registration of the other two images relative to it is accomplished by superimposing the green image and each of the others in turn on the picture monitor and adjusting five or more controls until the images coincide. This is most easily accomplished with a registration chart designed specifically for the process, but it can be done with any image involving a fair number of straight lines and right angles. The picture monitor should be set on overscan so that it displays the edge areas of the image that are normally cropped on a receiver.

In order to simplify the comparison between the green and the red or blue image, it is possible to flip a switch on the camera control unit to display a negative version of the green image or what is termed a minus green signal. If a line is black on the blue image and white on the green image, any registration problem causing the two not to coincide will show up immediately as a kind of "drop shadow" effect on the monitor. If the two lines are both white, the only way to judge registration is by evaluating the thickness of the line. With one line white and the other black it is immediately apparent when there is a discrepancy, and it is also obvious which image is which. With two images of the same polarity a thick vertical line will not tell you whether to move the blue image to the right or to the left, but a shadow effect to the right of a white line in the blue image tells you to move the blue image to the right (see 8.2).

There are five kinds of registration adjustments that it is feasible for a camera assistant to make on a routine basis: centering, rotation, skew, size, and linearity. On most cameras rotation is a physical adjustment of the pickup tube mounting that can affect the back focus setting. In other cameras rotation can be adjusted electronically. The other adjustments are all electronic.

One note of caution: With many cameras where circuit boards must be exposed in order to access registration controls, it is advisable to use a plastic screwdriver rather than a metal one to reduce the risk of inad-

8.2
Drop shadow effect
of minus green and
out-of-register blue
test image

vertently shorting out circuits with the screwdriver. Actually the ideal screwdriver is a plastic one with a metal tip, since a plastic tip can often wear out the plastic slot on the adjustment screw faster than a metal tip would.

Perhaps the best way to approach registration is to view it as a video game, the point of which is to get two images to coincide by manipulating a variety of parameters for one until it exactly matches the other. As with any good video game, a move made with one control can have repercussions for a parameter adjusted by another control. Some skilled players can play using two screwdrivers simultaneously, but others prefer the more mundane single-screwdriver technique. The more you play, the more efficient you can become at it; and some people are naturally more attuned to it than others. One dolly grip, who was fascinated by the registration process, became quite adept at it without knowing any of the technical jargon used to describe what he was doing, much less any of the theory about why it needed to be done.

Centering

Centering is the first adjustment that should be made since it is much more difficult to evaluate the need for other adjustments until the image in question is centered relative to the green image. There are two controls for centering—horizontal and vertical. Each of these controls moves the entire image left and right or up and down. The point is simply to make the center of the blue (or red) image coincide with the center of the green image—hence the name *centering!* (See 8.3.)

Once the centers coincide, it is then possible to see whether additional adjustments are necessary. Centering is the easiest step. The process gets more challenging as you proceed.

Rotation

An adjustment in rotation uniformly rotates the entire image clockwise or counterclockwise around the center just as you would expect it to do. This adjustment can be judged simply by comparing the horizontal lines. If the image is centered and the horizontal lines running through the center do not coincide all the way across the image, then a rotation adjustment is required (see 8.4).

Judge rotation purely by reference to the horizontal lines and not by the vertical lines, since the skew adjustment only affects vertical lines.

It is wise to make any necessary rotation adjustment immediately after the images are centered and before proceeding with other registration adjustments. This is particularly true in cases where a rotation adjustment requires a physical rotation of the pickup tube in its mount. Moving the tube may throw off back focus and require a return to square one, so you might as well go through all this before you devote time to fine tuning the electronic adjustments.

Skew

An adjustment of rotation should make all the horizontal lines parallel to each other even if they are not all superimposed. If the vertical lines are still not parallel to each other, then an adjustment in skew is required. Skew will change a parallelogram into a rectangle. (See 8.5.)

Neither rotation nor skew will throw off centering, since in both cases the adjustments are all relative to a fixed center.

8.3
Image in need of hor-
izontal centering: (a)
incorrect registration;
(b) correct registration

(a)

(b)

8.4
Test image in need of
rotation

8.5
Image in need of
skew adjustment

8.6
Image with
keystoning

8.7
Image with horizontal
size problem

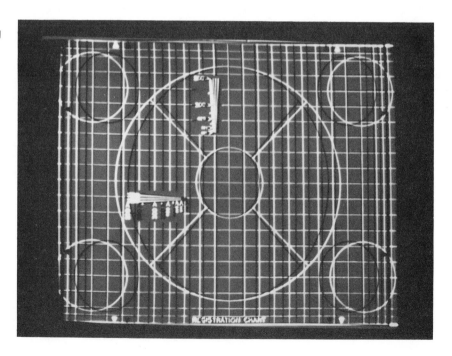

Note that skew cannot convert a trapezoid into a rectangle. This bit of magic is performed by a "keystoning" control that is generally reserved for advanced players and maintenance personnel. (See 8.6.)

Size

Size can be adjusted horizontally or vertically. If the image is centered, but the right and left sides do not both coincide with the sides of the green image, an adjustment in horizontal size is required. Turning the adjustment will cause the horizontal dimension of the image to expand or shrink without moving the center. (See 8.7.)

The vertical size adjustment does the same thing vertically. If the top and bottom of the image do not coincide with the top and bottom of the green image, an adjustment in vertical size will help. (See 8.8.)

Vertical size is sometimes called height, and horizontal size is sometimes called width.

Note that the size adjustment will move each opposite edge an equal amount. If the edges do not coincide with the edges of the green image and one is farther off than its opposite, or if one edge coincides but the

8.8
Image with vertical
size problem

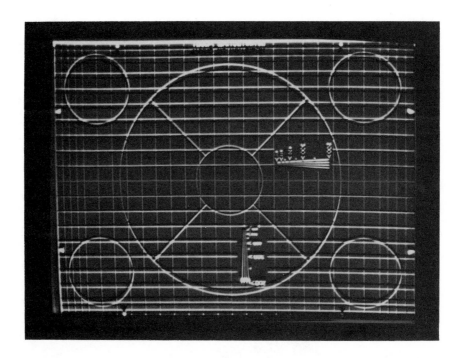

8.9
Images with
linearity problems:
(a) vertical linearity;
(b) horizontal linearity

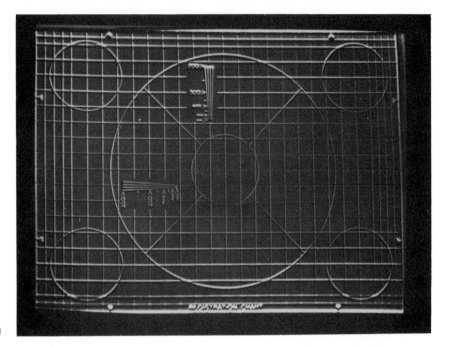

(a)

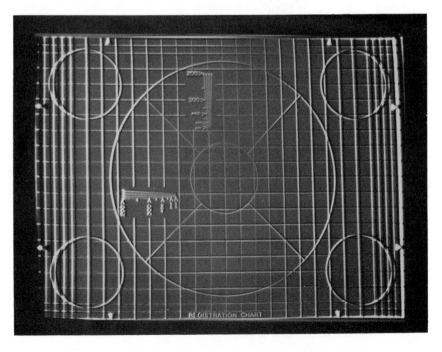

(b)

other does not, then a size adjustment alone will not suffice to completely correct the problem. A linearity adjustment is needed as well.

Linearity

Linearity can be adjusted vertically and horizontally. The circles in a test chart are a great help in evaluating linearity. If any of them is an oval instead of a circle, there is a linearity problem. (See 8.9.)

Linearity can be thought of as stretching or shrinking a line from one end or the other rather than from the middle. Linearity, centering, and size are interactive in that adjusting linearity will alter size and centering. It is best to start with centering, then go to size, and then adjust linearity. Adjusting linearity and then recentering will quickly reveal whether an additional correction in size is necessary.

This is obviously the point at which the game begins to be fun (or frustrating depending on your mental outlook). Experience will help in estimating on the first pass how much of a linearity adjustment is required, and a dual-screwdriver approach may or may not be helpful depending on your eye/hand coordination.

Centering, rotation, skew, size, and linearity are generally the only adjustments that can be made easily by the camera assistant without advanced training. They are also adjustments that can often be made automatically by a microprocessor in the camera control unit. In the case of the Panacam, centering and size are constantly monitored and adjusted during shooting. The camera control unit has a microprocessor that samples and compares detail contours between the three colors systematically and gradually adjusts centering or size. The EC-35 automatically performs all these phases of registration with the help of a special test chart and the camera control unit during setup. In both cases it is possible to override this automatic registration and fine-tune the camera manually if you prefer.

OTHER GEOMETRIC DISTORTIONS

In addition to these basic registration parameters there are four other parameters that can be adjusted. Keystoning has already been mentioned. Bowing and pincushioning adjustments correct for distortions in which straight lines are curved. (See 8.10 and 8.11.) Finally, start linearity is an even more esoteric adjustment that affects only the initial por-

8.10
Image showing
bowing

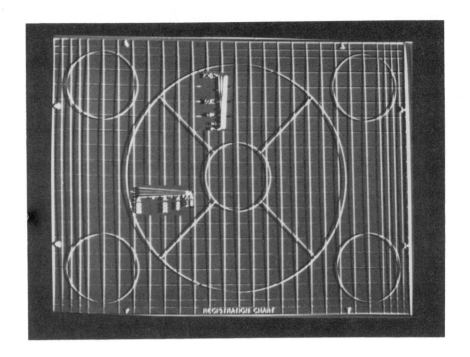

8.11
Image showing pin-
cushioning

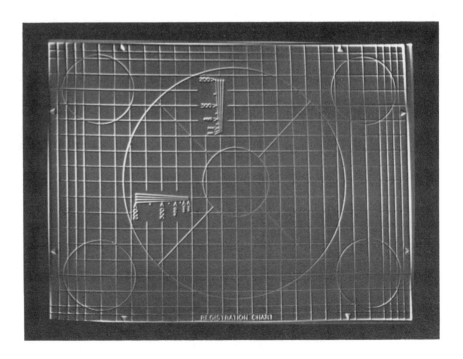

tion of the scan lines or the field. Start linearity corrects for distortions due to beam inertia at the beginning of its sweep.

Not all cameras have these controls, and they generally require a good bit of experience to be used effectively. Using them incorrectly cannot do any permanent damage to the camera, but it can complicate the registration process and make it difficult to get a perfectly registered image.

Some of the adjustments, such as pincushioning, theoretically make it possible to correct electronically defects that are really caused by inferior lens design. Similarly, adjustments for back focus can compensate for chromatic aberrations and other distortions caused by compromises in the lens design that do not allow the red, green, and blue images to focus in the same plane. Some computerized cameras even have registration controls hooked up to the zoom mechanism for the lens so that compensations can be made for variations in lens performance as the focal length changes. Electronic compensations of this sort, however, cannot replace good lens design. Even if some improvement in lens performance is possible with the manipulation of these controls, this improvement is gained at the expense of lens interchangeability.

SHADING

Another camera adjustment that is generally best left to an engineer or maintenance person is shading, in the sense of a systematic brightness variation across the image from left to right or top to bottom. The term *shading* is also used loosely to refer to the general manipulation of the gray scale of a video image—a creative adjustment in which every cinematographer should be involved. The more technical use of the term, however, refers to an adjustment designed to ensure consistent brightness levels throughout the image.

If the image of a perfectly even gray card appears darker at one edge than it does at the opposite edge, a shading adjustment is required. (See 8.12). This type of adjustment is often labeled by reference to the waveform of the signal that is added to the picture signal in order to correct it. If, for instance, the image is dark on one side and light on the other, then each scan line needs to be boosted at one end and not at the other. If a signal is generated that would accomplish this when it is added to the picture signal, it would resemble a saw with each tooth correspond-

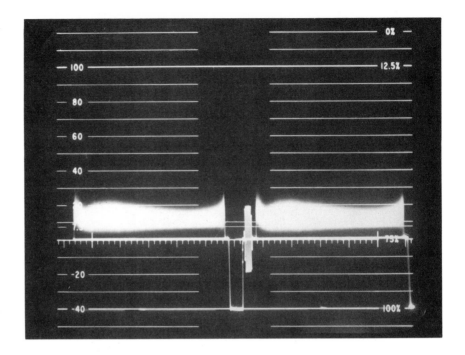

ing to one scan line. Such a signal is in fact called a sawtooth signal, and it is created by a sawtooth signal generator.

If the shading problem is a vertical one, for example, when the image is darker at the top than it is at the bottom, then the signal that must be added is a "vertical sawtooth" whose frequency corresponds to the 60 cycles per second of the field rate. A shading problem in which the center of the screen is different from both edges requires the addition of a parabolic waveform. It takes a high degree of experience to adjust these very subtle controls correctly.

Camera Setup

Levels and Color Balance

Color balance and the setting of camera levels are not only necessary to photographic quality control but they are also the point of departure for creative image manipulation. Visual craftsmanship dictates consistent image reproduction in most applications and deliberate departure from the norm when that is useful. When creative distortion is chosen for a scene, then consistency of this distortion is also vital.

With film, color balance is designed into the emulsion. Color balance will change from one piece of rawstock to another only to the extent that it is not possible to manufacture emulsions with absolute consistency. The cinematographer only needs to match the overall color balance of a scene to the color temperature for which the film is designed by means of filters or lighting. There is no way to tinker with the relative sensitivities of the red-, green-, and blue-sensitive layers of the emulsion, and any adjustments for inconsistency in the emulsion are generally made in printing the negative.

With video, of course, the cinematographer can change the gain of each color proc amp, thereby altering the color balance of the camera. Given Murphy's law, it is necessary to check and perhaps adjust color balance when setting up a video camera.

Color balancing is best accomplished with the aid of an evenly lit chip chart. Lighting on a registration chart is not all that critical, but lighting on a chip chart for evaluating gray scale reproduction must be a standard color temperature (either 3,200 K or a "daylight" corresponding to the predominant sky/sunlight mix of the scene being photographed). It is also useful if the light level is even all across the gray scale in order to avoid distortions in levels, but the need for absolute evenness of light on a chip chart is overstressed by many authorities. While it is convenient to have the chip chart resemble the pictures in a textbook, a uniform color temperature is far more critical than a uniform level in lighting a chip chart. Many cameras have been color balanced perfectly with one raking light source, and there is no need to waste precious time on a set lighting a chip chart to perfection.

Because a chip chart has two sets of chips running in opposite directions, any distortion in the gray scale due to uneven lighting will be immediately apparent. (See 9.1.) Moreover, in color-balancing the camera, one is not really concerned with the evenness of the gray scale. One assumes that the gray scale rendition in the green channel is appropriate and balances the levels of the red and blue channels relative to it.

The point of using a gray scale for color balance is to ensure that the camera is color tracking, or that the gammas of the red and blue channels match that of the green. All that is required is a reasonable sampling of tones between black and white in order to compare the levels of the red and blue channels to that of the green channel. Adjusting the gamma of the green channel in order to ensure that a gray scale is being reproduced as evenly as possible is a maintenance function that is best left to the engineers.

9.1
Waveforms of (a) un-
evenly and (b) evenly
lit chip charts

(a)

(b)

It is also better if the color temperature of the light is 3,200 K (that is, that of standard quartz lights) so that color balancing can be done without an 85 filter. While a camera may be color balanced with daylight using an 85 filter, the color temperature of daylight can vary so much that it might be necessary to rebalance the camera if it is set up in a different location or taken inside for use with artificial light.

SETTING BLACK LEVEL

The most important thing to remember in setting the black level for the green channel (or for any channel) is that the darkest chip on a chip chart does not represent complete black. The black chip represents a black piece of paper with light on it, not darkness, which is the true photographic black. On a standard EIA chip chart the darkest chip has a reflectance of 3 percent.

The easiest way to shoot absolute black is to cap the lens. The signal generated by a tube with the lens capped is the level that corresponds to complete black and is the level that should be set at 7.5 units on the waveform monitor.

Adjusting black level for the green channel is done by means of the pedestal adjustment on the control unit for the camera. Once black has been set at 7.5 by means of the pedestal adjustment it is possible to adjust black levels for the red and blue channels by means of the individual black level controls for these channels.

When the full RGB or composite signal is displayed on the waveform monitor, a discrepancy in black level for the red or blue channel relative to the green will show up as a widening of the line representing black on the waveform monitor. Adjusting the red and blue black levels until they correspond to the black level for the green channel will cause the line on the waveform monitor to become thinner. (See 9.2.) Adjusting black level for the red and blue channels is similar to focusing a lens on an image. As an adjustment is made the line gets thinner and thinner until the optimum point is passed and the line begins to get thicker.

SETTING WHITE LEVEL

In order to set the white level on the green channel simply take the cap off the lens and open up the aperture until the white chip on the chip

9.2
Waveforms showing
adjustment of black
levels: (a) poor; (b)
correct

(a)

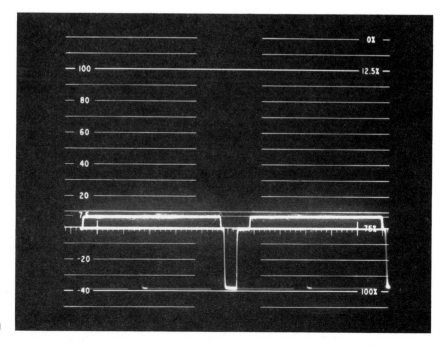

(b)

9.3
Poor white balance
and correct white
balance on a chip
chart

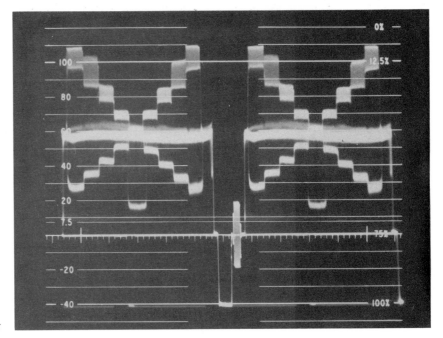

(a) poor

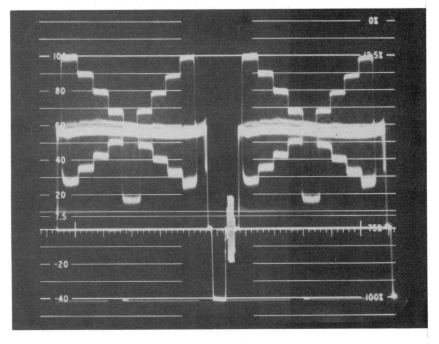

(b) correct

chart reads 100 on the waveform monitor. White levels for the red and blue channels can then be adjusted relative to the green channel by means of red and blue gain controls on the camera control unit. Again the levels can be evaluated by displaying the RGB or composite signal on the waveform monitor and observing the thickness of the line representing 100 units. (See 9.3).

RED AND BLUE GAMMA

Although color balance is generally referred to as **white balance,** it is not just the purity of white that must be balanced; it is essential that all of the grays between white and black be completely neutral as well. It is entirely possible for a camera to be balanced for black and peak white and still be out of balance in the midtones. This would result in a variation in color reproduction with exposure. The hue of an object would shift according to the amount of exposure it had.

An imbalance in the midtones shows up as thick lines on the waveform monitor for the midgray chips even when the black and white chips are represented by thin lines. (See 9.4). It is corrected by adjusting the individual gamma adjustments for the red and blue channels. Again it is simply a matter of turning knobs or screwdriver-adjusted controls until the lines in the midgray area are as thin as possible.

If an adjustment is made in the red or blue gamma, it may affect the white balance for the red or blue channel as well. If so, it is necessary to go back and adjust the red or blue white level.

The object is to adjust red and blue channel gamma and/or black level until all the lines on the waveform monitor representing the chips in a gray scale are as thin as possible. This ensures that gray will always be neutral at every exposure level, which is another way of saying that color rendition will be as faithful as possible at every exposure level.

FLARE COMPENSATION

Flare compensation or flare correction is a control that eliminates the effects of lens and optical block flare on the black levels. Adjusting flare compensation for the blue and red channels may enable you to match the black levels for the three channels even better than was possible

simply with the black level controls. As with all the other controls we have discussed, it is better to leave any adjustment in the green channel to the maintenance engineer. Flare "comp" is usually adjusted after the color balance is finished to adjust for blacks that may be "thin" when the lens is capped but "thicker" on the black chart chip because of optical flare. Adjust flare comp for the "thinnest" possible line on the black chips of the chart. (See 9.5).

It is important to realize that no circuit can compensate for photographic or lighting-induced lens flare. Flare comp cannot eliminate the effect that lens flare has on the appearance of a scene. It can, however, compensate for any color differential the flare may cause so that the flare has less effect on the color balance or tracking of the camera. Presumably flare comp would not be needed in video cameras if the optical beam splitters were not susceptible to internal reflections.

AUTOMATIC COLOR BALANCE

Most sophisticated video cameras have automatic white balance, and some also have automatic black balance. It is advisable periodically to

9.4
Poor gamma
balance

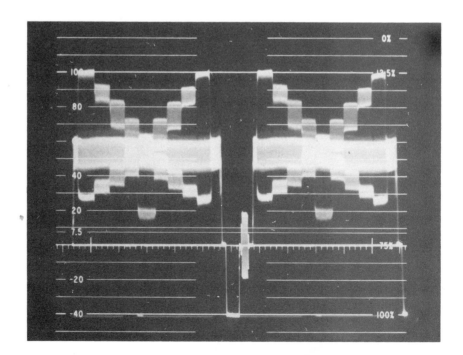

fine-tune the auto white balance circuits manually, but auto white balance is a simple procedure that can be executed in a matter of seconds and improves color reproduction.

Normally all that is required is a white surface. It can be an element in the scene or anything that is white. Essentially the camera is told that what it is seeing is white, and the microprocessor in the control unit automatically adjusts the red and blue gain controls until the signal corresponding to the white object is properly balanced. When the white balance control is released the circuits store this correction setting and maintain it until a new auto white balance is performed.

It is very important to note that no auto white circuit can correct the color tracking of a camera that is badly out of adjustment. Auto white can only balance a camera back to its best state of tune. It cannot fix a misadjusted camera.

CREATIVE COLOR BALANCING

It is possible to use the color-balancing procedure to create color-tinting effects. In order to see how this is possible one need only imagine what

9.5
Waveform showing the need for flare compensation

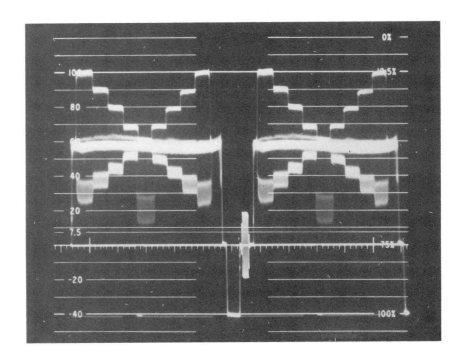

would happen if a camera were balanced on a blue card instead of a white card. The camera and the control unit are very trusting servants, and if you tell them that the camera is looking at something white, they will believe you even if the object is actually blue. Balancing on a blue card will cause that particular shade of blue to be reproduced on the screen as white, and it will throw off all the other colors by a proportional amount.

If the blue gain is adjusted in such a way that a blue card is reproduced as white, then the blue component in all of the other colors will be drastically reduced. What would normally be white will now be yellow (that is, red plus green), and what was magenta (red plus blue) will now be red. The net result is a yellowish cast to the entire scene. Similarly, performing a white balance using a yellow card will result in a bluish cast to the entire scene.

With some experimentation it is possible to determine what color card will result in the specific tinting effect desired for a particular scene. So long as the card is kept clean, it is possible to repeat the tinting effect accurately at any time during a production—even when the color temperature of the illumination for the scene varies. If, for instance, you want to give a series of exterior scenes a sepia tone, balancing the camera on a blue card may be an effective way to achieve it since the balancing process will compensate for any variation in the color temperature of the daylight.

In other instances, however, it may be easier to achieve consistent color effects through the use of filters in front of the lens. The camera is white balanced in the normal manner without the filter, and then the filter is added for the scene. It is always advisable to shoot something unfiltered at the head of the roll (preferably a chip chart) with the same lighting as will be used with the filter for the scene. This will help ensure that the color effect is not misinterpreted at some point in the postproduction process and balanced out of the scene to produce a "normal" picture.

COLOR BARS

Color bars, the familiar white, yellow, cyan, green, magenta, red, blue, and black vertical stripes so often seen at the head of a videotape, are an artificial signal generated in the camera and designed to facilitate adjustment of encoders. Color bars are routinely recorded at the head of every

roll of videotape used on a production so that the post-production equipment can be lined up appropriately to compensate for any errors in the adjustment of the camera's encoder that would otherwise result in color reproduction errors during the post-production process. Since color bars are electronically generated by the camera, they have nothing to do with exposure or color balance of a scene. Bars can be useful in matching the output of two cameras in a multi-camera setup, and they can be used to set up a color monitor.

SETTING UP A COLOR MONITOR

Although a monitor on the set is not always the best indication of what the recorded image looks like, it is often the only indication available of image sharpness or of a colorizing effect or of the effect of diffusion, nets, or star filters. If any use is made of a monitor during production, it is essential that it be set up as well as possible. Anyone who has ever fiddled with the controls on a conventional television receiver knows how weird the color reproduction can be if the set is not tuned properly. While it is unlikely that a crew on a set would tolerate purple faces as some viewers do at home, nonetheless a monitor on the set may be very misleading if it is even slightly off.

Setting up a monitor is a routine procedure that anyone can perform. To some extent it is a matter of taste, but there are some basic adjustments that must be done systematically first. Start with brightness, which is actually an adjustment in black level. Display color bars on the monitor and turn the color control on the monitor completely down so that the color bars are seen as a gray scale. (The color bar signal was conceived so that its luminance component is a reasonably even gray scale.) Adjust the brightness control until the black bar, which represents reference black or setup level of 7.5 IRE units, is completely black. The simplest way to judge this is by turning up the brightness level until the black bar is reasonably gray and then turning it back down again until the black bar just ceases to get any darker.

The second adjustment is contrast, which is used to set the white bar. If your bar generator produces a white bar at the 100 percent level (check on the waveform monitor), lower the contrast until the white bar is well into the gray and then turn it up just to the point where the white bar no longer gets any brighter. If the contrast is turned up too much, it will begin overloading the monitor power supply, resulting in a change

in image size of the picture display. The actual setting of the contrast will vary according to the ambient light falling on the monitor screen. If the white bar in the color bars generated by the camera is not at 100 percent on the waveform monitor (some may be at 77 percent), set contrast on the monitor using some element of the camera picture that is at 100 percent.

For more critical and repeatable adjustment of levels on a monitor use the Eastman monitor analyzer developed by Kodak for use in conjunction with a standard test film for setting up film-to-tape transfers. The monitor analyzer is essentially a test signal generator producing standard black and white reference signals and a light meter for measuring the brightness of a selected area of the screen. Other monitor analyzers are available, but they all require additional signal generators and are therefore too cumbersome and costly for field use.

Once the brightness and contrast have been set, the hue can be set by referring to the yellow and magenta bars (the second and fifth from the left). There is only one position where they will both appear the right color. The yellow should be a lemon yellow, not orange or green; and the magenta should not be red or purple.

If the monitor can be set to display only the blue component of the image, there is another method for setting the hue that some engineers prefer. Set the monitor on blue only and adjust the hue until the four bars containing blue are the same shade of blue. The four bars are the white, cyan, magenta, and blue (the first, third, fifth, and seventh from the left, respectively). The other bars should not appear at all when the monitor is set to display blue only. If they do appear, it means that the hue is out of phase, and the monitor is interpreting some other color as blue. This method of setting hue on a monitor is generally less convenient than the other. For one thing, not all monitors have a blue-only switch; and matching the shades of blue for the bars with blue in them is not all that easy. Finding the point where both yellow and magenta appear that proper color is much simpler and more universally used.

Adjusting the chroma level or saturation on a monitor is largely a matter of taste. A professional-quality monitor should have a preset position for chroma, a setting the adjustment knob will click in and out of; but with other monitors it is necessary to rely on your own eye to adjust the saturation level. The actual setting may vary according to the viewing conditions, but in no case does the way in which a monitor is set affect the look of the image being recorded.

Chroma levels for the recorded image are set by the encoder in the camera using the color bar signal generated by the camera. They are set

to a standard, and there is really no simple way to manipulate them electronically for creative purposes. Adjusting chroma levels in a camera is a maintenance function best left to engineers. There are ways to desaturate a video image through the use of filters.

No matter how well the monitor has been set up, it is not a reliable means for evaluating lighting and exposure. The apparent contrast of an image on a monitor screen is too dependent upon the ambient light in which the monitor is viewed, and tailoring the lighting or exposure to the monitor may result in a very different image being recorded.

Exposure

Exposure is a tool for visual expression in film and is also exactly that in video. Correct exposure in video should not be based on a mathematical concept or some vague technical idea of FCC "rules and regulations." Exposure is a creative, not a technical, adjustment; and it must be based on picture content. To surrender that control to an auto iris is to surrender your creative control to an electronic device.

As we have seen in the discussion of tone reproduction in Chapter 6, exposure is a critical factor in determining the look of an image. Aside from the fact that gross over- or underexposure will produce image defects, variations in exposure can alter the appearance of an object or the mood of a scene. Exposure is not a purely technical matter that can be left to an engineer. It is a key part of the creative process and must be controlled by the cinematographer.

GENERAL PRINCIPLES

The more limited the latitude of a photographic medium, the more critical the exposure—depending, of course, on the brightness range of the scene. Some cinematographers mistakenly assume that a wide latitude means that any scene can be under- or overexposed without harm. If the medium has a latitude of 8 stops and the scene has a total brightness range of only 3 stops, then it would indeed be possible to over- or underexpose the scene by 1 stop without distorting the tonal relationships in the image. The range of exposure values would still fall within the straight-line portion of the characteristic curve. (See 10.1.) On the other hand, if the scene has a brightness range of 8 stops, there is only one exposure that will not distort the tonal relationships. Over- or underexposing the scene will cause a loss of detail in either the highlights or the shadows, because the range of exposure values will extend beyond one end of the curve. (See 10.2.)

With the color negative films available for cinematography today the latitude is such that there is often a wide range of exposure levels that will yield excellent images. In addition, the loss of detail is fairly gradual at each end of the curve. As a result some cinematographers routinely give a high-speed color negative as much as 2 stops less exposure than other cinematographers might under the same conditions.

The relatively limited latitude of pickup tubes does not permit this kind of variation in exposure. With anything but the flattest scene, a 2-stop difference in exposure is sure to result in a considerable loss of detail or increase in noise.

Given the limitation in the contrast range or latitude of a video image, the traditional approach to exposure represents an attempt to make the greatest possible use of the available tonal range. As a result video engineers like to see blacks at 7.5 and whites at 100 IRE units no matter what the content or context of the scene.

A prime example of this attitude is a comment by G. Boris Townsend in his article on telecine in *The Focal Press Encyclopedia of Film and Television Techniques:*

> In photography it is now axiomatic that the most pleasing reproduction of a scene is obtained when the overall transfer characteristic is such that the brightness range of the reproduction process is used to the full, but only just to the full. That is to say, the reproduced brightness scale may be compressed or expanded with respect to the original scene, but the tone range of the receiver should be just fully utilized.

10.1
H&D curve for latitude of 8 stops and scene with 3-stop brightness range

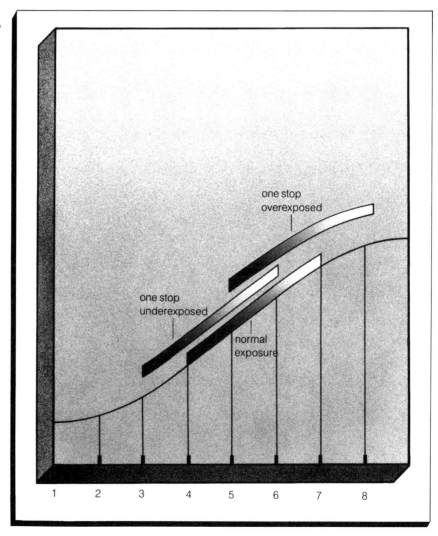

Moreover, the traditional video lighting texts all stress flat lighting for video, as do traditional video engineers who may have read them. The cinematographer will, of course, have a different perspective on the use of the available tonal range and the appropriateness of flat lighting. Scene content and context are the paramount considerations.

If the optimum exposure always resulted in a peak white level of 100 units, it would be a relatively simple matter to automate the exposure control so that neither the cinematographer nor the video engineer

10.2
H&D curve for latitude of 8 stops and scene with 8-stop brightness range

would ever have to be concerned with it. The problem with such an approach, of course, is that it totally ignores the content of the scene. Suppose you are shooting a scene with a skier going over a hill. The brightness range of such a scene will probably exceed the latitude of any photographic medium, so a compromise must be made in exposure. In a long shot you would set the exposure to hold detail in the snow-covered hill and let the skier be a silhouette, but for a close-up you would expose for an appropriate rendering of the skin tone and let the high-lights in the background burn out.

As was pointed out in the discussion of automatic exposure control in Chapter 2, no matter how sophisticated the automatic exposure control system is on a video camera, it can never understand the content and context of the scene being shot. Even a tone capture exposure control that keys the exposure to flesh tones in the scene cannot know the difference between a high-key scene and a somber dramatic scene in which faces are deliberately placed in shadow.

What is required is an accurate system for determining exposure that takes all the elements of the scene into consideration and specifies a setting for the iris that can be left constant throughout the shot. Such a system was developed for motion picture photography over 40 years ago, and there is no reason not to use it in video production. It has three ingredients: a light meter, a sensitivity rating for the film or camera, and the creative judgment of the cinematographer.

The first step in the process is to establish a direct relationship between incident illumination and f-stop that is independent of the reflectances of the objects composing the scene. The second step is the application of the judgment of the cinematographer in adjusting the exposure level or f-stop based on considerations of the content and context of the shot. The second step is possible only on the basis of the first, and it is the first step that is missing in the traditional approach to exposure in video.

The type of exposure meter most commonly used in cinematography measures incident light and has a scale that reads in f-stops. It is able to do this because it is designed to accept slides that alter the amount of light striking the photoelectric cell according to the ASA or Exposure Index of the film. There is a slide for each common film speed, and the whole system is conceived with the idea that the specified f-stop would cause a gray card with a reflectance of 18 percent to produce a mid-density on the negative. The point is always to set the f-stop so that the 18 percent gray card will be consistently reproduced as a mid-density on the negative regardless of how much light is falling on it.

Obviously such a system for determining exposure depends on a consistent method for rating the speed of the film. While there have been some revisions made in recent years regarding the method for measuring the speed of a particular film, on the whole the manufacturer's specified exposure index is a reliable basis for calculating exposure.

Video camera specifications generally include some kind of figures for the sensitivity of the camera, but there are no widely accepted standards for measuring the sensitivity of a video camera. Also, the specified sensitivity ratings apply to one camera of a given type that was tested and may not apply to the particular camera you are using. Just as with automobile EPA mileage ratings, you must expect the manufacturer to select an exceptional camera for their test specimen and test it under ideal conditions.

The sensitivity of a video camera is generally specified in terms of the amount of incident illumination required on a specified reflectance to produce a fully modulated video signal at a given f-stop, and it is tied to the signal-to-noise ratio specified for the camera. Just as there is a trade-off between speed and grain in a film emulsion, there is a trade-off between sensitivity and noise in a video camera.

A typical sensitivity rating for a video camera might be 200 fc of 3,200-K light on a 60 percent reflectance at $f/4$ with a signal-to-noise ratio of 58 decibels (dB). Such a rating assumes that the camera will be set up so that the 60 percent chip on the EIA nine-step chip chart (the "white" chip) will register at the peak white level and the crossover chip, which has a reflectance of 13.4 percent, will be at the midgray level. This would place an 18 percent reflectance about $1/3$ stop above the middle gray, but we can assume for now that this is a reasonable compromise given the limited latitude of video in comparison to film. It assumes that extreme highlight detail is more expendable than shadow detail.

There is a mathematical formula for the relationship between f-stop (or T-stop), ASA (or exposure index), and the incident illumination required to yield proper exposure: ASA = $(1{,}250 \times f \times f) \div I$, where f is the f-stop (or T-stop), I is the incident illumination in footcandles, and 1,250 is a constant. In this case the ASA equivalent would be $(1{,}250 \times 4 \times 4) \div 200$ or 100.

Not all camera sensitivity specifications are so easily translated into an ASA equivalent. Often the illumination is specified in lux rather than footcandles, so it is necesary to divide the illumination by 10.76 (1 lux = 10.76 fc). Some camera sensitivity specifications involve a 90 percent reflectance rather than a 60 percent reflectance, and some involve a

gamma setting of 1.0 rather than 0.45. Either of these factors can result in the impression of greater sensitivity, and converting them for comparison is a more complex matter. Obtaining a standard peak white signal with a 60 percent reflectance requires about a half stop more exposure than with a 90 percent reflectance, given the same camera and the same incident illumination.

There are also specifications involving gain boosts of up to 12 or 18 dB. Boosting the gain is the equivalent of forced development with film. It increases noise levels as well as sensitivity. What is even worse is that many specifications for camera sensitivity do not spell out all the factors, and there is no way to know what reflectance or gamma setting or gain boost is involved. Also, the manufacturer's specifications may not be sufficiently accurate for the particular camera with which you are working.

The practical solution to this problem is a simple procedure for rating the sensitivity of a video camera at the beginning of a shoot. It will enable the cinematographer to use an incident light meter exactly as it is used with film.

DETERMINING THE EXPOSURE INDEX OF A VIDEO CAMERA

When you are setting up a video camera at the beginning of a shoot, it is possible to establish an effective ASA rating or exposure index for the camera by means of a simple procedure that takes only a few minutes. First set up a chip chart and light it evenly just as you would for color-balancing the camera. Then focus the camera on the chart and open the iris until the crossover chip is at 55 units on the waveform monitor or the peak white chip is at 100. Normally you will have already done this in order to set levels.

Check the f-stop on the lens, and then take a reading with an incident meter at the chip chart. The photosphere on the meter should be pointed at the camera. Change the slide in the meter until the f-stop reading on the meter coincides with the f-stop at which the lens is set. Once you have found the slide that results in the closest approximation to the f-stop on the lens, you have determined the effective exposure index of the camera. You need only keep that slide in the meter and use it as you would with film.

This method of setting up the meter to coincide with the camera has the added advantage of compensating for any light loss due to the camera optics. It is the equivalent of establishing *T*-stops for the lens, since what you are doing is matching the meter to the amount of light that is actually reaching the pickup tubes. The *f*-stop on the lens then becomes an accurate indication both of exposure and of depth of field.

It is possible, of course, that none of the slides for the meter will result in a reading that exactly matches the *f*-stop on the lens. In this case simply use the slide that produces the closest approximation and make the necessary adjustment when setting light levels or the *f*-stop for each shot. If the slide results in a reading that is a half stop above the *f*-stop on the lens during camera setup, then subtract a half stop consistently from readings during the production.

The exposure index determined in this manner may not be a scientific measure of the camera's sensitivity, but it is a reliable, practical basis for setting the *f*-stop during production. It enables you to expose every scene so that midtones will be consistently reproduced or to adjust the exposure so that the reproduction of the midtones will be altered in a controllable manner.

It may be helpful to review how using an exposure index of this sort differs from setting exposure simply by means of the waveform monitor. A waveform monitor is like a reflected light reading. It can tell you how to expose a scene so that as much as possible of it can be encompassed by the latitude of the camera, but it cannot easily ensure that a given object will be reproduced with consistency.

Normally a waveform monitor is used by a video engineer to set an *f*-stop that will place the brightest object in the scene at peak white in the signal. If the engineer knows that the brightest object is something like a window where detail is not important, he or she may adjust the exposure and let the brightest area exceed the normal peak white level in order to bring out more detail in the shadow areas; but nothing on the waveform monitor indicates how much to adjust the exposure. Similarly, there is no guarantee that the brightest object in a given scene should necessarily be at peak white. Depending on the content of the scene, the brightest object may be a skin tone or some other object that really looks better at a much lower level.

The waveform monitor also cannot easily ensure that an object will be reproduced consistently from one shot to the next. Consider as an example a scene involving two different angles in a room that has dark paneling on the walls and is filled with dark furniture. One angle in-

cludes a white marble bust of Napoleon next to the bookcase. The other angle does not include the bust but includes a table and part of a wall visible in the first. Suppose that the brightest area in the second angle is a portion of the polished tabletop that is reflecting light from an off-screen window. The same tabletop is visible in the first angle, but it would obviously not be as bright as the white marble bust.

If the *f*-stop for each angle were set so that the brightest area was at peak white, then the paneled wall would appear much darker in the first angle than in the second. This might be all right for each shot out of context, but if the two are cut together in one scene the result would be distracting and confusing. The solution is obviously to set the exposure so that the tabletop or the wall is more or less at the same exposure level in both angles. Accomplishing this without an incident light meter would require analyzing the display on the waveform monitor in order to determine which portion of the signal represented the wall or the tabletop and matching that level for both shots. While this may be possible, it is not very practical, especially since using an incident light meter will give identical results.

With an incident light meter it is only necessary to take a reading with the photosphere pointed at the camera for each angle and set the *f*-stop according to the meter. In many situations it may be useful to refer to the waveform monitor after setting the *f*-stop. If the scene has an extended brightness range, it may be useful to check the waveform monitor to see how well the range of the scene is being captured. Adjusting the exposure level may be one way of altering the tone reproduction for that scene in order to deal with the extended brightness range. The use of gamma compression circuits on the camera (if it is so equipped) may be another.

THE WAVEFORM MONITOR

While an experienced cinematographer might be able to obtain good results by using only an incident light meter to determine exposure for a video camera, there is no reason to abandon the waveform monitor. Good exposure practice really requires the use of both the incident meter and the waveform monitor, and a cinematographer may want to own a waveform monitor as well as a light meter.

The waveform monitor is an invaluable tool on the set. Once you

know how to read it, the waveform monitor tells you most of what you would want a picture monitor to tell you if it were reliable; and it tells it to you with absolute precision. It is the equivalent of having a laboratory analysis of your negative before you shoot.

It is important to know that every 20 units on the waveform scale represents a difference of 1 stop or a doubling of the brightness (assuming the camera is set on a normal gamma of 0.45). The display on the waveform monitor is a graphic representation of all of the tonal relationships in the scene you are shooting. Once you have set the key light and the f-stop using the incident light meter, the waveform monitor can enable you to refine the rest of the image with a degree of precision that is virtually unattainable in film. If, for example, you have any question about the amount of light required to bring an object in the background just above the threshold of visibility, the waveform monitor can show you precisely the point at which it becomes visible.

What an experienced still photographer achieves with the mind's eye, a densitometer, and the zone system of exposure control is made readily available to the cinematographer working in video by the waveform monitor. It is a tool whose potential far exceeds the use to which it has been put and that needs to be put in the hands of creative cinematographers.

AESTHETIC CONSIDERATIONS

By far the most important considerations in setting exposure are aesthetic ones. What is the "correct" exposure for a scene is less a matter of reflectances and latitude than a matter of mood. Most cinematographers working in the film routinely over- or underexpose scenes in order to achieve a mood that is appropriate to the subject matter. The fact that current video pickup tubes have a limited latitude relative to film does not mean that there is no room for creativity in video lighting and exposure.

Obviously there are no hard-and-fast rules to be followed in the creative use of exposure. Rules found in textbooks concerning lighting ratios and appropriate exposure levels for Caucasian skin tone exist only to be broken, and may actually be more of a hindrance than a help since

they tend to inhibit experimentation. There is no "right" way to paint a picture, and the cinematographer working in video is painting with light just as much as the cinematographer working in film.

Lighting for Video

Lighting is the other part of the creative equation. Begin by forgetting everything you have been told about video lighting and use the same methods that have been used for lighting film. A cinematographer who lights video as if it were film will be successful 85 percent of the time. If you remember what we have discussed in this book thus far, your success rate will approach 100 percent.

Lighting for video can be as creative and sophisticated as lighting for any other photographic medium. The principal limitation will always be the imagination of the cinematographer. There are, of course, certain technical parameters of which the cinematographer must be aware, but the so-called limitations of video as a medium should not be viewed as laws prohibiting any kind of lighting style or technique. If video is to realize its potential as an artistic medium, cinematographers must explore all possibilities in lighting and find ways to stretch the limits of the video image.

Too often a technical specification for a video system will be translated into a rule regarding some production technique. Just because current pickup tubes are limited to a contrast ration of 40:1, that does not mean that the brightness range of a scene cannot exceed 40:1. It only means that the cinematographer needs to be aware of how the scene will be recorded by a video camera. Similarly, the relatively limited resolution of a video image and the smaller screen size in comparison to a motion picture screen size does not necessarily mean that every shot in a video production has to be a medium close-up.

Many of the common practices in video lighting stem from technical or engineering considerations that are no longer relevant. Today's production cameras are much more sensitive and stable than the old cameras for which television studio lighting techniques were developed. Today's video productions are also much more sophisticated visually. The time has come to adapt all of the lighting techniques developed for motion picture photography to video.

LIGHTING STYLES

There are numerous basic approaches to lighting for film, and each will find its proponents in video. The same debates about the virtues of source lighting or the necessity of clearly illuminating the faces of the performers will be heard in video as in film. Some will prefer to begin with a key light; others will start with an overall ambient light level. Some prefer hard light while others prefer softlight. It is a question of taste or style or, in many cases, the interpretation of the subject matter.

This book cannot attempt to deal with the aesthetics of lighting, except to say that cinematographers should feel free to try anything in video that they would try in film. There are other books and journals

that discuss lighting for film; and, even better, there are countless beautiful examples to be viewed and studied. The availability of so many films on video cassette provides a wonderful opportunity for studying film lighting techniques and their applicability to video. Lighting styles that have been thought to be suitable only for film can be viewed and evaluated on a television screen. Some allowance must be made for the fact that the images were originally recorded on film. Film origination involves contrast compression that would be absent in a video camera without a gamma compression circuit; but basically, if you can see it on a television screen, you can shoot it with a video camera.

LIGHT LEVELS

Most video cameras will probably be found to have an effective exposure index of about 100. They will also have a gain switch that can be used to boost the sensitivity to an effective exposure index of about 200 and 400. A 6-dB increase in gain is the equivalent of 1 stop or a doubling of the exposure index (9 dB would be 1½ stops, 12 dB 2 stops, 18 dB 3 stops, and so on). As the sensitivity is boosted with the gain switch, the signal-to-noise ratio will be decreased, and each cinematographer will have to decide whether the increase in sensitivity is worth the increase in noise. Remember, however, that the noise increase will get worse with each tape generation in post-production, particularly in the smaller tape formats. Judging noise level on a picture monitor at the time of production can be very misleading.

With an exposure index of 100 the cinematographer has a wide range of possibilities regarding the amount of light used on a set. The fact that the camera specs rate the sensitivity of the camera at $f/4$ with 200 fc does not mean that the camera performs best only when the set is illuminated with 200 fc. So far as exposure of the pickup tubes is concerned there is absolutely no difference between 200 fc at $f/4$, 100 fc at $f/2.8$, 50 fc at $f/2$, or 400 fc at $f/5.6$. The choice of light level can be based on other considerations.

One consideration is depth of field. Higher light levels permit greater depth of field, or, depending on your perspective, lower light levels permit selective focus. There is no "best" f-stop so far as depth of field is concerned. It is a matter of the style in which you choose to work for a particular production. Obviously cinematographers accustomed to

working in 35mm will have to adapt their thinking when they begin shooting in video with a ⅔-inch camera, since the depth of field for a given field of view will be greater at any given *f*-stop. (See Chapter 2.)

Another consideration in determining light levels is the ease of evaluating and controlling the light. This is again largely a matter of personal preference. Some experienced cinematographers will prefer to work with a 150-fc key simply because their eye is accustomed to judging fill light levels relative to that kind of key light. They may also feel that lower light levels are more difficult because smaller changes in level produce greater relative changes. For instance, if the key light is 40 fc, changing a fill light by 5 fc from 10 to 15 fc would result in a change in the contrast ratio from 5:1 to 3.6:1. With a key light of 200 fc a change in the contrast ratio of that magnitude would require changing the fill light almost 25 fc from 50 to 75 fc.

Other cinematographers will insist that lower light levels are much easier to work with because spill light is less of a problem and smaller units are easier to position and control. The argument is also made that lower light levels make for a more comfortable set and an atmosphere that is more conducive to acting and kinder to makeup.

Ideally the mood and style of the production should determine the approach to lighting, and a cinematographer should strive to remain flexible rather than relying on habitual methods.

LIGHTING RATIO

The lighting ratio is defined as the ratio of key plus fill to fill alone. It is concerned purely with the incident illumination and should not be confused with the brightness range or contrast range of the scene itself. Many people will say that lighting ratios in video should be kept as low as 3:1 or even 2:1. This notion is based on the assumption that home receivers typically cannot reproduce more than a 20:1 contrast ratio and that every tone in the scene needs to be reproduced on the home screen. What it ignores is the possibility of low-key lighting in which large portions of the image are deliberately in shadow. It also seems to ignore many of the advances made in video cameras, recorders, and receivers during the last 20 years.

A very simple lighting test will demonstrate that lighting ratios of 8:1 or 16:1 are perfectly viable in video. In fact, given the appropriate scene it is entirely feasible to light someone with a cross light and no fill

light at all. All you need to do is light a medium close-up of someone and check a monitor as you back off on the amount of fill light you are using.

Obviously a face lit with a 16:1 ratio looks very different from a face lit with a 3:1 ratio, but this is an aesthetic consideration and not a technical one. With a decent camera and monitor you will still see detail in the dark side of the face with a 16:1 lighting ratio. When a group of professional film and television directors and producers in Hollywood were asked to specify their preferences as to picture quality with such a demonstration, they preferred a picture lit with a 6:1 ratio and were greatly surprised to discover this.

This is not to say that you can light a long shot of a set with a 16:1 ratio and expect to see the same detail in it on a TV screen that you can see with your eye on the stage. The contrast range of the system is limited, and some experience is required to judge how a scene will reproduce.

CONTRAST RATIO

The principal difference between lighting for film and lighting for video stems from the fact that current pickup tubes have a contrast ratio of 40:1 (5¼ stops), as compared with a contrast ratio for color negative film in excess of 128:1 (7 stops). This means that in order to create the same overall effect for a scene it will be necessary to reduce the lighting ratio by using more fill light with video. If the same scene were lit with the same key light for film and video and certain areas were supposed to have only marginal shadow detail, the light level in those areas would have to be greater for video. What would produce marginal shadow detail on film would not register any detail at all with video— assuming, of course, that the exposure level relative to the key light is the same.

Lighting for video is simply a matter of adapting to the tonal range available. A camera with a gamma compression circuit to simulate the contrast range of film can enable a cinematographer to light essentially as he or she would for film. With conventional cameras, however, the range between absolute black and maximum white in the image is limited in comparison to film. Again, this does not mean that the entire set has to be brightly lit. It is still possible to have dense shadow areas and hot highlights; the difference in the light levels required to achieve them is just less.

EXTREME HIGHLIGHTS AND BACK LIGHT

One of the concerns in lighting for video is the way in which pickup tubes respond to overexposure. If a camera is not equipped with automatic beam optimization and gamma compression circuitry, overexposure can result in image defects that are quite distracting. Avoiding these defects can require careful control over such things as windows or practical lights in a scene and it can require the elimination of specular reflections. Many cinematographers accustomed to working in film have found that they use inordinate amounts of dulling spray on their first time out with video. This is not really necessary if you start by exposing for the extreme highlights and work down to the fill levels required for the look desired, rather than following the traditional engineering admonition to build a baselight or fill level first and then light the key side.

Generally speaking, if a camera does have automatic beam optimization and gamma compression circuitry designed to emulate the response of film to highlights, it will be possible to deal with highlights in the same way as one does in lighting for film. A window can be allowed to go several stops over maximum exposure without causing problems; hot rim lights can be used to add sparkle; chrome surfaces need not be banished from the set; and so on. There may be some loss of highlight detail relative to what could be captured on film, but the overall effect can be very similar.

LIGHT METER VERSUS PICTURE MONITOR

The key to achieving consistently good results in lighting for video is using a light meter in the same way one does in lighting for film. As mentioned in Chapter 1, the idea that a picture monitor on the set makes lighting for video faster and easier is one of the great fallacies about video. In fact a picture monitor is a very unreliable and inefficient tool in lighting.

First of all, a picture monitor requires that the camera be fired up and shooting the composition that is being lit. Prelighting a set or lighting while the camera is being set up or adjusted is impossible if one is dependent on the picture monitor.

Second, picture monitors, especially the type one is likely to have on the set as opposed to in the van or near the recorder, are notoriously

unreliable. Setting up a picture monitor is to some extent a matter of subjective evaluation of the image it is displaying, and the image on a monitor may not be an accurate indication of what is actually being recorded. A picture monitor is comparable to timed dailies with no indication of the printer light. It shows you one way the scene can look, but it does not really tell you what you have to work with.

Moreover, a picture monitor does not really enable you to do consistent lighting from one setup to the next. The picture monitor tells you nothing about how the levels compare to those in a previous setup. It is entirely up to your memory to compare what you see to what you saw earlier.

Consulting a picture monitor to evaluate lighting will probably require walking back and forth from the set to the monitor repeatedly during a setup—unless you abandon the set altogether in favor of a work station near the monitor from which you instruct your crew via an intercom. Neither is a very efficient procedure. The best place from which to light a set is on the set and next to the camera or the position where it will be placed.

Generally, if you ask the production company to provide a monitor for you on the set, you will get a modified home receiver or the monitor that has received the least maintenance. Even if you bring your own monitor, the ambient light levels on the set will wash out the picture so much that you cannot judge contrast in the image.

It is also inadvisable to become dependent on a picture monitor for lighting, since there will occasionally be times when it is not possible to have a monitor. When the camera is battery powered, for example, it will probably not be possible to have a picture monitor; but you may still have to light.

Using a light meter that you can carry around with you as you work is really the simplest and most efficient method of lighting. Using a light meter properly also ensures consistency from scene to scene.

When you are lighting a set, the video camera and picture monitor are really just the world's most expensive and clumsy light meter.

There is another problem associated with the use of a picture monitor as a tool for evaluating lighting. It tends to invite lighting by committee. While a good monitor may promote constructive discussion of lighting in some instances, there are also plenty of instances where discussions of the lighting based on what the scene looks like on the monitor may be fruitless and counterproductive.

If you are still unconvinced about the use of a picture monitor in lighting, consider the following: Anyone who shoots video will at some

point inevitably have to insist that the producer or the client ignore the way the image looks on the monitor. You will know that it is not an accurate indication of the image you are recording; but if you yourself have been referring to the monitor while lighting, your ability to persuade them that it is unreliable will be considerably diminished.

THE WAVEFORM MONITOR

The waveform monitor, of course, is a completely reliable indication of the image you will be recording and is a valuable complement to a light meter in evaluating the final stages of a lighting setup. It is especially valuable if you have any doubts about whether highlights or shadow areas are within the range of the pickup tube. (See Chapter 5.)

COLOR TEMPERATURE

Video cameras, like most film emulsions, are designed to be most efficient with light that is 3,200 K. This is the color temperature of standard tungsten lights. Shooting with daylight, which is generally considered to be 5,900 K, requires the use of an 85 filter to correct the color balance of the light. As a general rule, it is better to color correct with filters than to color correct electronically by adjusting the gain on the three channels in the camera. For anything other than a minor correction it would probably be necessary to boost the gain of one channel so much that there would be a noticeable increase in noise in the image. Since the actual color temperature of daylight may vary dramatically, it is advisable to balance the camera for the light that is actually illuminating the scene. The same is true for tungsten or any other artificial light source. The camera should always be balanced using the light that is supposed to be interpreted as white light in a particular scene.

Other nonstandard lights such as fluorescent, sodium vapor, or mercury vapor lamps present special problems in terms of color balance because they do not emit a continuous spectrum. Fluorescent lamps come in a wide variety of "color temperatures," and generally the best solution when shooting under fluorescent light is to replace all of the fluorescent bulbs with a type that has a color balance and spectral distri-

bution closest to those of daylight or tungsten light. The problem with most fluorescent lamps is that they emit very little or no red and an excessive amount of green in comparison to daylight.

Another solution that may be more practical and that can yield excellent results is to mix tungsten and fluorescent light. If you add enough soft fill light at 3,200 K to raise the overall level the equivalent of 1 stop in exposure, then you will have added enough red light to shoot using an 85 filter with the camera balanced for daylight. The fill light can be added by means of softlights or by bouncing light off the ceilings and walls.

The light from mercury vapor lamps is blue-green with no red in it, and no amount of filtering can add red to it. Unless red light can be added to the scene, there is no hope of getting a video image that looks normal. Color-improved mercury vapor lamps with frosted bulbs have a phosphor lining in the bulb as in fluorescent lamps and do contain some red. Filtering can produce acceptable images with light from color-improved mercury vapor lamps.

Low-pressure sodium vapor lamps contain nothing but yellow light, and again no amount of filter or color balancing in the camera can correct it adequately. High-pressure sodium vapor lamps have enough of a spectral distribution to be correctable.

The only way to be absolutely certain of the color temperature of a light source is to use a color temperature meter. The effect of a filter can also be checked by putting the filter over the color temperature meter and taking a reading through the filter. The result should be close to 3,200 K.

Contrary to popular opinion, video cameras are no more sensitive to variations in color temperature than motion picture film stock, nor are they less sensitive. All of the literature on balancing and mixing color temperatures in lighting film applies equally to video.

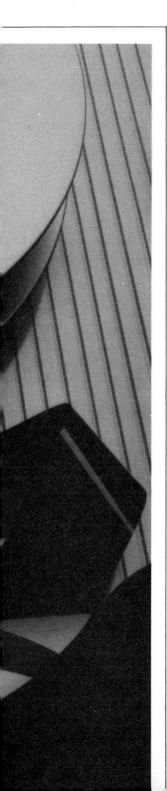

Video Recording

Video recording is a necessary part of the craft of video image making, but unlike film recording the recording method used in video is functionally "transparent." What is sought ideally is an exact reproduction of the image without any changes in gamma, color balance, or video levels. That is why so much more emphasis has been placed on video cameras than recorders. This is not to say that a thorough understanding of VTRs is not essential to the cinematographer's art.

While much of the technology involved in video recording need not concern the cinematographer, it is essential to be conversant with certain basics that may have an effect on the quality of the image or on production logistics. As the number of recording mediums and formats proliferates, the task of choosing the most appropriate one for a particular production becomes increasingly difficult unless one has a grasp of the differences.

VIDEOTAPE VERSUS VIDEO DISC

There are currently two basic configurations for the recording medium: tape and disc. Video discs are only beginning to have production applications as a medium for off-line editing. While it is probable that the main application of video discs will continue to be for playback only, the costs of mastering discs have decreased to the point where they have become a viable method of duplicating a tape or film original for editing purposes in certain situations.

The direct read after write (DRAW) laser disc has also opened the door to a new realm of off-line video editing. A DRAW disc is a laser disc that can record in real time and be played back immediately on the same machine or another, playback-only machine. It records by means of a laser similar to the one used to read in playback but with the power boosted to the point where it can cut the necessary microscopic holes in the metal foil portion of the disc.

The primary benefit offered by a disc is the possibility of random, almost instantaneous access to any portion of the recorded material. Rather than having to rewind through hundreds of feet of tape, it is only necessary to move the pickup head a few inches. A DRAW disc, for example, can access any track on the disc in ½ second, or less.

The difficulty with a disc is in devising a means for recording the density of information required on the available space. Discs currently available use microscopic variations in the surface that are detected either by a laser or by a capacitive sensor and that generally must be mastered under exacting conditions in a time-consuming manner. DRAW discs represent a major breakthrough in video disc technology and may change the use of video discs radically.

Magnetic discs comparable to those used with computers cannot contain enough information to be practical for anything other than very short takes. The original slow-motion devices developed for instant

replay used a magnetic disc, and magnetic discs were used in one configuration of the CMX editing system to record up to 30 minutes of black-and-white video.

For purposes of electronic cinematography the only currently viable recording medium for production is magnetic tape.

TAPE SIZES

Videotape comes in six different widths: 2 inches, 1 inch, ¾ inch, ½ inch, ¼ inch, and 8mm. It would be nice if one could assume that a larger-size tape meant better image quality, as is generally true with film gauges. Unfortunately this is not the case. Although a larger-size tape makes it easier in some ways to design recorders with better performance, there are other factors that make it possible to record a better image on 1-inch tape than on 2-inch tape and a better image on ½-inch than on ¾-inch tape. Advances in technology that have been applied to the design of smaller-format tape recorders in the interest of portability have not at the same time been applied to the older, large-format recorders.

One of the principal factors determining the amount of information that can be recorded on magnetic tape is the writing speed, or the speed of the tape relative to the recording head. With audio recording, running the same tape over the same recording head at 15 rather than 7½ inches per second (ips) will result in improved fidelity. With most video recorders the recording head rotates so that it moves across the tape against the direction in which the tape is traveling. In this way the writing speed is greatly increased without having to drastically increase the tape speed itself. This is why videotape is wider than audiotape as a rule. The recording head moves across the width of the tape as the tape moves through the recorder.

RECORDING FORMATS

Exactly how the recording head is designed and how it moves relative to the tape varies in each of the ten recording formats currently in use.

Quad, which is short for quadruplex, was the first videotape recording format developed. It uses 2-inch tape and has four recording heads on a drum that rotates at 90 degrees to the direction of the tape travel.

The tape generally moves at 15 ips and the drum rotates at 240 revolutions per second (rps). The result is a writing speed of 1,560 ips. (Some quad recorders can also record with a tape speed of 7½ ips.) Separate stationary recording heads record the audio signal and a control pulse. As the tape passes the drum with the video recording heads, it is curled and held so that it is flush with one side of the drum. (See 12.1.)

Quad recorders were the industry standard for 20 years and are still quite common, although 1-inch recorders are replacing them in both field recording and postproduction at a very high rate.

One-inch **helical** recorders are designed so that the tape is wrapped around a drum that is rotating more or less in the opposite direction of the tape travel. There are two types of helical recorders: type B and type C. There was a type A, but that design was soon abandoned. The type C recorder has one head, and it is designed in such a way that the head rotates once for each field of video. The tape travels at 9.61 ips and the head moves across the tape at 1,007 ips. The great advantage of this design is that the head can rotate with the tape standing still and play

12.1
Quad recorder head and tape configuration and recording format

back a single field of video over and over. The tape can be moved more slowly than normal and the machine will play back in slow motion. One disadvantage of the design, however, is that the rotating drum containing the head has to be so large it is difficult to keep stable. Gyroscopic effects can produce noticeable image defects if the recorder is moving while it is recording. (See 12.2.)

Type B 1-inch helical recorders use a much smaller drum with two heads. The tape travels at 9.65 ips and is wrapped around 190 degrees of the drum rather than being wrapped all the way around it. Each head records only a portion of a field as it passes the tape. (See 12.3.) While still frame and slow-motion playback become much more complicated with type B recorders, they do offer greater stability and generally better performance in the field. Type B recorders also permit the use of cassettes that protect the tape from dirt and damage and are still compatible with the reel-to-reel format.

The ¾-inch U-matic recording format was originally developed for consumer products. It never really caught on as a home video format, but it was rapidly refined to the point where it became viable for many

12.2
C-format recorder

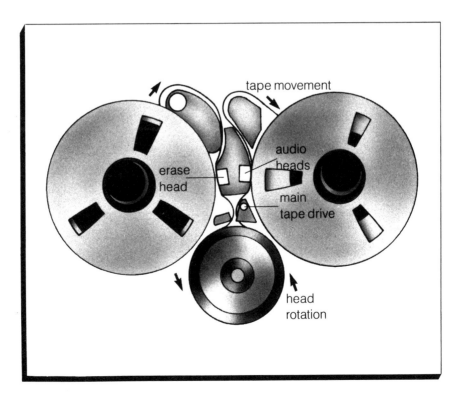

professional applications. A ¾-inch cassette recorder has a tape speed of 3.75 ips and a writing speed of 404 ips. As a result of this slow speed (and in order to be cost-effective) compromises had to be made in the way in which the image is recorded.

Because the ¾-inch recorder cannot deal with the high frequencies at which the color information or chrominance signal is encoded onto the luminance signal, it employs an approach known as heterodyne or "color under" recording. The high frequencies containing the chrominance information are separated from the composite video signal, and the chrominance information is extracted and put into a form that can be recorded separately from the luminance signal.

This approach has several drawbacks. First of all, fine detail or high frequencies in the luminance signal can no longer be distinguished from chrominance information. Actual picture resolution is limited to 260 lines, and fine detail shows up in the image as chroma noise. Secondly, a delay is introduced in the color information that is compounded each

12.3
B-format recorder
and recording format

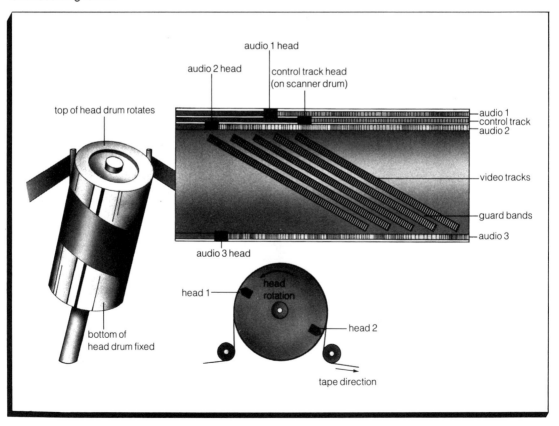

time the image is rerecorded from ¾ inch to ¾ inch. The result is a substantial degradation of the image with each generation, and for this reason ¾-inch originals are often edited onto 1-inch masters.

There is a modified ¾-inch recorder that increases the tape speed and the head rotation by a factor of 3 and is able to eliminate the heterodyne recording and achieve performance comparable to that of 1-inch recorders. This is called a **high-band** ¾-inch recorder. Prototypes were produced, but there were never enough machines sold to qualify the format as an accepted standard.

There are a variety of recording formats that use ½-inch tape, and it is important to understand the difference between the ½-inch formats designed for home video use and the ½-inch formats designed for professional use. Betamax and VHS ½-inch cassette recording formats were designed for consumer use and have slow tape speeds with heterodyne recording. While they have found professional application in industrial use and for off-line editing of larger-format tape and film productions, they are not suited to broadcast.

The newer ½-inch recording formats, on the other hand, were developed specifically for professional use and are capable of image quality surpassing that of ¾-inch and approaching that of 1-inch. There are two competing formats, the Betacam format developed by Sony and the M-Format developed by Matsushita (Panasonic) and RCA. They use Betamax and VHS cassettes, respectively, but with an increased tape speed and a completely different method for recording the chrominance signal. The chrominance and luminance signals are not composited but recorded on separate parallel tracks, thereby preserving high-frequency detail in the luminance signal and avoiding problems with chroma noise. (See Chapter 7.)

This is the first commercial application of high-definition television technology. While the format was developed initially for news applications, it is entirely conceivable that it will become a common format for production.

Similar signal-processing techniques are used with the ¼-inch recording format developed by Bosch. The use of helical scan recording onto ¼-inch cassettes is made possible by time expansion and time compression encoding techniques. Luminance and chrominance information for each line of the image is stored and then recorded sequentially, the luminance signal being expanded and the chrominance signal being compressed. This enables the luminance frequencies to be reduced to a recordable range without compromising the chrominance signal. The result is an image that is better than that obtainable with conven-

tional ¾-inch cassette recorders and potentially as good as that of current 1-inch recorders.

There are other ¼-inch formats and an 8mm format that are designed for consumer use. They do not really have professional applications in their current form.

COMPONENT AND DIGITAL RECORDING

Two advances in video recording make the prospects for electronic cinematography even brighter: component recording and digital recording.

Component recording was discussed in Chapter 7. It can take different forms, but they all eliminate the image defects associated with the process of encoding and decoding the color information. While conventional broadcasting will always require encoding of some type, many postproduction processes are much more successful with an RGB signal. Matting, for instance, generally requires an RGB signal for the foreground and yields much better results if the signal has not been encoded and decoded on its way to the matting device. With RGB or component recording it would be possible to obtain the same quality of blue screen work in postproduction as can be obtained with an RGB signal from a live camera.

Component recording also makes it possible to do gamma manipulation and color correction in postproduction without the danger of image degradation. Once a video signal has been encoded, decoding it in order to manipulate the image will inevitably introduce noise. If it is not encoded when it is recorded, all of the manipulation that is now done during production with a live signal can be performed equally well in postproduction.

Digital recording is the logical extension of the digital signal processing employed for so much special effects work. As with digital audio recording, the main advantage of digital video recording is that there would be no degradation of the image as it is duped through several generations.

Specifications for digital video have been standardized in an international agreement, so that the prospects are good for the development of a wide range of digital video equipment. In order to appreciate the significance of this to the cinematographer, it is helpful to understand some of the basics of digital video.

A **digital** signal has only two levels representing on and off or 1 and 0. If it is sampled at a fixed rate, it can be interpreted as a series of 1s and 0s, which in turn can be interpreted as a series of binary numbers. If, as is often the case, the signal is interpreted as a series of eight-digit binary numbers, such as 01001110 or 11100011, each number can have any one of 256 values. (Binary numbers are a way of counting using only two digits: 0, 1, 10, 11, 100, 101, 110, 111, and so on. When you have a combination of eight 1s and 0s, there are 256 possible combinations.)

If a video signal can be represented as a series of values between 0 and 255, it can be translated into a digital signal (or "digitized"). If such a signal is recorded or transmitted, the various types of noise that distort it will never be so extreme as to destroy all distinction between a 1 and a 0. Moreover, once the signal is interpreted in terms of 1s and 0s, it can be completely regenerated so that the emerging signal will be as good as new. That is to say, once a video signal has been digitized, the video information is completely impervious to noise from the system that is recording, processing, or transmitting it.

Digitizing a waveform is comparable to assigning values to points along a curved graph. (See 12.4.) Obviously the fidelity of the waveform that will be produced when the digital signal is converted back into an analog signal for playback is a function of the frequency at which the original analog signal is sampled. The more samples per second, the greater the fidelity. The sampling rate specified in the digital standards is 13.5 million per second for the luminance signal. This is some indication of the magnitude of the task of developing equipment that can effectively process or record a digital video signal, and this standard is

12.4
Digitizing a waveform

for current broadcast systems. Digital processing of high-definition television signals is another matter altogether.

Video recorders are the foundation on which electronic cinematography is built. Prior to the development of videotape recorders by Ampex in 1956, video was purely a broadcast medium and all camerawork had to be executed in real time. Actually, until the development of electronic editing in the late sixties, videotape recording was simply a means of preserving and distributing what were in essence live broadcasts. Only after it became feasible to manipulate images in postproduction was it possible to develop production styles that permitted complete control over staging, lighting, and composition.

Peripherals

No aspect of video is peripheral if it creates a problem during a production, but these aspects of video are sidebars to our central theme of creative video manipulation. Anyone creatively manipulating sync is in for an aesthetic disappointment.

There are certain aspects of a video system that are crucial from an engineering standpoint, but are generally of no concern to the cinematographer—until something goes wrong. Denise Gallant has described an all-too-typical experience in *American Cinematographer,* June 1982, Vol. 63, No. 6, p. 597:

> I was videotaping a theater production in an old barn and unaware during the shooting that the lighting for the stage created a large enough voltage drop to garble the sync pulses on my video signal. The production represented the culmination of a senior project for theater students, and I poured a lot of energy into capturing it creatively on tape. When it was over, everyone was anxious to view the tape, but all I had was a series of rolling images that wouldn't sit still long enough to see anything.

Of course, this particular sync problem can happen only with unsophisticated equipment, but it is an example of the way in which sync is a concern only if you haven't got any.

VIDEO SYNC

Every system for cinematography requires some method of synchronization between the camera and the display device. With film it is the sprocket holes that provide the basis for sync. If a camera pulled down film at the rate of four sprocket holes per exposure and a projector for some reason pulled the same film down at a rate of three sprocket holes per shutter opening, the result on the screen would be an image whose vertical positioning changed twenty-four times a second—in short, a mess. Or if the position of the image on the film is not absolutely consistent relative to the sprocket holes, the image will appear unstable on the screen. There are even instances for scenes involving critical optical compositing where film is rejected as unusable because the sprocket holes themselves are not consistent enough in their size and spacing.

All of the same kinds of things apply to video—except that the sprocket holes are electronic signals. In addition, video is even more complicated because each frame is made up of hundreds of discrete lines that have to be positioned consistently relative to each other when the image is displayed.

Consider some of the things that can happen to a video image if the playback is not accurately synchronized with the recording. Suppose, for example, that the scanning beam in the monitor returned from the end of one line to start the next line in less time than the scanning beam

that recorded the image originally. The result would be that a vertical line would appear slanted, because the monitor scanning beam would get progressively ahead of where it should be on each scan across the screen. Actually the edges of the whole frame would appear slanted if you could see them on the monitor, but most monitors are set up to crop the image well inside the frame lines.

Similarly, if the monitor scanning beam returned to the top of the screen to begin scanning the next frame faster than the scanning beam in the camera, the result would be a rolling image of the sort you can get by throwing the vertical hold adjustment out on a TV set. Each successive frame would begin slightly lower on the screen, so that the frame line would gradually move down through the screen.

Obviously what is needed are two kinds of sync reference: horizontal and vertical. These are provided in the form of electronic pulses from a sync generator that are combined with the video signal in between the picture information at the encoder. The sync pulses are also combined with **blanking pulses** that ensure that the video signal level will drop to zero while the beam is returning across the screen. Both blanking and sync signals can easily be seen on the waveform monitor or on the picture monitor if it has an option called pulse cross that advances the timing of the sync pulses so that they are displayed on the screen. (See 13.1.)

The sync generator in a camera also produces the signal that drives the scanning of the beams in the pickup tubes. These are appropriately called horizontal and vertical drive pulses. In terms of timing they are the same as the sync signals that are combined with the video, but the drive pulses are used purely for controlling the scanning or "sweep" of the pickup tubes.

If you remember that there are 15,750 scan lines each second, you can easily appreciate how critical the timing of the sync pulses is. There are also other aspects of sync that are essential from an engineering perspective but do not really have any bearing on cinematography. It may be helpful in some situations to understand all the complexities of the sync signals, but it is certainly not necessary in order to begin doing creative electronic cinematography.

TIME BASE CORRECTION

There is another complication regarding sync when the video signal is recorded rather than simply broadcast live. Videotape recorders are me-

chanical as well as electrical devices, and minute variations in the speed at which the tape is transported (called wow and flutter) can cause the sync to be recorded or played back in a way that is not sufficiently compatible with the way in which it was originally generated. This lack of compatibility is frequently described as time base instability.

The recording of the sync and the timing of its playback are so critical that sometimes a tape can be played back only on the recorder that recorded it. More often, however, a tape with time base instability cannot be played back at all. This problem was especially acute with the development of 1-inch helical recorders, and it was not until the development of time base correctors that were capable of correcting large input errors that 1-inch and ¾-inch recorders became completely feasible for production.

Time base correctors are an electronic means of adjusting the timing of a video signal so that the sync pulses come regularly at the appropriate intervals. You can think of a time base corrector as an underpass with

13.1
Picture monitor displaying sync and blanking signal.

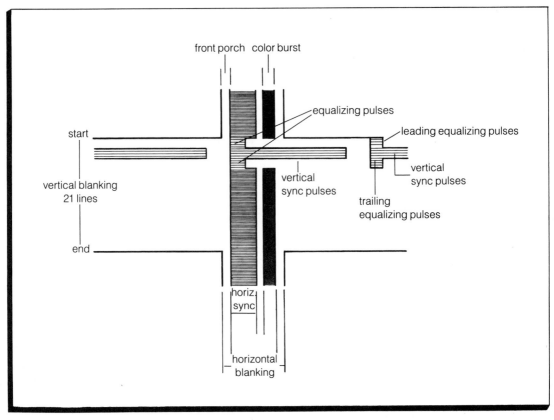

a traffic cop in the middle of it. If the traffic lights controlling the flow of traffic into the tunnel are on the fritz, the cop inside the tunnel intervenes and periodically stops the traffic for long enough to restore the orderly flow. The traffic cop in a time base corrector is generally a digital memory or storage device. If it is possible to store a scan line or a frame of picture information, then it is only necessary to have a stable electronic reference governing the release of the signal from the memory in order to restore uniformity to a signal.

There are also analog time base correctors that employ a delay line network. The B-format Bosch recorder, for instance, uses an analog time base corrector.

Depending on the size of its memory and the sophistication of its circuitry, a digital time base corrector can also perform a variety of other monitoring and correcting functions. The development of digital storage techniques for video signals has given birth to a wide range of special effects devices that use computers to manipulate the picture while it is in a digital form. It will probably not be long before every step in the video production process is performed with a digital signal.

COLOR BURST

One more part of an NTSC video signal is visible on the waveform monitor: color burst. (See 13.2.) **Color burst** is a reference signal for interpreting the color information that has been encoded onto the luminance signal.

Color information is combined with the luminance signal in the NTSC system by modulating it onto a high-frequency wave (the color subcarrier at a frequency of 3.58 MHz) and then adding that onto the luminance signal. The modulation of the subcarrier is such that its amplitude represents saturation (or signal strength) and its phase (or timing in relation to the color burst) represents hue. That is to say, each cycle of the signal contains saturation information for every hue. The saturation for red corresponds to the amplitude at a phase of 103 degrees, the saturation for green corresponds to the amplitude at a phase of 241 degrees, and so on, figuring a complete cycle as 360 degrees.

This method of encoding color information requires a clean reference signal for the subcarrier that has no color information on it and serves to establish the phase. Once the color information has been modulated onto the subcarrier there is no way to tell what the original subcarrier

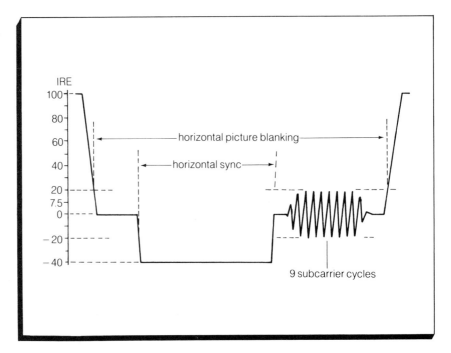

wave looked like. Only if an accompanying sample is locked into it in terms of phase is it possible to interpret the phase of the modulated subcarrier. Misinterpreting its phase causes colors to shift systematically the way they do when the tint control on a receiver is turned so that faces become green or purple. The absence of a color burst signal causes television monitors and receivers to interpret the video signal as a black-and-white image.

TIME CODE

Another signal is recorded either on a separate track on the tape or within the video signal and has a variety of uses. It is time code, and its function is similar to that of edge numbers on film. It provides a way of identifying the location of a particular frame on the tape and of synchronizing the video with a number of other things.

Time code was developed by EECO and standardized by the Society of Motion Picture and Television Engineers (**SMPTE**); it is sometimes referred to as **SMPTE time code.** It is eight numbers that signify hours,

minutes, seconds, and frames, so that once you know the time code for a specific frame you can always go to it automatically simply by telling the playback machine to find that number.

There are two forms of time code: longitudinal time code and vertical interval time code. Longitudinal time code is recorded on a separate track on the tape that is designated specifically for time code, or on an audio track if the tape format does not provide a special time code track. It can be recorded onto a reel of tape all at once so that the tape is numbered continuously from beginning to end, or it can be recorded as the video is shot. Generally the hours, minutes, and seconds are arbitrary, but it is possible to set them so that they indicate the actual time at which the image was recorded. This is commonly done for concert- or event-type productions, especially those shot with multiple cameras, since it aids in the identification and cataloging of the footage shot.

Longitudinal time code has two drawbacks, which led to the development of vertical interval time code. Longitudinal time code requires that the tape be moving past a head in order to be read. If a playback machine is in a still frame mode, the longitudinal time code cannot be read by the machine. The second drawback is that often a video signal must be rerecorded onto another tape in such a way that longitudinal time code cannot go with it. In most editing systems the tape onto which the image is being rerecorded during editing has to have continuous time code for the machine to be controlled properly by the computer. This means that the time code for the edited master will not match that for the scenes from which it is compiled, and an elaborate logging system must be developed in order to keep track of where the image came from.

Vertical interval time code overcomes both these drawbacks by being recorded within the video signal itself during the time when the scanning beam is returning to the top of the frame to begin a new field (the vertical blanking interval). Since it is within the video signal it will always accompany it as it is recorded, and it can be read while a machine is in a still frame mode of playback.

Vertical interval time code is completely compatible with longitudinal time code, although the elimination of the longitudinal time code track on the tape can make room for an extra sound track. At first it was difficult to design a method for reading vertical interval time code when the tape was being run at high speed, so it was common to have both types of time code on a tape. This limitation of vertical interval time code was soon overcome, however, and it is feasible to use vertical interval time code exclusively on the original production tape.

DROP FRAME—TIME CODE

Time code assumes that there are precisely thirty frames of video per second, and there were until the development of the NTSC color system. One side effect of the NTSC color system was the alteration of the video frame rate to 29.97 frames per second. The difference of course, is unnoticeable to anyone except a time code generator that is assuming each frame is $\frac{1}{30}$ of a second. What the time code would say was exactly 1 hour's worth of video would in fact take 3.6 seconds less than an hour to play back.

In order to compensate for this cumulative error the time code generator need only skip a frame number 108 times during the course of an hour. **Drop frame** time code does this by skipping two frame numbers at the end of every minute except for every tenth minute. It is useful when time code is used for timing a show where the running time is critical.

USER BITS

When time code was standardized, someone had the foresight to design the format so that additional information could be recorded along with the hours, minutes, seconds, and frames. Time code is a digital signal, so this room for additional information was christened in computerese: user bits. The thirty-two user bits provide enough extra digital signals for the "user" to record either four letters or eight numbers of his or her own choosing with each frame. It is possible, for instance, to slate each take with a set of numbers or letters in the user bits of the time code. If the slating information is too long to be contained in the four letters or eight numbers that accompany each frame, there are ways of spreading it across several frames.

User bits have to be recorded at the same time as the rest of the time code. They cannot be altered separately after the time code has been recorded.

Vertical interval time code has ninety bits of information instead of the eighty that longitudinal time code has. These extra bits are devoted to various additional functions, including the identification of each field as opposed to just each frame of video. This has many useful applications in postproduction.

Since time code is a digital signal, it can be regenerated each time it is rerecorded. It is advisable to regenerate longitudinal time code whenever it is transferred from one tape to another. If the time code is not regenerated, it may become distorted and illegible at fast speeds. Vertical interval time code is not regenerated each time it is rerecorded; but so long as the video image is intact, the vertical interval time code will be legible.

RESET

FRAMES

FORWARD

SECONDS

MINUTES

REVERSE

HOURS

SHUTTLE/JOG(PUSH)

SEARCH

STOP

F FWD

Postproduction

One of the advances that has set the stage for electronic cinematography is film-style single-camera postproduction. With the development by Lucasfilm Ltd. and Convergence Corporation of EditDroid, which uses optical laser disc technology, video postproduction could now come full circle and revolutionize film editing.

Creative electronic cinematography is fruitless unless the postproduction process complements it with a similar concern for quality and attention to detail.

Three aspects of postproduction are essential to electronic cinematography. The first and most obvious is the preservation and enhancement of image quality throughout the editing and distribution or broadcasting of the production. The second is the degree of flexibility in picture editing that is required to take full advantage of the single-camera approach to production. The third is the less obvious requirement for a comparable sophistication in the design, recording, and editing of the sound track.

THE IMAGE IN POSTPRODUCTION

As the story in Chapter 1 illustrates, it is entirely possible for the postproduction process to undo everything the cinematographer has worked so hard to accomplish during production. Almost all of the means for manipulating the image electronically that are available to the cinematographer are also available to the editor or the producer or the distributor or anyone else involved in the postproduction process.

Sometimes with film a cinematographer can deliberately expose the negative in such a way that it can be printed only one way, thereby forcing the visual look of the film to conform to his or her intentions. With video it is practically impossible to nail down the look of a scene so firmly that someone else cannot find a way to alter it. The only solution is for the cinematographer to find ways to communicate effectively with the key people in the postproduction and somehow to create an atmosphere of concern for the image.

It is customary in film for the cinematographers to work very closely with the timer in the lab in order to ensure that their intentions are fully understood and realized in the printing of the negative. It should be equally common for the cinematographer to participate in video postproduction processes that affect the look of the images. It should, in fact, be mandatory for the cinematographer to supervise any attempt to color-correct or otherwise enhance the image during postproduction.

COLOR CORRECTION

Color correction can be performed either during the on-line editing session as the individual takes are rerecorded onto the edited master or afterward during the dubbing of a second tape from the edited master. In general, it is more efficient and economical to do the color correction after all of the editing has been completed. Even though this means taking the material through an additional generation and possibly risking image deterioration, it is certainly more economical to do color correction in a separate session, and it is probably easier to do a better job of ironing out inconsistencies in the images if a specialist is doing it without having to deal with other kinds of choices and problems at the same time.

The equivalent of a film timer in video is called a colorist. Colorists who work in film-to-tape transfer for commercials and movies are among the highest-paid personnel in postproduction. The ability to evaluate color rendition and to manipulate it effectively is a specialized and demanding skill that is justly rewarded. This caliber of color correction work should be applied to every production in which the cinematography has been done with care.

For the most part, color correction is concerned with ironing out differences in color rendition due to variations in the color temperature of the light from one setup to another during production or variations in the technical setup of the camera itself. In many cases, however, color correction techniques can be used to introduce subtle color effects that could not be achieved during production, and cinematographers have a powerful ally in the colorist—provided they can communicate exactly what they are trying to achieve.

One of the simplest and most valuable tools for communicating with the colorist or editor is the slate at the head of a reel or a sequence of takes. If a slate with a gray scale or a chip chart is shot for a few seconds using the light for which the camera is balanced, it provides a means for fine-tuning levels and color balance prior to rerecording. If there are colored lighting effects in the scene, shooting a slate with white light will help ensure that the colored lighting is properly understood and not "corrected" out of the scene.

Once the levels and color balance are set for the slate they can be left that way and the color effect will appear as it was intended to look. This procedure is especially useful if the cinematographer cannot be involved

in the postproduction. Without it the editor or colorist has no firm basis for interpreting the color effect.

The problem with slates, of course, is that they get eliminated in the editing. If a colorist is working with an edited tape, none of the slates are available.

REFERENCE WHITE

In discussions of lighting and exposure for video one often finds the recommendation that every scene contain some element that is lit and exposed so that it will be at peak white. The idea is that video operators or editors in postproduction will then automatically set levels properly.

In the early days of television, when receivers did not have a certain form of circuitry known as DC restoration, including a reference white and reference black in every scene helped ensure that the receiver did not automatically alter the tonal scale of a scene. A receiver without DC restoration sets its picture tube brightness at a level where the average signal level is a midgray. If the extremes of the gray scale are not present in every scene, then the receiver alters the midtones by adjusting to the average signal level. Most receivers today have DC restoration, however, so this is no longer an important consideration.

The argument that including a reference white and a reference black in every scene in order to guide a video operator in setting levels may have a degree of validity in some situations, but it is ultimately no more valid than simply sending along a note with the tape politely requesting that the video operator set the levels according to the chip chart at the head of the tape and then leave them alone for the rest of the reel. No one would seriously argue that every scene shot on film should have a reference white and a reference black in it as a guide to the timer in setting printer lights.

The best form of communication, of course, is direct and personal. The cinematographer should discuss the scene with whoever is assuming responsibility for it in postproduction.

There are three approaches to color correction. The first simply adjusts the phase of the chrominance signal in order to effect a uniform shift in all the colors. The second decodes the signal into RGB and alters the levels of white, midgrays, and black in the three component signals before reencoding them. A CBS Labs postproduction color corrector is the original and best example of this approach. The third approach

requires an RGB signal and uses digital processing to manipulate as many as forty-eight different parameters of the image independently.

The first method is obviously a lot less expensive to accomplish, but it is limited in what it can achieve. The problem with the second and third methods is that unless component recording has been used, it is necessary to decode and then reencode the signal, a process that inevitably increases the noise in the image. It does enable one to alter the blue without altering the red, and, at least potentially, it offers types of color correction that are completely impossible with film.

In order to get a sense of what is possible with digital color correction one need only take a look at the controls on a typical system. The System 60XL, for instance, has a control panel with thirty-two knobs on it. On the left-hand side is a set of nine knobs for controlling the gain, the gamma, and the pedestal for each of the three component signals (red, green, and blue). Each of these controls is independent of the others, and independent of the luminance controls as well. In other words, altering the blue gain will not affect the luminance signal, nor will it affect the red or green signals in any way. It will alter the white balance.

In the center of the panel are twelve knobs for controlling the saturation and hue of the yellow, green, cyan, blue, magenta, and red. Again these controls operate independently of each other and of the luminance signal. Adjusting the hue of the yellow control could cause the yellow bar in a set of color bars to turn orange without affecting the other color bars. Similarly, the saturation of just the blue could be altered without affecting the saturation of any other color. Imagine what it would take to accomplish this with film in an optical printer.

On the right side of the panel are nine knobs for manipulating the luminance signal independently of the color. There is a density control for adjusting white level, a pedestal control for the luminance signal, and a special form of gamma control for manipulating the midrange of the luminance signal. Then there are six density controls for each color. These controls enable you to alter the luminance signal selectively for areas in which each color appears. In other words, you can make the image brighter wherever it is green without in any way affecting the white balance, the hue or saturation level of the green itself, or the brightness of any other area of the image.

Now you can see why colorists are well paid. The possibilities for image manipulation with such a system are mind-boggling, especially in comparison to the limitations of conventional film color correction or the painstaking optical work that can be involved in achieving color effects

with film. Consider, for example, the work required to make a scene in a film gradually go from color to a sepia tone. This effect requires making a color interpositive and a black-and-white master positive, doing wedge tests, and finally making a negative with a dissolve from one to the other. In video, with a digital color correction system you can try it ten different ways in 5 minutes simply by twisting some knobs.

IMAGE ENHANCEMENT

Another area of postproduction of direct concern to the cinematographer is the possibility of image enhancement. *Image enhancement* as a broad generic term can refer to a growing number of ways in which an image can be improved during or after the recording process. Image enhancement techniques have been developed for use with photographic images that can electronically remove grain, restore detail to overexposed areas, emphasize detail that is only marginally apparent in the original, and so on.

In video *image enhancement* generally refers to the technique for increasing the apparent sharpness of an image by exaggerating the borders defining areas in the image. It is also called detailing, and it is commonly done in production as well as postproduction. It has its place because of the limited resolution of NTSC video and the relative softness of video as compared to film, but it can also be easily overdone. (See Chapter 4.)

One thing a cinematographer should remember is that image enhancement can always be added to an image, but it can never be removed once it has been added. If one is shooting with a really good video camera, it is conceivable that one could shoot without any enhancement and then add the desired amount of enhancement during the last stages of postproduction. This might facilitate controlling the consistency of the enhancement—provided, of course, that the cinematographer participates in the postproduction. In most cases it is probably preferable to add the enhancement when the image is initially recorded and not to add more during postproduction, because of the increase in noise caused by the extra signal-processing required.

There are other forms of image enhancement involving computer processing of video signals that could prove very useful to the cinematographer as a postproduction tool once they become economically feasible. Such things as noise reduction and selective detailing will provide a means for compensating for compromises that have to be made during

production. Noise reduction circuits, however, have difficulty distinguishing between noise (random changes in the image) and changes in the image due to movement that is part of the scene. As a result, noise reduction circuits can introduce a sense of unreality in an image when there is movement in the scene or camera movement.

RERECORDING

Every time an analog video signal is rerecorded, there is a slight degradation of the image. It is not as great as the degradation that occurs when a film image is duplicated. The main problem in film is the contrast buildup and the increase in the graininess of the image. With a video image there need be no increase in contrast, but there can be an increase in noise (the video equivalent of grain) and a loss of fine detail.

It is possible for a 1-inch tape to go through as many as ten generations before there is an unacceptable loss of quality. Nonetheless, producers who are required to deliver an edited master of a show to a network will routinely deliver a dub from the actual edited master in order to retain the original. This indicates both that the difference between a second- and a third-generation tape is not that great and that the producers are concerned enough about the degradation in dubbing to want to hold on to the original edited master for their own purposes.

With 1-inch tape the B format is superior to the C format in terms of how the image holds up when it is rerecorded. This is one of the reasons why B is a better production format and C is often considered a format for quick-and-dirty broadcast. The smaller drum on a B-format recorder results in better head-to-tape contact, which in turn produces a better high-frequency response and fewer dropouts. The net result is better chroma reproduction and a better signal-to-noise ratio over multiple generations.

Heterodyne recording such as is used for ¾-inch cassettes should never be used in postproduction except for off-line editing and for reference copies. (See Chapter 12.)

STANDARDS CONVERSION

If video programming is intended for an international market, it becomes necessary to convert it from one broadcast standard to another.

There are several methods of doing this, and from a commercial point of view it is an entirely viable method for distributing a show. There are image considerations, however, and the cinematographer should at least be conversant with the trade-offs involved in standards conversion.

Two things generally have to be altered in standards conversion: the number of scan lines and the frame rate. Going from NTSC to PAL, for example, requires a conversion from 525 lines to 625 lines and from 30 frames per second to 25 frames per second. Extrapolating additional lines (or dropping lines when going the reverse direction) affects the resolution of the image. Altering the frame rate can cause defects in the rendition of motion. Some form of compromise must be made, but with state-of-the-art conversion systems the results will probably not be noticeable to the viewer.

One such system developed by Image Transform decodes the signal and processes it in a pure RGB form in order to maximize the quality of the converted image. The system also includes a wide range of signal-processing techniques developed from Image Transform's work in tape-to-film processes.

VIDEO EDITING

In order to appreciate what is required for editing to do justice to electronic cinematography, it is necessary to understand the difference between off-line and on-line editing. **Off-line** editing is comparable to cutting workprint in film, and is often called worktape editing. It is the decision-making process that does not involve the camera original. Off-line editing is generally done with ¾- or ½-inch cassettes made from the production tapes. Once all the decisions have been made, the original is then edited by means of rerecording the appropriate cuts in the **on-line** editing process. Often the on-line editing process is a completely automatic, computer-controlled procedure.

Off-line editing has traditionally been performed by rerecording each cut onto a second cassette as the decisions are made. There are several problems posed by this approach which have made it difficult to achieve a degree of flexibility in video editing which is comparable to that possible with film.

The first problem is simply that the editor is often dealing with cassettes containing 30 minutes or more of original material and, in order to work with any piece of it, must fast-forward back and forth through

the cassette. While this may simply seem like a nuisance, it can have a profound effect on the efficiency and therefore the creativity of the editing process. The second is that the editor must build up a sequence completely in continuity, and cannot easily start with the middle and work out toward the beginning and the end.

The most significant problem, though, is the fact that an edited sequence cannot be reedited without rerecording a great deal, if not all, of it. A film editor can pull two frames out of the middle of a reel in a matter of seconds, but in the traditional approach to video the last half of the reel will have to be rerecorded if an adjustment is made in the middle. Randy Roberts, a film editor who cut *One from the Heart* partially on videotape, summed up his frustrations with video editing in the *Editor's Eagle* (a newsletter):

> Tape can't be shortened or lengthened. How many times I wanted to take a splicer to the tape and cut out an inch and a half of tape to save an hour and a half of work. Tape has the best search capability. As for making changes, you can't beat the speed of making changes in film. That's why it's so nice to first cut or even second cut in video, but after that point, film is faster.

A variety of solutions have been developed for this problem, but the key to each of them is the notion of avoiding rerecording altogether in at least a portion of the off-line editing process. The editor needs to see how the cuts look; if they can be seen, they don't actually have to be recorded.

If enough copies of the original material are available for simultaneous playback so that the device controlling the playback can fast-forward to the next cut on one machine while another machine is playing back the first cut, then an entire sequence can be viewed simply by switching back and forth between machines playing the original cassettes.

Video discs make the process a great deal simpler because of the speed with which they can go from one section to another, but it is entirely feasible to achieve the same result using cassettes. It would probably take more cassettes than discs, depending on the arrangement of the material on the cassettes and the way in which it is being edited.

The development of relatively inexpensive mastering processes for video discs and, even more important, the introduction of the DRAW laser disc have made this form of video editing even more practical. It is rapidly becoming the most efficient and creatively flexible form of off-line editing. The time required to access any track on a DRAW disc is ½ second or less.

The key to this form of off-line editing is obviously the use of computers to control the playback machines. As each section is viewed and a cut is made, the decision is recorded in the computer memory. Once the entire list of decisions exists in the memory, the computer plays back all the sections in the proper order using however many playback machines it has at its disposal. It can also automatically record the edited sequence if a reference copy is required for viewing elsewhere.

This form of editing sets editors free to experiment. Not only can they recut with ease and give a scene the kind of pacing that comes only through polishing; they can also cut numerous different versions of a scene without having to undo one to get another.

The achievement of this kind of flexibility in video editing is making film editors turn to video as an alternative to film workprints. The editing can be done with video and the computer can provide the necessary information for conforming the film negative to the decisions made by the editor. While still in the experimental stages, this form of film editing is clearly going to achieve widespread acceptance.

SOUND

Postproduction sound work is another area where the electronic techniques available have become so sophisticated that they are replacing the traditional methods in film postproduction work. Video production has traditionally given short shrift to sound, however, and it is taking time for the techniques that are available to be adopted as routine.

The development of electronic synchronizers that use time code to sync up multitrack audio recorders with video recorders has paved the way for sound tracks on video productions capable of complementing visuals created by electronic cinematography.

The concern for sound quality has led to the development of double-system production recording techniques comparable to those used for films. The reason for this is that the audio recording portion of a video recorder can never match the specifications of a good audio recorder. The tape transport mechanism (especially on a C-format recorder), the oxide on the magnetic tape itself, and the allocation of space for recording tracks are all designed to optimize the recording of the video signal and necessitate compromises in the audio recording. Using a good ¼-inch recorder or a multitrack recorder that is synchronized with the video

recorder provides maximum quality and flexibility in the recording of the production sound.

For postproduction sound work it is customary to work on multitrack recorders even if the production sound tracks were recorded on the videotape. Whether it is economically feasible to take full advantage of the sound editing and mixing techniques available with multitrack recording may depend on the budget for a particular production, but there can be no doubt that the means are there to do virtually anything imaginable.

One of the greatest advantages of multitrack recording in postproduction is the possibility of hearing sound effects tracks as they are being built. Rather than being able to hear only one or two effects at a time as he or she is cutting them, the sound editor can listen to twenty or forty effects tracks simultaneously while laying down each new effect. The audio postproduction methods that are used were developed in the music industry and are quite sophisticated and flexible.

High Definition Television

The problems inherent in the adoption and use of high definition television are political and procedural even more than technical, but there can be little doubt that a vast improvement in video picture quality and distribution methods is about to be realized. It is up to the production community to ensure that the creative aspects of production do not lag behind these technical advances.

The future of electronic cinematography lies in high definition television. When video images achieve a resolving power comparable to images recorded on 35mm film, electronic cinematography will begin to realize its full potential.

WHAT IS HDTV?

High definition television **(HDTV)** represents an improvement in television comparable to the difference between old-fashioned phonographs and stereophonic high fidelity. The concept of HDTV embraces more than just the number of scan lines used in each frame. It includes requirements for greatly improved horizontal resolution, a new widescreen format, and the assumption that the image will be viewed on a large screen with high-fidelity stereo sound. It also involves a concern with maximizing the frame rate as a means of reducing the effect of noise and improving the rendition of motion. Ultimately it should also include the goal of matching the contrast range or latitude of film.

DEFINITION

Increased definition is obviously the primary goal of a high definition television system. This requires an increase in both horizontal and vertical resolution. Vertical resolution is a function of the number of scan lines in the image—assuming horizontal scan lines. (There has been an HDTV proposal involving the concept of vertical scan lines in which the number of scan lines would determine the horizontal resolution instead.) Generally a television system is designed to permit the horizontal resolution to be comparable to the vertical resolution, so the bandwidth for a HDTV system will have to allow for this.

The bandwidth requirement for a luminance signal is a function of the horizontal resolution, the number of scan lines, the frame rate, and the aspect ratio. With NTSC the maximum possible horizontal resolution in TV lines can be calculated by multiplying the available bandwidth (in MHz) by 80. Studio equipment capable of a 10-MHz bandwidth can resolve 800 TV lines. NTSC broadcasts are limited to 4.2 MHz, so that the horizontal resolution of a transmitted image is limited to about 336 TV lines.

If the number of scan lines and the aspect ratio change, the bandwidth requirement for a given horizontal resolution will change accordingly. Depending on how the color information is transmitted in an HDTV system, there may also be additional bandwidth required for the chrominance signal. Most proposals for HDTV involve a bandwidth of 25 MHz or more, that is, at least six times the bandwidth for current broadcast television.

The sharpness of 35mm film is generally regarded as the target for HDTV, although everyone is quick to point out that 35mm film is a moving target. Today's 16mm film is as sharp as the 35mm film of 10 years ago. While the trend in film emulsion design is currently toward increases in speed rather than sharpness, it is entirely conceivable that emulsion technology will yield another dramatic increase in the resolving power of film.

Kodak conducted some tests using simulated HDTV displays that indicated that an image on 35mm 5247 negative is comparable to a scanned image having 2,330 lines. Tests conducted by NHK indicated that an image with 1,100 scan lines was comparable to an image on 35mm color print film, and an image with 1,500 scan lines was comparable to a 35mm color transparency. The NHK tests also indicated that a viewer's impression of sharpness increased until the number of scan lines reached 1,600. Beyond that point, increasing the number of scan lines did not seem to produce a perceivable difference under the particular viewing conditions used for the tests.

It is necessary to distinguish between the definition of a recording medium and the apparent sharpness of projected images. Sharpness is a subjective reaction to more than just the definition or resolving power of the medium. Contrast and brightness, as well as edge enhancement, can affect the apparent sharpness of an image.

Sharpness is also a function of the relationship between screen size and viewing distance. The closer a viewer is relative to the size of the screen, the more critical the definition of the image. While conventional television is designed on the assumption that the viewing distance will be 4 or 5 times the picture height, HDTV proposals are more likely to assume that the viewing distance will be 2 or 2½ times the picture height.

When designing a video system to compete with film, many design engineers are perhaps overly defensive about matters of resolution. It is not the superiority of film over video, in terms of absolute sharpness, that is the problem. A relatively small area of the picture, in any given frame, is critically sharp. The resolution characteristic of film, which is

the most difficult to imitate with electronic cameras, is the gradual transition from sharp areas of the image to soft-focus areas of the image. Owing to the optical nature of this transition in film, it seems natural to our eyes, compared to the aperture-corrected, electronic appearance of video contours. This same transition in video, from an in-focus, enhanced portion of the image to an out-of-focus and thus unenhanced portion, is most objectionable.

When discussing resolution in motion picture film, two very important practical considerations must be kept in mind:

1. The motion picture industry has never proved a correlation between image sharpness and box office success, or even between image sharpness and artistic success. *The Concert for Bangladesh,* for example, utilized 16mm film blown up to 70mm, and whatever measure of success that production met with was not limited by its lack of sharpness. A feature film called *Signal 7,* directed by Rob Nilsson, was shot on ¾-inch video cassette. Photographed entirely under low-light conditions, in car interiors and on city streets at night, it was blown up to 35mm by Image Transform and met with critical acclaim at the Telluride Film Festival. No one is suggesting, of course, that the resolution limits inherent in ¾-inch videotape (286 TV lines maximum) are adequate for large-screen projection; but nevertheless the audience did not throw tomatoes at the screen and run out of the film festival shouting. As a matter of fact, it seems quite clear from all accounts that a large percentage of the audience did not know they were viewing a film that was originally shot on videotape.

2. The practical consideration of resolution is that sufficient motion picture sharpness for professional theatrical applications can be defined as follows: that amount of resolution which allows the cinematographer to put diffusion or nets in front of the lens, and deliberately toss away a large portion of the available resolution. This also allows the assistant, working with high-speed lenses, to miss his or her critical focus once in a while and still provide a result that can be screened to a large audience, on a projection system that is rarely in focus, without that audience stamping its feet and complaining. If this seems to imply that motion picture resolution requires a reserve of sharpness to handle a certain amount of accidental or intentional abuse in the hands of cinematographers, then that is exactly the point.

It is worth touching on the subject of registration in a high definition camera. Any situation but perfect registration would produce major resolution limitations in the final high definition picture. For example, a 1,125-line high definition camera that was out of registration between the blue and green by one horizontal line (just 1/1,125 of the picture height) would result in a resolution of 563 lines. If red and green were also out of registration by one line, the camera would have a resolution of 281 lines. Obviously, conventional means of registering an HDTV camera are inadequate, and some form of computer-controlled or computer-assisted registration is essential.

ASPECT RATIO

It is generally agreed that HDTV requires a wide-screen aspect ratio. For large-screen display, aspect ratios of 1.85:1 and 2.35:1 have been suggested, and an aspect ratio of 5:3 (1.67:1) has been used for HDTV by NHK and others to conserve bandwidth for broadcast viewing on smaller home receivers.

The reasons for a wide-screen aspect ratio in HDTV are essentially the same as the reasons given for wide-screen aspect ratios in film formats. The history of the motion picture industry shows that, given a choice between wide aspect ratio and resolution, the industry has chosen wide screen and wide aspect ratios on every occasion. The motion picture industry has done this based on the most conclusive, most immediate type of audience preference poll—that of whether or not they will pay at the box office.

The psychological impact of a wide-screen image is judged to be greater for a given screen height. Tests done at NHK indicated that viewers preferred a 5:3 aspect ratio on smaller screens such as might be used in homes, but a 2:1 aspect ratio for larger theater screens. A 5:3 aspect ratio is comparable to the European nonanamorphic wide-screen film format (1.66:1). A 2.35:1 is now the most common anamorphic aspect ratio in films.

There have been proposals for the use of anamorphic lenses with HDTV in order to achieve the wide-screen format without the bandwidth penalty. Some teleconferencing systems currently use anamorphic lenses with conventional television signals to produce wide-screen

images for projection. A video image could be unsqueezed electronically through the use of frame store technology at the receiver or projection end. This could also be accomplished in an even simpler fashion by modifying the receiver's vertical height with a switch and fixed resistor to change the vertical size. This system of deanamorphisizing has been used in motion picture production video assist monitors for some time.

Studies indicate that the impact of wide-screen images results from the fact that the wide format doesn't allow the viewers to take in the whole image in one glance. It requires them to scan the image with their eyes and edit it into a visual experience. The fact that the viewers must participate in their visual experience tends to involve them more fully. This is especially true for extremely large screen presentations, and assumes a low viewing distance to screen height ratio.

SCREEN SIZE

HDTV requires a large-screen projection system to realize its visual potential, whether it is a 6-foot screen in a home or a 40-foot screen in a theater. The full impact of a high-resolution image depends on a large screen as well as a wider viewing angle. The same image viewed on a larger screen from farther back can have greater impact than when it is viewed on a smaller screen closer up.

Fortunately there are already video projectors capable of projecting images with more than 1,000 scan lines. The Eidophor projector and the GE light valve projector can both project high-resolution video images onto a large screen, and the possibilities for developing even better video projectors are good. Sony developed a prototype CRT projector with a 6½-foot-wide screen that was demonstrated with the NHK HDTV system. The Sony projector has a bandwidth of 30 MHz, a contrast ratio of 30:1, and a resolution of 800 TV lines.

One of the areas of research being pursued by NHK in conjunction with its HDTV work is the development of a flat video display device, that is, a TV screen that can be mounted on a wall like a picture frame. They have constructed experimental gas discharge display devices, and it is entirely conceivable that such a panel display device could be used in conjunction with HDTV.

FRAME RATE

There are four principal considerations in setting the frame rate for an HDTV system: flicker, reproduction of motion, noise reduction, and bandwidth requirements. The higher the frame rate, the greater the bandwidth requirement of the system, all other things being equal. The object is to choose as low a frame rate as possible without compromising the image quality, but frame rates as high as 80 frames per second have been proposed.

The threshold for perception of flicker is about 40 frames per second. Film projectors eliminate flicker by using double- or triple-bladed shutters, so that each frame is projected two or three times. With a repetition rate of 48 or 72 times per second there is no perceptible image flicker. Current broadcast television standards eliminate flicker by means of the interlace scanning of the image. It is the field rate rather than the frame rate that determines whether there is any perceptible flicker. NTSC has a field rate of 60 fields per second, which is comfortably above the threshold. With PAL and SECAM the field rate is 50 per second, and a degree of flicker can be observed with exceptionally bright images. Screen brightness of PAL receivers is generally held within limits that prevent noticeable flicker.

One of the considerations in designing an HDTV system is the question of whether it needs to be compatible with film frame rates. Since one form of application envisioned for HDTV (especially in its initial implementation) is the production of movies to be transferred to film for conventional distribution, it may be advantageous to adopt a frame rate of 24 frames per second, or one that is divisible by 24 frames (for easy conversion). Flicker would be a problem with a 24-frame-per-second system when viewed on a video monitor, especially if it did not have interlaced scanning.

If the system were designed purely for transfer to film, then the problem of flicker on monitors used for production or postproduction prior to transfer to film could be overcome. Frame-store devices could be used to convert the image to a 30-frame-per-second interlaced image just for viewing during production. If, however, the system is designed for anything other than transfer to film, then a frame rate of 24 frames per second is not really feasible.

Higher frame rates permit better rendition of movement. One of the advantages of Showscan (a 60-frame-per-second, 70mm motion picture

film system) is that its higher frame rate improves the appearance of moving objects, especially on a very large screen. Moving objects can be sharper without creating a strobing effect. The higher frame rate involves a shorter exposure time in the original photography, so that moving objects tend to be sharper, but the higher frame rate in projection means that strobing is less likely because of the increased number of images presented to the eye.

The same principle applies to some extent with video. Higher frame rates improve the rendition of motion. There is another complication in the reproduction of motion with video, however, in that interlaced scanning can result in motion aliasing. Motion aliasing is the effect of jagged edges produced when an object has moved during the time between the scanning of the first field of a frame and the second. The net effect is a loss of definition since the jagged edge is perceived as a blurred edge. Higher frame rates help reduce this effect by reducing the time between the scanning passes and therefore reducing the difference between the position of the edge in one field and its position in the next field. The best method of eliminating motion aliasing is through the use of non-interlaced or progressive scanning. Progressive scanning, however, requires high frame rates to eliminate the resulting large-area flicker. High frame rates, in turn, require excessive bandwidth. One proposed solution to this spiral of complexity is to broadcast an interlaced signal and, through the use of a frame store, convert the signal at the receiver end to a progressive scanned signal for display or conversion to film without motion aliasing. Philips and others are currently demonstrating such systems.

Another advantage of higher frame rates in video or film is the reduction in noise. With film the grain pattern becomes less noticeable as the frame rate increases, since the grain pattern varies from one frame to the next. If the frames change fast enough, the grain patterns cancel each other out. The same is true with noise in a video image. Higher frame rates can reduce the visibility of noise.

SENSITIVITY

Sensitivity in a video or film camera translates directly into work hours required to light a set. Other hidden costs of low sensitivity are: electrical power consumption caused by increased lighting and air conditioning needs on the stage, fatigue factor on the part of actors, expensive pro-

duction delays caused by the need to reapply makeup that has faded from heat and perspiration, and the length of time required to set up and strike a location of heavy-weight as opposed to light-weight lighting instruments. It has certainly not been lost on the advocates of motion picture technology that high sensitivity in relation to signal-to-noise ratio is currently a major advantage of film over video technology. This advantage will increase rather than decrease as video technology progresses farther in the direction of high-definition video systems. As a high-resolution tube beam discharges a smaller portion of the target area with each scan line, it produces a higher-resolution image, but it also discharges a lower-level signal. Since it is sampling a smaller percentage of the total picture at any given beam pass, the net effect is to render the HDTV camera less sensitive than a conventional camera. Only solid-state sensors can offer help in this regard, but an HDTV solid-state sensor presents its own problems.

COLOR ENCODING

HDTV requires a different method of transmitting the chrominance signal in order to avoid compromising the definition of the luminance signal. A pure RGB signal is not considered an efficient use of bandwidth, since color does not really need to be as highly resolved as brightness or luminance. Some form of component signal is generally advocated for HDTV, but just what is the best relationship between luminance and chrominance has yet to be determined. The system developed by NHK uses a luminance signal with a 20-MHz bandwidth and a chrominance signal with a 6.5-MHz bandwidth. Other proposals for HDTV systems involve a lower luminance-to-chrominance bandwidth ratio.

ADVANTAGES OF HDTV

There are several reasons for the development of HDTV. The most obvious is simply the desire to enrich the viewing experience possible with television. Television has grown up under the shadow of theatrical motion pictures, and the desire to match the viewing experience of film is a natural goal for television. Movies have two advantages over tradi-

tional television: a huge screen viewed in a darkened room and a recording medium capable of greater subtlety of detail. HDTV represents an attempt to compete with film in both these areas.

Another reason for the development of HDTV is the theory of the electronic cinema, that is, the electronic distribution of movies that seems to offer certain advantages to producers and distributors. Aside from the physical and economic advantage of not having to make 500 or 1,000 prints of a movie and "bicycle" them all over the world, there are the anticipated antipiracy advantages. Piracy or unauthorized duplication of motion picture products, according to Variety, is an industry whose profits have reached $1 billion a year. Complex encoding schemes and the use of encryption devices promise to make motion picture piracy a more difficult undertaking. Declassified U.S. military encryption devices, currently in use for cable broadcasting, allow the scrambling of a video image so that it may be viewed only by customers who have correctly keyed a six-digit "password" into their pay-TV decoders. Present equipment permits the changing of this password as frequently as every thirtieth of a second, if required for picture security. Because of the electronic nature of the video image, it lends itself to scrambling or encoding schemes in ways that are not possible with an optical motion picture image.

This has great appeal for producers, and certainly is a tangible argument for high definition video production of dramatic subjects. Simultaneous worldwide distribution via direct broadcast satellite also promises the producer a sizable immediate income from the product. More important, it is a profit that can be realized before motion picture piracy can significantly erode the box office earnings of the production. This short turnaround between completion of a production and the box office return on its investment promises to stimulate production in an era of high interest rates, and in some small measure stem the tide of rising production costs. And don't think the promise of a worldwide release before the reviews can come out is lost on the production community, either.

From a creative perspective the desire to make movies electronically represents a desire to take full advantage of the speed and flexibility of electronic processes in production and postproduction. Electronic editing and special effects techniques are already being used even when the movie is shot and distributed on film. The ability to use electronic means for the entire production process without sacrificing image quality could result in either greater efficiency or greater experimentation in production.

HISTORICAL PERSPECTIVE

Television systems with more than 525 or 625 scan lines are not a new development. The Germans had a 1,000-line system before the Second World War, and the broadcast standard used by the Germans in Paris throughout the war led to the adoption of the 819-line system used in France until the sixties. These were, of course, black-and-white systems, as was the experimental 1,200-line system developed in England in the late forties. The French abandoned their 819-line system when they adopted the 625-line SECAM color system. It may be interesting to note that, far from being controversial and experimental, HDTV technology has actually been in use for some time in medical applications and military (and civilian) flight simulators. Also, high-definition computer-generated graphic images were used on the Disney motion picture *Tron*.

IMAGEVISION

The hope of producing theatrical movies on videotape and then transferring them to film for distribution led to the development of the Image-Vision system by Image Transform, a company whose principal business was the transferring of videotape to film by means of a patented process. The Image Transform tape-to-film process consists of computer-assisted image processing for noise reduction and image enhancement followed by the making of black-and-white separation elements using a scanning process that eliminates the scan lines in the film image.

ImageVision started out as a camera modification and a videotape recording format designed exclusively for transfer to film. The idea was to shoot with a video frame rate of 24 frames per second so that there would be no motion discontinuities in the transfer to film, and then to use the extra time available for each frame to increase the number of scan lines. The bandwidth requirements for a 655-line, 24-frame-per-second system are about the same as those for a 525-line, 30-frame-per-second system. In addition, it was possible to compress the scan lines closer together, because the system was designed for a 1.85:1 aspect ratio. This increased even further the vertical resolution achievable with the system.

As a further refinement of the system, a patented color encoding system was developed that made it possible to take full advantage of the horizontal resolution of state-of-the art video cameras. The 3.58-MHz color subcarrier was doubled in frequency (to 7.16 MHz) and placed outside of the luminance video area on the modified videotape recording format. This makes ImageVision technically a component video system, similar to half-inch component video systems, and is the key to its improved picture resolution. Many video cameras are capable of 700 or 800 TV lines of horizontal resolution, even though this resolution is reduced to 360 lines by the NTSC broadcast encoder. Since the Image-Vision system does not need to be broadcast-compatible, it can use modified encoders and recorders capable of preserving all of the camera's horizontal resolution.

Although the ImageVision system was conceived as a means of shooting on tape at 24 frames per second with a 1.85:1 aspect ratio for transfer to film, the color encoding system is independent of the frame rate and the aspect ratio. It is possible to use it for 525-line, 30-frame-per-second video in the 1.33:1 format. This sacrifices the increased vertical resolution, but retains the increased horizontal resolution.

ImageVision has been classified as an extended-definition system rather than a high-definition system. While it produces 35mm prints from a video original that many people consider adequate for theatrical exhibition (and it has been used commercially with some success), it does not produce a high-definition television image in the strict sense as defined by the SMPTE High-Definition Study Group.

THE NHK HDTV SYSTEM

The most significant work in HDTV during the late seventies was probably that done by NHK. Beginning with a series of psychophysical studies aimed at establishing goals for an HDTV system, NHK went on to coordinate the development of a complete prototype system that was demonstrated in 1982. In addition to experimental equipment developed by NHK, working prototype high-definition cameras, recorders, monitors, projectors, and time base correctors compatible with the NHK system were produced by Sony, Ikegami, and Matsushita (Panasonic).

The NHK system is a 1,125-line, 30-frame-per-second system with a 5:3 (1.67:1) aspect ratio. In order to achieve a horizontal resolution

comparable to its vertical resolution, it requires a bandwidth of 30 MHz, or about 6.6 times the NTSC bandwidth of 4.2 MHz. The cameras use experimental 1-inch tubes and probably have an exposure index of about 50. The Sony recorder is a modified 1-inch type C recorder that runs about 19 ips and can record up to 48 minutes on one reel.

It is worth noting that NHK's own psychophysical research set an ultimate goal for HDTV of 1,500 scan lines and a 2:1 aspect ratio for competition with 35mm motion picture film. The 1,125-line system was chosen as a more practical goal, given the current state of technology and the politics involved in the adoption of one worldwide standard. It is not necessarily regarded as achieving a degree of resolution comparable to that of 35mm film.

STANDARDIZATION

The development of HDTV presents the possibility of the adoption of one worldwide standard for television. Since one of the most practical ways to transmit HDTV will probably be by direct broadcast satellite, it would be highly advantageous to have a worldwide standard that could eventually replace NTSC, PAL, SECAM, and the other hybrid standards derived from them. What the prospects are for such an international agreement is hard to predict. The fact that a worldwide standard was adopted for digital television is encouraging, but there are any number of political, commercial, and even psychological obstacles to the adoption of a single worldwide standard for HDTV. It is therefore probable that a worldwide standard for production is feasible, but that standards conversion to many different national standards may be necessary for distribution. World television standards groups such as the European Broadcast Union (EBU) and the Comité Consultatif International des Radiocommunications (CCIR) are actively advocating one worldwide HDTV production standard even if many different distribution standards are eventually utilized.

COMPATIBILITY

One of the great obstacles to the commercial adoption of any HDTV system is the question of compatibility with existing broadcast systems.

There are essentially two different perspectives on the issue of compatibility. One compares the situation to that faced with the introduction of color television, when the only acceptable solution was felt to be a compromise in the color broadcasting system that made it completely compatible with the existing black-and-white broadcasting system. The other perspective compares the introduction of HDTV to the introduction of FM radio broadcasting, which provided improved fidelity and stereo but only to listeners who acquired a completely new receiver.

Concern about compatibility led CBS to propose an elaborate variation on the NHK system that would permit a slightly compromised version of the 1,125-line system to be broadcast in such a way that a portion of the signal would contain an image that could be received by conventional 525-line receivers. The compromise involves a sacrifice in vertical resolution in the areas of the wide-screen image that would be cropped off by a conventional receiver. The rationale given for this compromise is that the outer edges of a wide-screen image do not generally contain the same degree of detail as the central portions of the image.

Most proposals for HDTV systems assume that the compromises required to render an HDTV system completely compatible with existing broadcast standards would undermine the purpose of the system. Rather than attempting compatibility, they concentrate on "convertibility"; that is, they set parameters that facilitate conversion of the HDTV signal into an NTSC, PAL, or SECAM signal. The current state of technology would make it prohibitively expensive to include conversion equipment in home receivers, but conversion would be feasible prior to distribution to viewers with conventional receivers.

HDTV TRANSMISSION

Another major obstacle to the development of HDTV is the difficulty of broadcasting a 30-MHz signal. Even if conventional broadcasting techniques were capable of broadcasting a signal of this bandwidth, the spectrum space would have to be allotted, and presumably the number of channels would be fairly limited. The two most promising methods for transmitting HDTV are direct broadcast satellite and cable using fiber optics.

The Creative Potential of the Electronic Image

One of the unique attributes of video production that has separated it from all other forms of visual expression is that people working in video devote more thought and effort to technical considerations than to aesthetic concerns. This tends to advance technology at the expense of art.

ELECTRONIC VERSUS PHOTOCHEMICAL

So far we have simply assumed that because electronic production techniques exist and are becoming more prevalent, it is to everyone's advantage to learn how to achieve the same degree of control over an electronic image as the cinematographer has exercised over the photographic image for many years. Eventually, however, we must face the question of whether there are really any advantages to electronic production.

If the whole point of this book is to enable cinematographers to do electronically what they have been doing for years with film, what reason is there for doing it electronically in the first place? In other words, if it works, why fix it? Moreover, much of what we have been discussing is concerned with the limitations of video in comparison to film. In its current standard forms, video is capable of neither the resolution nor the contrast range of film. It simply cannot produce images that are as subtle as images produced on film. It would seem, then, at least from a creative point of view, that any trend toward video production rather than film is a step in the wrong direction.

There are, of course, characteristics of the electronic image and of the production techniques associated with it that many consider sufficiently advantageous to outweigh these limitations. The instantaneous nature of electronic processes is perhaps the chief of these. The electronic image does not have to be developed in a laboratory overnight; it is available for viewing the instant it is captured.

Another potential advantage is the amenability of electronic images to computer manipulation. Both the images themselves and the way in which they are combined with each other can be altered using computers.

The advantages of instant replay in video have been called into question by our insistence that the picture monitor is not a reliable means for evaluating lighting during production. Any other benefit of instant replay can be achieved just as well by using a video assist on a film production. Similarly, the advantages of computerized editing begin to pale a bit when one contemplates the cost and complexity of the hardware and software required to duplicate the editing techniques made possible by a splicer and a set of rewinds.

What, then, are the real advantages of the electronic image? Suppose film could be processed in a black box on location (as some experts predict will be possible in the future), and suppose video had the same resolving power and contrast range as film. Are there essential differences from a creative point of view? What could you do with an electronic image that you cannot already do with a photographic one?

The key to the creative potential of the electronic image lies in the possibilities for altering the characteristics of the image either as it is being recorded or afterward. The ability to manipulate the transfer characteristic of each component of a video image, combined with the ability to digitize the image, implies a degree of control over the image that surpasses that of any other medium ever devised. Ultimately it will be possible to do more to an image electronically then even a painter can do with paint on a canvas.

The description of color correction systems in Chapter 14 may give an inkling of this potential. Other indications of the potential for electronic image manipulation are digital effects and computer graphics. It is entirely conceivable, for example, that all the sets and locations for a movie could be created electronically in such a way that actors shot against a blue screen could move around and behind electronically generated objects and interact with them. This style of filmmaking may not appeal to everyone, but it is indicative of a way in which movies could become an even more direct expression of the imagination of their creators. And this, after all, is what cinematography is all about—the creation of moving images that communicate and entertain.

The tools available for electronic cinematography today may still be crude in comparison to the ultimate potential of the medium, but the groundwork has been laid. It is already possible to create beautiful and striking electronic images, and mastering the basics with the current technology will enable you to take full advantage of the improvements as they evolve.

ELECTRONIC PLUS PHOTOCHEMICAL

Any debate about the relative merits of electronic and photochemical imaging systems may be missing the point. The two are not necessarily mutually exclusive systems. It is possible to combine them in ways that may very well incorporate the best of both worlds.

Because the technology is in a state of transition, all manner of hybrid production techniques have emerged during the past few years (shoot on tape/edit on film/release on tape, shoot on film/edit on tape/release on film, and so on). Every conceivable combination of film and tape in production, postproduction, and distribution is currently possible and even commercially viable. The two most significant methods of combining film and video are (1) production on extended- or high-

definition video for distribution on film (see Chapter 15) and (2) production on film for postproduction on video.

Shooting film for transfer to tape produces different image characteristics on a television screen than shooting with a video camera. There has been a great deal of talk in recent years about the "film look" and whether it is possible to duplicate it with a video camera. Much of what is associated with the "film look" is simply a matter of single-camera production techniques and lighting. Some of it is also a matter of the tendency to use excessive amounts of edge enhancement or detailing with video cameras. Some of it, however, has to do with the way in which film compresses the brightness range of the original scene into a range that can be encompassed by the pickup device in a telecine (or film-to-tape transfer system). Highlight detail in the original scene that would be out of the range of a conventional video camera is captured on film and compressed so that it can be incorporated in the video signal produced by the telecine. Gamma compression circuits were designed to enable video cameras to emulate this effect, but some people still prefer the look of a film-to-tape transfer, especially if the film is exposed at 30 frames per second so that there are no motion discontinuities in transferring to 30-frame-per-second video.

It has become common practice to transfer to tape directly from an original film negative rather than first making a print from the negative. The image can be converted from negative to positive electronically, and gamma adjustments on the telecine can be used to ensure that the maximum possible contrast range of the negative is incorporated into the video image. In the future it may be possible to use digital image enhancement techniques to preserve even more of the image detail and to eliminate the grain pattern of film when transferring it to tape. Such image enhancement techniques are currently being developed for application in the printing of film. Their first use may be in still photo finishing, but they will eventually be applied to film-to-tape transfer systems as well.

TECHNOLOGY AND CREATIVITY

It is important to remember that video technology is a tool for creativity and not an end in itself. Just as the owners of expensive stereo systems can become so fascinated with their equipment they forget that the purpose of a stereo system is to play music, so video engineers and even

cinematographers can get distracted by the amazing sophistication of video equipment. What it is all about is not liquid crystal readouts of alphanumeric data but making pictures—pictures that stir the heart and engage the imagination, that transport the viewer into a different world and send him or her back a richer person.

Working with high-tech electronic gear can be a numbing experience for a cinematographer accustomed to working on a film set. Video production can be a very abstract activity that tends to divorce a cinematographer from the basic aesthetic issues at hand. There is, after all, a great difference between looking at a waveform monitor and looking at the expression on an actor's face.

Every cinematographer knows the concentration required to stay focused on creative concerns when the generator has just broken down and the production manager is worried about staying on schedule. To add video technology to all of the inevitable distractions on a set may seem like courting disaster, and it is unless the cinematographer has sufficiently mastered the basics of video.

That is why a video crew must include a director of photography in addition to the camera operator. There must be one person who is responsible for both the functioning of the crew and the realization of the visual design. Logistic priorities must be a function of creative decisions, and the only person capable of keeping the priorities straight is the cinematographer.

Glossary

This glossary was written specifically for this book. It was designed for those with production rather than engineering orientation.

ABC Automatic beam control. A circuit that provides dynamic control of the beam in the camera pickup tube, reducing image retention and comet tailing.

ABO Automatic beam optimization; another term for ABC.

Active video lines All video lines not occurring in the vertical blanking interval.

AGC Automatic gain control. An electronic circuit that automatically controls levels of audio or video during recording or playback of the signal.

Analog Describes an electrical signal that is continuously variable in signal level (that is, not digital).

Aperture An adjustable diaphragm located in the camera lens controlling the amount of light reaching the film emulsion or video tube. Also known as iris.

Aperture grill A masking screen on video monitors serving the same function as a **shadow mask.**

APL The average signal level with respect to blanking level during the active picture scanning time expressed as a percentage of difference between blanking and reference white (IEEE definition).

ASA American Standards Association. Publishes motion picture film dimensions and usage as well as sound and television standards.

Aspect ratio The ratio of picture height to width. TV = 3:4, 35mm film = 3:4 (1.33:1), and the aspect ratios of cinema with widescreen formats, in common use, are 1:1.85 and 1:2.35. (1:1.66 is common in Europe.)

Attenuate To reduce the strength of a signal.

Azimuth The angle of a recording head in relation to the longitudinal axis of the tape.

Band A range of frequencies.

Bandwidth A range of frequencies in relative rather than absolute terms. A band from 54 to 60 MHz and a band from 60 to 66 MHz would both represent a bandwidth of 6 MHz. Bandwidth specifications for video equipment give an indication of the maximum possible resolution to be expected in an image processed by that equipment.

Beam The focused stream of electrons inside a video tube or receiver/monitor picture tube.

Beam pooling An image defect associated with overexposure in a pickup tube. Beam pooling is a form of image retention in a relatively large area of an image which results when one pass of the scanning electron beam cannot fully discharge that image.

Beam-splitter prism A precision glass block used within the optical system to divide the red, green, and blue wavelengths inside a video camera.

Beam starvation Another term for the image retention in a highlight area of a video image from a pickup tube resulting from the inability of the scanning electron beam to fully discharge the target.

Betamax The Sony ½-inch video cassette format for consumer and industrial markets. Also known as Beta Format.

Bias light Light from a source within a video camera that uniformly illuminates the face of a pickup tube even when there is no image focused on it. Bias light creates dark current and is a means of reducing lag and improving shadow detail.

Black level The video signal (set at 7.5 on the waveform monitor) that reproduces as black on the monitor screen. Also called picture black.

Blanking pulse The level of the composite picture signal separating the range containing picture information from the range containing synchronizing information. (IEEE definition). The scanning beam of a TV camera or monitor traces and retraces the pattern of a raster across an image. The information is transmitted during the forward trace but not during the flyback or retrace. The pulses are then limited to black level (or zero picture content), referred to as line blanking (horizontal) and field blanking (vertical).

Burn A flaw in a video tube that reoccurs in the same frame position and is often caused by extended overexposure.

Burst A signal consisting of nine cycles of subcarrier that forms the phase or hue reference for all the other colors in the video image.

Burst flag A keying or gating signal used in forming the color burst from a chrominance subcarrier source.

CCD Charge-coupled device. A silicon chip storage device sometimes used in place of video camera tubes.

Chroma The saturation of color in a video signal.

Chrominance signal The portion of the color television signal containing the color information.

Clipping An electrical circuit that, when activated, automatically cuts variations in the signal above 100 percent white or at the level that the circuit is set to clip.

Coaxial cable A braided-shield, concentric axial, one-conductor cable used for video connections with an impedance of 75 ohms.

Color bars A test signal, typically containing six basic colors: yellow, cyan, green, magenta, red, and blue. Color bars are used to check the chrominance encoding functions of color TV systems.

Color burst In color systems, a burst of a subcarrier frequency serving as a color-synchronizing signal to establish a frequency and phase reference for the chrominance signal.

Color subcarrier In color systems, the carrier signal that is added to the monochrome signals to convey color information.

Comet tailing A streaking effect (resembling a comet) caused by the excessive light of a specular reflection moving within the scene being photographed.

Composite blanking The complete television blanking signal composed of both line-rate and field-rate blanking signals.

Composite sync The combined line- and field-rate synchronizing pulses including field-equalizing pulses.

Composite video The color picture signal plus blanking and all synchronizing signals.

Compression The reduction at one level of a picture signal with respect to the gain at another level of the same signal.

Control track The sync pulse recorded on videotape that guides the recorder transport speed in playback.

Convergence In color television, the meeting or crossing of the three RGB electron beams at the shadow mask of a kine tube, so that the red beam strikes only the red phosphors, the blue beam strikes the blue phosphors, and so on.

Crosshatch A test pattern consisting of vertical and horizontal lines used for converging color monitors.

Cross talk Undesirable interference between two or more tape tracks or signals.

CRT Cathode ray tube. The vacuum tube used in TV monitors and receivers composed of an electron gun aimed at a screen coated with phosphors that glow when hit by electrons.

DA Distribution amplifier. An audio or video amplifier having one input and two or more isolated outputs.

Dark current The current flowing from a pickup tube even when the lens is capped and there is no exposure to an image at all. Dark current is roughly the equivalent of base fog level on a film negative.

DBS Direct broadcast satellite. A video distri-

bution system utilizing satellite broadcast direct to homes.

Decibel dB. A logarithmic unit of measure applied to sound as well as ratios of powers, voltages, and currents.

Delta gun A television monitor tube in which the electron guns are arranged in a triangular configuration or delta.

Differential gain The difference in output amplitude (expressed in percent or decibels) of a small high-frequency sine wave signal at two stated levels of a low-frequency signal on which it is superimposed (IEEE definition).

Differential phase The difference in output phase of a small high-frequency sine wave signal at two stated levels of a low-frequency signal on which it is superimposed (IEEE definition).

Digital A system of circuits in which the output varies in discrete steps that represent a mathematical model of the original signal.

Diode gun A type of pickup tube in which the gun, or electrode array emitting and shaping the scanning beam, is one in which the electrons are focused at two points instead of three. The resulting smaller beam spot produces improved resolution.

Drop frame A form of SMPTE time code created to match clock time precisely. Two frames of code are dropped every minute on the minute, except the tenth minute, to correct for the fact that color frames occur at a rate of 29.97 per second rather than an exact 30 frames per second.

Dropout Usually refers to a videotape defect that appears to interrupt the image during playback and is caused by imperfect oxide coating or dirt on the tape.

Electromagnetic focus One of two methods of focusing an electron beam, the other being electrostatic. This method uses a magnetic field.

Electron gun The device inside a camera or monitor tube that fires electrons at the image-sensing or -reproducing surface of the tube. This beam is deflected to perform the scanning function.

Electrostatic focus One of two methods of focusing an electron beam, the other being electromagnetic. This method uses electrically charged plates.

Encoder Electronic circuitry that combines primary RGB signals into composite color video signals according to a particular country's television standard.

Equalizing pulses Pulses on one-half the width of the horizontal sync pulses transmitted at twice the rate of the horizontal sync pulses during the portions of the vertical blanking interval immediately preceding and following the vertical sync pulse. These pulses cause the vertical deflection to start at the same time in each interval, and also keep the horizontal sweep circuits in step during the portions of the vertical blanking interval immediately preceding and following the vertical sync pulse, and therefore they synchronize the interlace of horizontal lines.

Field One of the two equal parts of information in which a frame is divided in interlace scanning. *See* **Frame.**

Field blanking The blanking signals occurring at the end of each field, used to make the vertical retrace invisible. Also called vertical blanking.

Field frequency The rate at which one complete field is scanned.

Frame One complete picture consisting of two fields of 262½ (in NTSC) interlaced scanning lines. One field contains the odd-numbered lines and the other field contains the even-numbered lines. This scheme is used to prevent large-area flicker and totals 525 horizontal lines (NTSC) or 625 horizontal lines (PAL). One complete TV frame is scanned in $1/30$ of a second.

Frequency A video, audio, radio, or digital signal defined in terms of its repetition rate per second.

Front porch That portion of the composite picture signal lying between the leading edge of

the horizontal blanking pulse and the leading edge of the corresponding horizontal sync pulse.

Gain The level of signal amplification.

Gamma A general term describing the tonal reproduction characteristics or gray scale reproduction equivalent of a film or video signal. The word *gamma* is used differently by film technicians and video technicians.

Gamma correction A term used in video to describe a process through which a nonlinear output-input characteristic is introduced into the video signal for the purpose of changing the effective value of gamma to correct for a picture monitor's nonlinear gray scale reproduction.

Generation A term of measurement used to describe the number of duplications from the original recording.

Genlock The locking of one video system to the sync signal of an incoming signal.

Glitch A slang term for picture distortion.

Guardbands The space between tracks on videotape that prevents cross talk between adjacent tracks.

HDTV High-definition television. An abbreviation used to describe many new systems under worldwide development that will bring about improved video picture quality.

Helical A helixlike method of recording information on videotape in which the signal is recorded in diagonal tracks. This method is used by all VTRs on the market except quad VTRs. Also called slant-track recording.

Hertz Hz. The frequency per second of any electrical signal, also known as cycles per second.

High-band A video recording system of excellent quality utilizing a high-frequency FM signal deviation of 7–10 MHz.

Horizontal drive A pulse at horizontal rate used in TV cameras. Its leading edge is coincident with the leading edge of the horizontal blanking pulse, and the trailing edge is

coincident with the trailing edge of the horizontal sync pulse.

Horizontal resolution The number of vertical lines that can be observed by a video camera or receiver in a horizontal direction on a TV test chart.

Horizontal sync The sync pulses that control the horizontal scanning of the electron beam at 15,734 Hz for color and 15,750 Hz for black and white.

H rate The time for scanning one complete horizontal line, including trace and retrace.

Hue The attribute of color perception that determines whether the color is red, yellow, green, blue, and so on.

Interlace The process of alternating two fields to eliminate large-area flicker. *See* **Frame.**

IRE Institute of Radio Engineers.

IRE scale A waveform monitor scale that applies to composite video levels. There are 140 IRE units in 1 volt of video. Forty of these units apply to the sync amplitude and 100 of these units measure the video level. These can be thought of as the equivalent of percentage units of peak video.

Image enhancer An electronic device used to sharpen video images by exaggerating transitions between light and dark areas in the high-frequency areas of the photographed picture.

Image retention The tendency of video tubes to retain a "burned-in" image of overexposed picture areas. Also called stickiness.

Impedance Resistance to the flow of an electrical current.

Iron oxide Magnetic particles, adhering to the backing layer of video- and audiotape, that are rearranged to reproduce a signal by the action of the magnetic heads. Metals other than iron are also used, such as chromium dioxide, which is used in a form of high-energy videotape.

Kilohertz kHz. A thousand hertz or cycles per second.

Kinescope Originally the method of preserving video productions on film prior to the invention of videotape, by photographing a monitor.

Kine tube The video picture tube that uses a modulated electron gun striking a phosphor screen to reproduce a visual picture from a video signal. Also called CRT. *See* **Shadow mask.**

Lag Image retention on a camera tube in underexposed picture areas caused by the tube's internal capacitance or image-storing characteristics.

Line blanking The blanking signal at the end of each horizontal scanning line. It is used to turn off the electron beam during the retrace period, during which the beam returns to begin a new horizontal line. Also called horizontal blanking.

Line frequency The number of horizontal scans per second, normally 15,734.26 times per second for NTSC color systems. Also can mean power line frequency, for example IE60 Hz in the United States.

Luminance A component of a video signal describing what its brightness equivalent would be were it a black-and-white signal rather than a color signal. Also referred to as Y.

Megahertz MHz. A million hertz or cycles per second.

Mixed field tubes Pickup tubes employing both electrostatic and magnetic methods for guiding and focusing the electron beam. Electrostatic deflection combined with magnetic focus permits higher resolution and lower geometric distortion in the image.

Modulation The process of adding audio and video signals to a baseband carrier frequency.

Monitor A cathode ray tube picture display without the electronic circuitry (or tuner) to receive broadcast video.

Noise Distortions in a signal, such as "snow" in video and "hiss" in audio, increased over multiple-generation duplication.

Non–drop frame A form of SMPTE time code that runs in consecutively ascending numbers, even though it does not exactly match actual elapsed time.

NTSC National Television Systems Committee. An industrywide engineering group that, during 1950–53, developed the color television specifications now established in the United States.

Off-line Preliminary editing, usually performed on a low-cost editing system allowing edit decisions to be deliberated with plenty of time and experimentation before the final, more costly **on-line** edit. Often called work tape editing.

On-line Final editing, using the original master tapes to produce a finished program, usually associated with a more costly, high-quality computer editing system.

Oscilloscope A cathode ray tube used to align video equipment and measure signal levels.

PAL Phase alternation line. The color television system developed by Germany that is the broadcast standard used in Europe (but not in France, which uses SECAM).

Pedestal The portion of the video signal that reproduces black. Also called black level.

Phase The timing relationship between two signals usually, but not necessarily, of the same frequency. Also used as a term to label the hue control on professional video color monitors.

Plumbicon A trademark name for a lead oxide video tube made in Holland and the United States, whose principal distinguishing characteristics are high sensitivity and low lag.

Processing amplifier The portion of a video camera used to modify the camera signal in areas such as white level, black level, gamma, and color balance, as well as amplifying the signal to a level that is usable by the rest of the video system.

Quad Quadruplex, a 2-inch videotape record-

ing format that uses four record/playback heads in a transverse scanning pattern.

Raster A slang term for the scanning process used to display images on a CRT. *See* **Scan; Target.**

Receiver A picture monitor equipped to receive off-the-air signals, including a tuner, an audio amplifier, and a speaker, accepting transmitted video only.

Reference white level The level corresponding to the maximum white portion of a video picture that can be reproduced without a *total* loss of texture.

Registration The coincident or accurate alignment of RGB images to form a faithful reproduction of the original scene's colors and lines.

Resolution A measure of sharpness of a video image, or the degree to which detail in the original scene is faithfully reproduced. In video this measurement is usually described as the number of horizontal or vertical TV lines that may be perceived when viewing the video picture on a monitor.

RF Radio frequency.

RGB Red, green, blue. Describes the component parts of a color video signal.

Saticon A trademark name for a video tube, made in Japan and the United States, that utilizes silicon as its principal light-sensitive element and is distinguished by high resolution and low flare.

Saturation Indicates to what degree a color is diluted by white light.

Scan The horizontal and vertical movement of the electron beam to create or reproduce images in a camera tube or monitor. *See* **Raster; Target.**

Setup The separation in level between blanking and reference black levels.

Shading An image defect associated with pickup tubes in which some portion of the image is darker. It is generally the outer edges of the image which are darker, and shading can be corrected by processing the signal. The term *shading* is also used loosely to refer to the process of manipulating camera exposure in a video image.

Smear An image defect caused by image retention in a pickup tube as an object moves through the frame.

Shadow mask A perforated metal screen used as a component part of a kine tube on a picture monitor or TV receiver, which, through the use of holes or slots, aligns the three RGB beams so they strike the correct phosphor coating on the viewing screen of the tube.

Signal Information coded into electrical frequency and/or amplitude variations.

Signal-to-noise ratio The ratio of random undesirable noise to structured or desirable signal.

Skew A tape tension control adjustable on most VTRs.

SMPTE Society of Motion Picture and Television Engineers.

SMPTE time code A frame-numbering system developed by SMPTE to aid the editing process by assigning a number to each frame of video or film. Time code is divided into hours, minutes, seconds, frames, and "user bits" that may encode any information useful in the editing process. Example: 02:23:30:26. It is used primarily in video computer or time code editing.

Staircase A video test signal containing several steps at increasing luminance levels. The staircase signal is usually amplitude modulated by a subcarrier frequency and is useful for checking amplitude and phase linearities in video systems, as well as gamma reproduction characteristics.

Subcarrier The portion of the video signal that contains the color information, 3.58 MHz in the United States and 4.43 MHz in Europe. Also called chrominance signal.

Sync Abbreviation for synchronization. Applies to the synchronization signals, or timing pulses, that lock the electron beam of the picture monitors in step, both horizontally

and vertically, with the electron beam of the pickup tube. The color sync signal (NTSC) is known as the color burst.

Target The photosensitive portion of the video camera tube.

TBC Time base corrector. A device that compensates for timing variations in a videotape playback signal caused by "wow and flutter" in the mechanical transport of the video recorder.

TV lines A means of specifying horizontal resolution in a video image. Each TV line is the vertical equivalent of a horizontal scanning line. An NTSC video image with a horizontal resolution of 340 TV lines has a horizontal resolution which is equal to its vertical resolution. In the NTSC system a MHz of bandwidth is required for every 80 TV lines of horizontal resolution.

UHF Ultrahigh frequency, 300–3,000 MHz.

Vectorscope A special oscilloscope used to monitor hue and color saturation in television signals.

Vertical blanking interval The blanking portion at the beginning of each field. It contains the equalizing pulses, the vertical sync pulses, VITS, and/or VIRS (if desired). *See* **Field blanking.**

Vertical sync The synchronizing pulses that control the vertical scanning of the TV signal and are used to define the end of one field and the start of the next. In the NTSC system vertical sync has a frequency of 59.94 Hz.

VHF Very high frequency.

VIRS Vertical interval reference signal. A signal that may be included during the vertical blanking interval to allow home TV receivers to obtain a color and luminance reference from the transmitting station.

VITS Vertical interval test signal. A signal that may be included during the vertical blanking interval to permit on-the-air testing of the video system.

VTR Video tape recorder.

Waveform monitor A special oscilloscope used to display the video signal and to evaluate video "exposure" levels.

White balance The process of achieving the correct color balance of a video camera that will accurately reproduce as white in the scenes being photographed.

Zebra pattern A pattern of zebralike stripes superimposed over the viewfinder picture areas that are at or near 100 IRE units, as an aid to exposure (depending on the specific design of the camera).

Index